BERNINI
IN FRANCE

An Episode in Seventeenth-Century History

CECIL GOULD

PRINCETON UNIVERSITY PRESS
PRINCETON, NEW JERSEY

Copyright © Cecil Gould 1982

Published by Princeton University Press,
Princeton, New Jersey

Printed in Great Britain

Library of Congress Cataloging in Publication Data

Gould, Cecil Hilton Monk, 1918–
 Bernini in France.

 Bibliography: p.
 Includes index.
 1. Bernini, Gian Lorenzo, 1598–1680.
 2. Art, Baroque—France. 3. Art, Italian—
 France. I. Title.
 N6923.B5G6 1982 709'.2'4 81-47998
 ISBN 0-691-03994-1 AACR2

DEDICATED TO
TIMOTHY AND NANCY OSBORNE-HILL

Bernini's Design of the *Louvre*
I would have given my Skin for,
but the old reserv'd *Italian*
gave me but a few Minutes View

SIR CHRISTOPHER WREN

CONTENTS

PART THREE: THE COURT IN PARIS

PART FOUR: THE AFTERMATH

CONTENTS

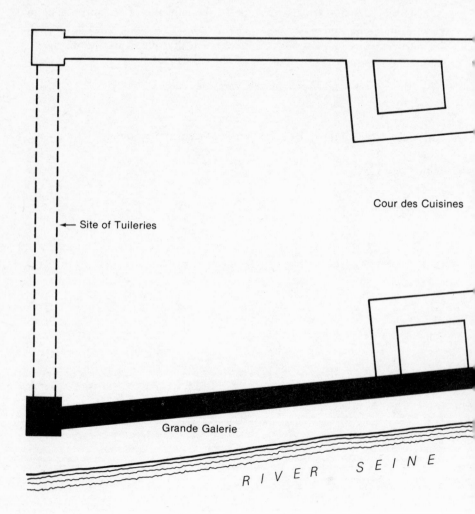

Site of Tuileries

Cour des Cuisines

Grande Galerie

RIVER SEINE

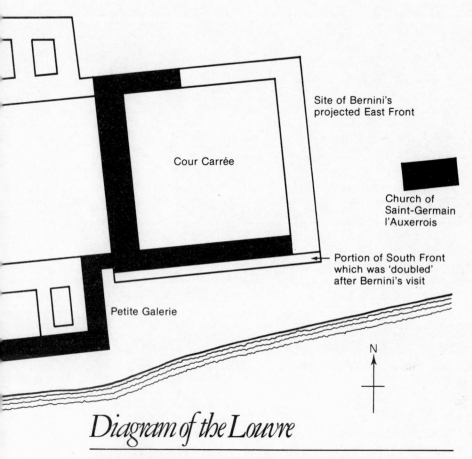

Site of Bernini's
projected East Front

Cour Carrée

Church of
Saint-Germain
l'Auxerrois

Portion of South Front
which was 'doubled'
after Bernini's visit

Petite Galerie

N

Diagram of the Louvre

Black portions are those which were completed before Bernini's arrival
Outlined portions are those which exist today and were built after his visit

ILLUSTRATIONS

Bernini, *Self-portrait*. Windsor, reproduced by gracious permission of Her Majesty the Queen.

Coysevox, *Bust of Louis XIV*. Musée de Dijon. (*Giraudon, Paris*)

Nanteuil, *Engraving of Louis XIV*. Bibliothèque Nationale, Paris. (*Giraudon, Paris*)

Le Brun, *Cardinal Chigi and Louis XIV*. Musée Nationale du Château de Fontainebleau.

Bernini, *Bust of Louis XIV*. Versailles. (*Alinari, Florence*)

Bernini's designs for the Louvre:
 First project, *Plans for Ground Floor and First Floor*. Louvre, Paris.
 First project, *East Façade*. Louvre, Paris.
 Second project, *East Façade*. National Museum, Stockholm.
 Third project, *West, South, East and Courtyard Façades*, engravings by Marot. RIBA, London.
 Third project, *Junction of South Façade with then-existing building*. Louvre, Paris. (*Giraudon, Paris*)
 Fourth project, *Plan of First Floor, including Oval Chapel*. Louvre, Paris. (*Giraudon, Paris*)
 Fourth project, *East Façade*. National Museum, Stockholm.

Guarini, Palazzo Carignano, Turin. (*Mansell Collection, London*)

The Royal Palace, Stockholm. (*A.F. Kersting, London*)

Velázquez, *Francesco d'Este*. Galleria Estense, Modena. (*Alinari, Florence*)

Bernini, *Bust of Francesco d'Este*. Galleria Estense, Modena. (*Alinari, Florence*)

Bernini, *Equestrian Statue of Louis XIV*. Versailles. (*Giraudon, Paris*)

Bernini, *Terracotta for Equestrian Statue of Louis XIV*. Galleria Borghese, Rome. (*Mansell Collection, London*)

Bernini, *Equestrian Statue of Constantine*. Scala Regia, Vatican. (*Alinari, Florence*)

Bernini, *St Jerome in Penitence*. Louvre, Paris. (*Giraudon, Paris*)

Lambert-Sigisbert Adam, *Self-portrait*. Ashmolean Museum, Oxford.

Bernini, Cathedra of St Peter's, Rome. (*Mansell Collection, London*)

Versailles, Chapel. (*A.F. Kersting, London*)

AUTHOR'S NOTE

I HAD COLLECTED most of the material for the present book in the 1950s, and had written about half a chapter, when my friend Rudolf Wittkower told me he was proposing to edit an English translation of Chantelou's journal. Though my own book was different, being always intended as a written history which should draw on all the sources, Italian as well as French, there is no doubt that Chantelou is the main one, and Professor Wittkower's prestige was such that I shelved my project. It was not until several years after he died in 1970, without having edited Chantelou, that I revived it. I have explained in a note at the end of the present book the nature of the copious published documentation. In addition I have drawn on some of the unpublished manuscripts in the Bibliothèque Nationale in Paris. It is understood that a forthcoming French edition of Chantelou will include a quantity of unpublished material. This is greatly to be welcomed, but to judge from the preview which was communicated to the Bernini conference organized by Professor Irving Lavin in Rome in May 1980 the new material is likely to consist of a series of interesting footnotes to what is already known, rather than of fundamental revisions or additions. The surprising fact is that there is almost a superfluity of documentation of Bernini's mission, much of which overlaps. It is also a fact that the existing material concerning the various plans, both French and Italian, for the Louvre which were produced during Colbert's ministry is sufficient to make a book in itself. Such a work is indeed desirable, but it would be of interest chiefly to historians of architecture, and since Bernini's contribution was only one of many, and since it accounted for no more than part of his activity in Paris, I have felt compelled to focus on that and only to discuss the others briefly in relation to it.

One of the innovations in the present book is that I have tried to reduce the number and the length of the notes. As a result of the wish of some modern scholars to close all loopholes to possible adverse criticism, footnotes have sometimes grown almost to the length of the text, thus forcing the reader, in effect, to read two books simultaneously. With this in mind I have included in the text what would have been the chattier type of footnote, and have normally restricted the actual notes to chapter and verse. Where no authority for a given statement is specified it must be assumed to be Chantelou under the date in question.

My first debt is to the late Rudolf Wittkower for directing my interest in the early days. For assistance and facilities during work on the book I am grateful

AUTHOR'S NOTE

to Professor A. F. Blunt, Mr Allan Braham, Monsieur Raymond Cazelles, Madame Hautecœur and Professor Irving Lavin.

C. G.
September 1980

PART ONE

The Preliminaries and the Journey

I

TOWARDS THE END of April 1665, Bernini, then aged sixty-six and the most famous artist in Europe, left Rome for a foreign country for the first and only time in his life. His destination was Paris. In view of the enormous number of facts which we know concerning almost every phase of the journey it is surprising that the date of Bernini's departure is usually given wrongly. The day of the month is specified, probably correctly, as the 25th by Baldinucci, whose life of Bernini was published in 1682, only two years after the subject's death. But Bernini's son, Domenico, has the 29th in his biography of his father (1713) and for some reason this has been generally followed, despite its being demonstrably wrong. A letter of 25 April, from Rome, says Bernini was due to leave that morning.[1] More convincing still, a letter from Siena dated 1 May 1665 from Bernini's assistant, Mattia de' Rossi, mentions that on the preceding Wednesday, 29 April, the party had been at Radicofani. This is about 150 kilometres from Rome, a distance which could not have been covered within a day in any manner consonant with the comfort of an elderly person.

The journey came about as a result of negotiations conducted personally between the young King of France, Louis XIV, and the Pope, Alexander VII (Chigi). Colbert, as Superintendent of the King's Buildings, had failed to find a French architect competent, in his view, to complete the Louvre. After consideration of plans sent by various Italians the King had requested the Pope to allow his own architect and artistic director, Bernini, to visit Paris. Louis had also written a personal invitation to Bernini himself.

The honours accorded to Bernini on this occasion were such as no previous artist had enjoyed, and appeared to the astonished and envious eyes of contemporaries to be appropriate only to royalty. Yet in the end the visit, which lasted a little less than six months, seemed to have come to nothing. Though the foundation stone of Bernini's Louvre was in fact laid, the work was then halted immediately. The expense would have been gigantic, including, as the final plan did, the masking of most of the existing building, in addition to the new work. It is certain, too, that by the time the crucial decision not to proceed with Bernini's plan was taken, in 1667, the King's interests were veering strongly towards Versailles. There were other reasons as well for rejecting Bernini's plan, such as the understandable resentment of the French architects, together with more fundamental and less discreditable factors. In the end a more restricted and less expensive project was executed at the Louvre under the direction of a trio of French artists.

Nevertheless Bernini's mission to France was by no means fruitless. Its effects may be traced in several directions. Echoes of both the first and the last of his four successive designs for the Louvre, for instance, may be identified in surviving buildings. In 1664, when his first plan arrived in Paris, it happened that a Theatine architect, Guarino Guarini, was there on a visit from Italy. As a mathematician and astronomer, as well as a philosopher and theologian, Guarini was one of the most remarkable artistic phenomena of the seventeenth century, but his architecture, in the main, has been regarded as being not so much in the Bernini tradition as carrying to an extreme the rule-breaking fantasies of Bernini's great rival, Borromini. Nevertheless, Guarini's Palazzo Carignano at Turin, dating from the 1670s, evidently derives to a great extent from Bernini's first Louvre project and, though covered with fantastic ornamentation which Bernini would not have used, gives some idea of how Bernini's building would have looked. We know that Bernini was shown an unfinished building designed by Guarini in Paris, but it is not recorded whether or not the two met.[3] As to Bernini's final Louvre plan, the models for it were seen in Paris by the Swedish architect, Nicodemus Tessin the Younger, in 1687. He had drawings made from them and was clearly inspired by them when rebuilding the royal palace at Stockholm.[4]

In addition to this, it seems probable that Bernini's designs for the Louvre exercised, as a result of a fundamental sympathy between him

and the King, an influence on buildings in France of a special kind. Such a process may be traced in the palaces built for Louis XIV by native French architects subsequent to Bernini's visit. Both in the portrait bust which he did of Louis, and in his designs for the Louvre, Bernini regarded his work as a visual embodiment of the idea of kingship, and, in particular, of that of the greatest and most powerful king on earth. He frequently and fervently reverted to this theme during the course of his visit.

It would be impossible to imagine anything which corresponded more completely with Louis' own ideas. He was as eager to be glorified as Bernini was to glorify him, and Chantelou may well have been in earnest when he said that the King and Bernini were made for each other (when Colbert said the same thing, as he did on one occasion, his sincerity was more suspect). The King had not yet found an artist who filled this role. Charles Le Brun was shortly to do his best to do so, but he was no Bernini.

If then we compare the exteriors of Louis' favourite residences – Versailles and Marly – with that of a country palace built for a private patron not long before Bernini's visit, namely Vaux-le-Vicomte, an essential difference is immediately apparent. Marly and Versailles appear much grander. The difference has little to do with ornamentation, or even with size – Marly was not enormous, and though Versailles eventually extended almost indefinitely in length the scale is otherwise not vast. It lies, rather surprisingly, in the treatment of the roofs. The traditional French high-pitched slate roof, retained at Vaux-le-Vicomte, gives nothing like the air of splendour which results if the slates are concealed behind a flat terrace or parapet ornamented with statues, urns or trophies. Terraced roofs, in one form or another, had featured in Italian Baroque palaces, and just before the Paris mission Bernini himself had designed a very mature version in the Palazzo Chigi-Odescalchi, a building which, with his palace of Montecitorio, may be seen as a foretaste, in some ways, of his final Louvre project. Though terraced roofs had been adumbrated in some of the unexecuted projects for the Louvre by French architects it is questionable how many of these reached the King. Even if they did, they would have been less likely to leave a mark on his mind than Bernini's designs. In any case, they are not normally found in palatial buildings executed in France before Bernini's visit. He had envisaged them in all four of his Louvre designs: and the

form then appears not only at Versailles and Marly, but also in two post-Bernini additions to the Louvre – the east colonnade and the new façade to the south wing. It can hardly be doubted that this was by the King's wish, both because the palaces in which this feature occurs were intended for his own use, and because in those of his buildings which were not – pre-eminently the Invalides – it is not found. It would also be characteristic of Louis XIV to have read into it the idea that as no roof is visible there is nothing above the King's head but the sky (in 1667, after Bernini had returned to Rome, Colbert's office criticized adversely a plan to build either one large storey or two small ones above the King's apartments).[5] There might, therefore, be some justification for regarding this type of palace both as a monopoly, for the time being, of the Sun King, and as a personal legacy to him from Bernini. And it is certainly not irrelevant that the state of Venice, with its oppressive vigilance and its sumptuary laws, recognized that the parapeted roof of a palace produced such an excessive effect of splendour that Venetian citizens were forbidden to indulge in it.[6]

It must nevertheless be admitted that this legacy was one of which the King could have made more use if he had been more mature at the time – that is, if he had already arrived at that degree of self-worship which he achieved later in life. Though evolved in the ecclesiastical context of Counter-Reformation Rome, Baroque art, of which Bernini was the leading exponent, was better adapted than any other to reflect the vainglorious aspirations of autocratic sovereigns. For this reason Louis XIV and Bernini really might have been made for each other if the age gap (exactly forty years) between them had been less, and if Bernini had been less chauvinistically Italian. Even as things turned out no one can read the voluminous documentation and be in any doubt that the mission started as a dialogue between two outsize personalities – Bernini and the King – and ended as a struggle between one of them – Bernini – and a third giant – Colbert. Though a creative genius of a very high order, and at the same time a straightforward, even generous, nature, Bernini loved the great of the world. If he had not done so, not even his colossal talent would have sufficed to assure him the degree of favour which he had enjoyed with successive Popes and foreign princes. But though he had made up his mind in advance that he was going to like Louis XIV there can be no doubt that in the event their personalities did chime. Louis showed Bernini great kindness, together with great tolerance of his

frankness (which profoundly shocked the French court on occasion). And for Bernini's part it is clear that he was virtually obsessed with the King throughout his stay in France.

The last and most important effect of Bernini's mission did not reveal itself until after his death. While still in Paris he had agreed to watch over and guide one of Colbert's pet projects on his return. This was the French academy in Rome. The impressions formed there on young French artists eventually led, as we shall see, to a dissemination of Bernini's influence in France on a scale which no one in Paris at the time of his mission could have foreseen.

II

As with the dominant Italian artist of the fifteenth century – Donatello – and of the sixteenth – Michelangelo – the first and main art of Bernini, who was pre-eminent in the arts of seventeenth-century Italy – was sculpture. Like Donatello and Michelangelo again he was of a Florentine family, though born in Naples. But more than Donatello's, or even Michelangelo's, his energies had proliferated in different directions. Though he never embarked on a major work of painting he had in fact painted many pictures, and others had been executed from his designs. He was known for his comedies, stage sets, stage machines and caricatures; and in late middle age, like Michelangelo, he had turned increasingly to architecture. In this, his most prominent and probably most successful work was his huge, nutcracker colonnades in front of St Peter's, designed to diminish, by optical means, Maderno's over-wide façade. These were nearly, but not quite, finished at the time of the Paris journey.

The prestige which Bernini enjoyed in Rome in his lifetime is conspicuously attested by the fact that more than one reigning Pope had visited him at his house. And Charles Perrault reports, with no friendly intent, and even in a spirit of incredulity, that just before Bernini left for Paris the French ambassador paid a call on him immediately after his state visit to the Pope, and with identical ceremony.[7]

Except for a short period of eclipse under Pope Innocent x in the 1640s Bernini had been in effect the artistic dictator of papal Rome for

over forty years. As a child prodigy in the time of the Borghese Pope, Paul v, he had been accorded special favour. For Cardinal Scipione Borghese, the Pope's nephew, Bernini had executed a staggering succession of sculptures – the *Rape of Proserpine*, the *David*, the *Apollo and Daphne* – which carried virtuosity in marble carving farther than anyone had ever done before, and indeed almost beyond its legitimate limits. On the accession of Maffeo Barberini as Pope Urban viii, in 1623, the favour knew no bounds. The new Pope declared, according to Baldinucci, 'It is your good fortune, Cavaliere, to see Cardinal Maffeo Barberini elected Pope. But our fortune is even greater, in that the Cavaliere Bernini should be living in the time of our pontificate'.[8] The Pope lost no time in confirming his promises. Still only in his twenties, Bernini was commissioned over the head of the official architect, Carlo Maderno, to design and execute the bronze baldacchino above the high altar of St Peter's. The result, in its combination of fantasy, naturalism of detail, colossal size and overwhelming self-confidence, became the quintessential work of Roman Baroque art. It is altogether relevant that it is impossible to classify Bernini's baldacchino. It is either architecture, or sculpture, or both, or neither.

The baldacchino was not the end but the beginning of Bernini's contributions to St Peter's. Indeed, almost all its most conspicuous internal features are due to him – the marble inlay of the pillars; the spandrel figures in the nave; the decoration of the crossing piers; the tombs of Urban viii and, in due course, of Alexander vii; the altar-piece with the kneeling angels in the Cappella del Sacramento; the statue of Constantine facing the vestibule; the Scala Regia above it; the relief *Pasce Oves Meas* over the main entrance, and finally the Cathedra at the farthest extremity and the colonnades outside. St Peter's before Bernini would have been an austere wilderness, unrecognizable to those accustomed to its present luxuriance.

As it was at St Peter's, so also with the rest of Rome. Bernini left a mark which has constituted its hallmark ever since. The central fountain of the Piazza Navona, the Tritone fountain, the elephant obelisk of the Minerva, the church of S. Andrea al Quirinale, the ecstasy of St Theresa at S. Maria della Vittoria, and of Lodovica Albertoni at S. Francesco a Ripa, the statues on the Ponte S. Angelo and very many other Roman monuments owe their existence to his ebullient imagination, unparalleled opportunities and extraordinary energy.

Bernini's mission to France may be seen as the culmination of the sporadic relations between him and that country which had started over forty years previously. On 22 July 1665 Bernini told Chantelou that he had been invited to France before Cardinal Barberini was elected Pope, and therefore not later than 1623. By 1625 enough of the fame of the young Bernini had reached Paris for the King (Louis XIII) to ask for details of his apparatus for representing a sunrise on the stage. In 1638 Cardinal Richelieu (in Paris) had commissioned a portrait bust, now in the Louvre, from Bernini – to be carved from the triple portrait painted by Philippe de Champaigne which is now in the National Gallery in London. Richelieu also ordered a full-length statue which never materialized. Meanwhile, during Mazarin's residences in Rome in the 1620s and 1630s, he and Bernini had become friends. During the lifetime of Pope Urban VIII there would have been no possibility of luring Bernini away from Rome, but after his death in 1644 Mazarin, who had succeeded Richelieu two years previously, tried to do so (the letter is printed in Baldinucci). Though this particular attempt failed, Mazarin continued to press Bernini. In addition, there is no doubt that Bernini's fame was kept alive in Paris during the years that followed by the presence there of Italians who knew him, particularly Cardinal Antonio Barberini, the nephew of Pope Urban VIII, who took refuge there after his uncle's death. Cardinal Antonio crossed Bernini's path on a number of occasions. According to Baldinucci it was he who acted as intermediary between Cardinal Richelieu and Bernini in the matter of the Richelieu bust,[10] and he also ordered from Bernini a marble *Madonna and Child* for the Carmelite church in Paris. His diplomatic presents to Louis XIV are likely to have included a bronze version, which is now in the Louvre, of one of Bernini's busts of Pope Urban VIII.[11] We also know that Cardinal Antonio commissioned Bernini to design decorations at the church of S. Trinità de' Monti, in Rome, together with a firework display in honour of the birth of the Dauphin in 1661.[12] There are three small sketches by Bernini for the festivities. It was Cardinal Antonio who had extended an invitation on behalf of Louis XIV to Bernini to visit Paris in October 1662.[13] We do not know exactly why this invitation was sent (one possibility will be mentioned later), but Bernini, in his reply, said the matter was for the Pope to decide. No more was heard of it at that time, but the influence of the Italian faction at the French court was to be crucial in the end. Indeed, at the close of Bernini's mission (12 October

1665) the Abbé Butti, who made it his business to know everything, said, in answer to a question, that it was Cardinal Antonio Barberini who had first spoken of getting Bernini to come to Paris and then the Marquis de Bellefonds, the King's *premier maître d'hôtel.*

Mazarin's personal friendship with Bernini had not been reflected in his policy towards the Papacy. On the contrary, the Cardinal had been at pains, throughout much of his ministry, to provoke the Pope, and diplomatic relations between France and the Vatican had ceased for several years before Mazarin's death in 1661. In the following year Louis XIV appointed an ambassador, the Duc de Créquy, but little more than two months after he arrived in Rome he went out of his way to break the *détente* by blowing up an affray which followed a street brawl into an international incident (20 August 1662). Queen Christina of Sweden, then living in Rome in the odour of sanctity following her conversion, immediately wrote to Louis XIV offering her good offices as peacemaker, but to no purpose.[14] The fact that Cardinal Antonio Barberini's invitation to Bernini to visit Paris was dated 27 October 1662 – only a little more than two months after the Créquy incident – suggests that the Cardinal also may have been trying to pour oil on troubled waters. After stormy scenes and warlike preparations on the part of the French (who had seized the papal city of Avignon) an agreement was finally reached at Pisa in February 1664, one of the provisions of which was that the Pope should send a mission to Louis XIV by way of apology.

It is at this point that political events may have affected Bernini, for the head of the peace mission, the Pope's young nephew Cardinal Flavio Chigi, was a friend and patron of Bernini. We know that during the mission, in which the Cardinal was treated courteously by the King, he discussed with Monsieur, Louis' younger brother, the progress of Bernini's current work on the Cathedra at the extremity of St Peter's and on the colonnades outside it.[15] This was in July 1664, and in that same month it happened that Bernini's first plan for the Louvre arrived in Paris. We know that this was shown to the Cardinal and that Colbert discussed it with him.[16] At this time Bernini was – officially, at least – merely one of the four Italian architects who were being considered. But we shall see that Bernini's supporters in Paris had already seen to it that he was given preferential treatment in Rome over the other three, and Cardinal Chigi's presence in Paris is likely to have added weight to the pro-Bernini lobby at the French court.

A theory has recently been propounded that Bernini's mission was planned by the French as a further means of humbling the Pope, by depriving him of his artistic director.[17] Nevertheless, the unprecedented (and unnecessary) magnificence of Bernini's reception in France is hardly compatible with the idea of humiliating anyone. Furthermore, the Pope, his master, had not consented to be deprived of his services for very long, as Bernini's original leave of absence was only for three months. In the event, his current work in Rome – on the colonnades and Cathedra – was well advanced at the time of his departure and could be, and was, continued during his absence. Above all, the sequence of events in Paris leaves no doubt that once it was decided to proceed with Bernini's plan for the Louvre his presence on the spot was a matter of expediency. If, in addition, there was an ulterior motive at this stage it is more likely to have been an attempt at a peace initiative on the part of the Italian and pro-Bernini faction at the French court. It is true that the Pope was reported (12 October 1665) to have been annoyed by Bernini's departure from Rome, and also (28 September 1665) by his withdrawing three craftsmen from St Peter's to work for him in Paris, but the report of 12 October also suggested that Alexander VII was easily annoyed.

The architectural antecedents of the visit were equally complicated, or more so. In the mid-sixteenth century François I had started to rebuild the medieval fortress of the Louvre by initiating work on the Lescot wing, which still exists. This has a variety of carved ornamentation (including exquisite and famous reliefs by Jean Goujon) about which there was to be much discussion in Bernini's time. Slightly later, in the 1560s, Catherine de Médicis started to build the palace of the Tuileries, about a quarter of a mile to the west. This had subsequently been connected to the Louvre by the immense Grande Galerie, parallel with the Seine, and, at the Louvre end, by the Petite Galerie which ran at right angles to it. Not long before Bernini's visit the Petite Galerie had been burnt out. Progress on both the Louvre and the Tuileries had continued under Louis XIII and during the early years of Louis XIV. By the early 1660s the west and south ranges of buildings facing the Cour Carrée were already (more or less) as they appear now, and about half of the northern wing was also finished. As Colbert put it, in one of his memoranda to Bernini, two and a half sides out of the four were already completed. The main task which remained was the building of the east wing. Since it faced the Ile de la Cité it was regarded as the principal

façade of the Louvre. The rest of·the present north wing – the long arm along what is now the Rue de Rivoli – was not built until the nineteenth century, though it is already adumbrated in Marot's engraving of Bernini's third project. At the time of Bernini's visit the building of the east wing was commonly referred to as 'completing' the Louvre.

In January 1664 Colbert purchased the office of Surintendant des Bâtiments and immediately set to work to act as the new broom. For reasons of his own he was determined not to proceed with the plans for the east wing by the official architect, Louis Le Vau, even though a start had already been made on them. He had handed the drawings for criticism to other architects in Paris, and they, not unnaturally, condemned them and submitted plans of their own. Colbert would almost certainly have liked to employ the great François Mansart as architect, but by this time he was elderly and more wilful and eccentric than ever. He ruled himself out, in effect, by declining to commit himself to any one of a series of designs and variants which he submitted, or even to finish any of them in a presentable fashion.

At this point Colbert turned to Italy, and repeated, with slight variations, the procedure he had adopted in Paris. First, according to Perrault,[18] he had intended that Nicolas Poussin, who had been resident in Rome throughout most of his adult life, should act as liaison with the Roman architects. Perrault says that he himself drafted the letter, which he prints and which will concern us again later. (Inasmuch as Perrault specifies that the letter was to be sent over Colbert's signature we may well enquire how many of Colbert's subsequent letters to Bernini were really the work of Perrault. This possibility, as we shall see, was to recur frequently.) In the letter Poussin is asked to show Le Vau's plans to architects referred to as being of his (Poussin's) choice, though Pietro da Cortona, Rainaldi and Bernini are actually named. Poussin is asked, wisely, to get the architects to give their reasons for any objections they might make. It was taken for granted that they would also produce designs of their own. This letter is not dated, and Perrault says that for reasons unknown to him it was never sent. Probably word reached Colbert that Poussin was too old and too ill to take effective action (he was already partly paralysed and died on 19 November of the next year, 1665). Instead, Colbert instructed the Abbé Elpidio Benedetti, who had been one of Mazarin's spies in Rome and who was to emerge in the near future as the most tireless and intriguing partisan of Bernini, to return

to Rome with letters to Rainaldi, Pietro da Cortona, an otherwise unknown amateur called Candiani (also referred to by Chantelou on 20 October as Landiani) and Bernini himself. According to Chantelou the brilliant and eccentric Borromini had also been considered, but had declined.[19] Bernini (and presumably also the others) was invited to criticize Le Vau's plans and to submit designs of his own. But apparently none of them was told that the same instructions had been sent to the others. Benedetti arrived in Rome on 19 April 1664 and gave Bernini a start of several weeks over Pietro da Cortona.[20] This was the earliest indication that the dice were already loaded in Bernini's favour. Another pointer comes from the fact that Benedetti had been charged, or had got himself charged, with having small copies made in Rome for the King of some of Bernini's more celebrated sculptures – the *Apollo and Daphne* and the four rivers from the fountain in the Piazza Navona.[21]

Throughout the summer of 1664 there was great activity in Rome, and much correspondence survives concerning it. The day after he reached Rome (20 April) Benedetti delivered to Bernini Le Vau's plans, the current ones in a series which continued, as we shall see, even after the commission had been given to Bernini.[22] At the very end of his French mission (20 October) Butti told Chantelou that Bernini had deliberately not looked at them, wishing to keep his mind clear. On 4 May Bernini himself wrote to Colbert accepting the commission.[23] On 13 May Benedetti reported that Bernini was already working on a scheme of his own, but that he, Benedetti, was taking his time with regard to Pietro da Cortona, 'Without this kind of circumspection one might as well stay at home, these virtuosi being whimsical and bizarre creatures'.[24] Nevertheless, by 20 May, Benedetti evidently thought Bernini had had sufficient start and that he could involve Pietro da Cortona with a clear conscience (he does not specify his timetable with the other two architects).[25] Later letters show that Pietro was laid up with gout at this time and delayed starting. In the event, his designs, of which Benedetti spoke slightingly at first, were not sent off until September, and then Pietro sent them direct to Paris. Benedetti mischievously told Colbert that he assumed that Pietro thought that otherwise he, Benedetti, might show them to Bernini (as well he might). And he repeated, 'These virtuosi are jealous of each other and bizarre, and one must just put up with their failings.'[26] Rainaldi's and Candiani's drawings were reported as ready on 15 July

1664.[27] Little more is heard of them, and it is unlikely that they, or Pietro's, were ever seriously considered in Paris.

Before Pietro da Cortona's designs had even left Rome Bernini's had already arrived in Paris (25 July).[28] Presents sent from the King to all the architects concerned by way of encouragement were reported to have been handed over to Benedetti by the French ambassador, Créquy, on 3 June. Bernini's consisted of a jewelled portrait of the King.[29] Bernini was said to have taken umbrage (a state of affairs easily brought about, but evidently not lightly courted) because the first communication from Colbert merely announced the receipt of his plans without comment or thanks. It was not until 3 October that Colbert wrote Bernini a brief letter of appreciation combined with a request to do another plan. Long before Bernini can have received this letter Benedetti had acknowledged receipt of Colbert's memorandum (30 September), but having read it he took fright. It was so critical that he did not dare to give it to Bernini. Instead, he waited until Cardinal Chigi returned to Rome from Paris and left the unenviable task to him.[30]

III

IN ADDITION TO documenting in great detail the events in Rome in the summer of 1664 the surviving letters include two which throw some light on what subsequently became the crux of the matter, that is, the differences between Italian and French architectural needs, and therefore architectural practice. In effect, it became a tussle between display and amenity, Bernini and the King for display, Colbert for amenity. The official Italian point of view was discreetly summarized in a letter from Benedetti to Colbert of 24 June, which enclosed Bernini's plans.[31] 'As regards the arrangement of the rooms', he writes, 'and the siting of the amenities, our Italian architects are so much imbued with our native traditions that they may not lightly conform with French practice, which is rather different. Conversely, the French architects, who are not fully cognizant of the magnificence of our buildings, lack a certain nobility which is in evidence here.' Benedetti goes on to recommend, among other things, that French architects learn to improve their staircases (when sending Candiani's drawings to Paris, with Rainaldi's, on 15 July,

Benedetti drew attention to the magnificence of the staircases).[32] Oddly enough, the French took the opposite view. A letter of the Duc de Créquy, dated 25 November 1664, comments in particular on the inadequacy of the Italian staircases.[33] He complains that they are *fort obscurs* and that even in his own embassy – the Palazzo Farnese, the finest private palace in Rome – the staircase had had to be reconstructed by Michelangelo himself, with great difficulty. He added that Italian courtyards were also too narrow.

A different and more personal antithesis, namely the architectural ideals of Bernini and of Colbert, is limpidly set out in Perrault's memoirs.

It would have been very difficult [he wrote] to find two natures more opposed. The Cavaliere never went into detail. He was only concerned with planning huge rooms for theatricals and fêtes, and would not bother himself over practical considerations – the amenities, and the arrangement of the living quarters. Such things are endless and demand a degree of application foreign to the rapid and lively instincts of the Cavaliere. It is my firm opinion that as an architect he was only fit for scenic designs and theatrical apparatus. Monsieur Colbert, on the other hand, wanted precision. He required to know where and how the King was to be housed and how the service could be most conveniently arranged. He thought, rightly, that it was not merely a question of housing the persons of the King and the royal family well, but also of providing convenient lodgings for all the officials down to the most junior, since they are no less essential than the most important ones. The Cavaliere would have none of this, taking the attitude that it was beneath the dignity of a great architect such as himself to have to bother about such details.[34]

Though Perrault was correct in stressing that Bernini was more interested in architectural grandeur than in practicality, he was triply biased – as being Colbert's assistant, as the brother of a rival architect, and as the avowed enemy of Bernini. To set the record straight it must be emphasized that Colbert's mania for supervising the smallest details at every stage would have appeared as intolerable interference to anyone trying to work for him. In these circumstances a show of exasperation would have been natural, even on the part of an architect less distinguished, and less accustomed to being humoured, than Bernini.

The drawings which Bernini sent from Rome to Paris in the summer of 1664 are known through plans of the ground floor and first floor and perspective drawings of the east front. In view of Bernini's denial that

he had looked at Le Vau's plans it is difficult to visualize precisely how the task would have presented itself to him. In particular, we cannot tell to what extent he realized at this stage that the problem was not so much to create a new building as to complete an old one. Even if he understood this in principle, as he must have done, he paid the minimum attention to it. Like many architects of all ages, including many of vastly less creative talent than his own, he found it easier to create than to adapt. In addition, he had no experience of French architecture and had never seen the Louvre.

In his covering letter of 24 June 1664 Benedetti emphasized to Colbert that Bernini had paid most attention to the east front.[35] In fact his failure to adapt is seen in this, the first of his four plans for the Louvre, in two separate respects. He planned to construct arcaded galleries round the inside of the courtyard. Though it seems, from the plan, that these would have been two-storeyed on the east side only, and single-storeyed on the other three, they would still have concealed much of the existing architecture. Secondly, his highly original idea for the east wing was in the most advanced Roman Baroque style, with convex and concave curves on the ground plan, open arcades and concealed roofs, all of which would have looked somewhat out of place in Paris. At the same time, it should be pointed out, but normally is not, that anyone looking at any of Bernini's designs for the Louvre will inevitably tend to visualize them carried out in travertine, like his Roman buildings. If they had been executed, as they would have been, in French stone, the discord with the Parisian buildings would have been rather less marked.

It is probably the curves of Bernini's first design which appear to us its most revolutionary feature. In one form or another curved plans had indeed been characteristic of Roman architecture of the High Baroque. There were notable examples by Borromini and Pietro da Cortona, and in his church of S. Andrea al Quirinale, designed in the 1650s Bernini had flanked an oval central space with concave walls, as he was to do, in principle, in his first Louvre design. But Le Vau had also been working in this direction. At Vaux-le-Vicomte, for example, and in his Louvre plan which was sent to Rome, he had designed central oval spaces which broke the line of the external walls, and in his Collège des Quatre Nations he was to flank a central circle with concave wings (this building was under construction at the time of Bernini's visit: Chantelou quotes an adverse criticism of it on 19 September 1665).

In any case, however, it was not the curves of Bernini's plan to which Colbert most objected. As always, his criticisms were practical rather than aesthetic. His memorandum, brilliantly lucid, and surviving in a draft in his own handwriting, shows that the most questionable features of Bernini's plan, in his view, were the open arcades and the flat roofs.[36] Both of these, Colbert claimed, were unsuited to the French climate. He makes great play with this factor, and with such emphasis that Bernini might well have inferred, not yet knowing it, that the Parisian weather resembled that of the Arctic – which is only exceptionally the case. In addition, Colbert went on, the arcades on the ground floor, communicating with the street, would make access to the palace a great deal too easy. Though the King himself was delighted with the appearance of Bernini's façade, Colbert, predictably, found every kind of fault with the project on utilitarian grounds. In addition to features which were unsuitable, he said, in a building which was normally only used by the King in winter (he was in the event to spend much of the summer in it when Bernini was in France), Bernini had placed the King's own apartments in the noisiest part of the building (no one in Bernini's position could have known this, but Colbert was not one to make allowances: as we shall see, others may have had a hand in his memorandum). Furthermore, Bernini had left insufficient room for daily functions, and had not allowed enough light either for the rooms or the staircases.

IV

CARDINAL CHIGI ARRIVED back from Paris on 9 October 1664, but since the Pope was out of Rome the Cardinal was unable to make his solemn entrance, and remained incognito in the country.[37] On 4 November Benedetti reported that all was now in order and that he had delivered Colbert's criticisms to the Cardinal for transmission to Bernini. In the meantime Bernini had been advised by Benedetti to continue working on the Louvre designs.[38] By this time Bernini had discovered (or the mischief-makers of Rome had informed him) that other Italian architects than himself had been involved. This did not please him. He told Benedetti that if he had known he would not have agreed to contribute; not, he hastened to add, because he considered himself greater than the

others – on the contrary, he was the least of all – but merely because he disliked the principle of competition.

The storm which broke after Cardinal Chigi had delivered Colbert's observations to Bernini is vividly described by the French ambassador, Créquy, in a letter of 2 December 1664.

Last Thursday I was at the Cavaliere Bernini's [he wrote] and in discussing with him the new plans which you tell me that the King wishes him to make for the Louvre he seemed to me outraged [extrêmement scandalisé] at the manner in which his earlier one has been treated. He said that the faults which have been found with his building were more numerous than the stones which would be needed to build it, and even if he were to do another plan it would be the same story all over again. French architects would never miss an opportunity to denigrate whatever he did, and were only interested in seeing to it that the work of an Italian was not executed.[39]

Créquy's experiences with Bernini were taken to heart by Colbert, as he was to show later.

Créquy added that, having let Bernini get it off his chest, he at last succeeded in pacifying him and in persuading him to submit another plan. But Bernini added, with a degree of professionalism which seems at first surprising, that he would need more detailed plans and more accurate measurements of the existing buildings than had been vouch-safed him hitherto. He said he had deduced that those he had been sent were faulty.

It is nevertheless doubtful if Bernini could have received such infor-mation in time to use it, since his second plan was reported to be finished at the end of January 1665.[40] Since the time, in the summer of the preceding year, when his first plan reached Paris a papal nuncio had taken up residence there, doubtless as a result of the Chigi mission. He was Carlo Roberti de' Vittori, titular archbishop of Tarsus. Not only did he prove himself a powerful and resourceful advocate of Bernini's second plan when it reached Paris on 16 March 1665, he was also a voluble one. Three long despatches which he sent to Rome, dated 20, 23 and 27 March 1665, give us far more background information on the reception of Bernini's second plan in Paris than is available in respect of the first.[41]

This is of particular value in that the ground plan for the second project is lost, and no drawings for the scheme have come to light in France. Nevertheless, since Mirot wrote his account of the journey, a

drawing has been published, now in Stockholm, of a perspective.[42]. It was once the property of Nicodemus Tessin the Younger, who, as we have seen, had had Bernini's fourth plan copied. For several reasons it can hardly be doubted (and never is doubted) that it represents the east façade of Bernini's second project. It abandons the open arcades on the ground floor, to which Colbert had objected on security grounds; it raises the total height of the building – an innovation on which Colbert commented unfavourably in his memorandum on the second project; and it appears as a link, architecturally, between Bernini's first project and his third. Whereas the first envisaged both concave and convex curves, and the third abandoned curves in favour of straight walls with recessions, the Stockholm drawing shows only concave curves. The flanking blocks are connected with the centre by concave wings, much as in the first plan, but the centre itself, though brought forward from the wings, is itself concave. It is a pity that the ground plan has not been found, as it would be of interest to see how Bernini would have planned the rooms. While a convex external curve is a logical consequence of a circular or oval room, an external *concave* curve is an awkward liability internally. Even in Bernini's first plan the area behind the concave wings is virtually wasted. It was perhaps this which the Ambassador, the Duc de Créquy, had in mind when he wrote in a letter of 25 February 1665 that Bernini's second plan was 'very beautiful, but I think difficult to execute'.[43]

Specific and detailed difficulties which he saw in Bernini's plan were unfailingly indicated by Colbert in another masterly memorandum.[44] Like the first, it is devastating in its insistence on practical considerations, though it should be borne in mind that as both exist only in draft (and both, incidentally, are undated), it would be possible that they were toned down later. Colbert starts, it is true, by praising the nobility of the design, but soon afterwards gets the bit between his teeth. He stresses the historical significance of the Louvre in an effort to dissuade Bernini from destroying all of it. As to private houses which might have to be demolished to make room, this would involve enormous expense. 'Even though in the case of essential beauty and utility the factor of expense should not enter into it, when extreme expense results in only a slight increase in beauty and utility that should be taken into account by a great architect when making his plans.' It is to be regretted that Bernini's comment on this governessy attitude has not been preserved.

It emerges from Colbert's memorandum that Bernini's second plan envisaged transforming the square court into an oblong by prolonging it eastwards by some ninety feet. In addition to necessitating extensive and expensive demolitions Colbert pointed out that this would bring the east wing too near to the parish church of the Louvre, Saint-Germain-l'Auxerrois – a church which still exists. (The inviolability of this sacred cow of a building is a recurrent theme at every stage of the affair: it is a Gothic church of mixed period and no outstanding merit.) Moreover, an oblong courtyard, Colbert went on, would mean that the domes in the centres of the existing north and south wings would not be opposite the centres of the corresponding sides of the new courtyard. Colbert also complained that the new arcades (this time in three superimposed tiers) in the courtyard would completely hide the external decorations, and that the extra height of Bernini's new walls in general would involve heightening all the others. As in the first project, Colbert complained of the inevitable darkness of the rooms, and of other practical considerations.

It was at this point that the new Nuncio, Roberti, showed his mettle. When Colbert mentioned two million francs as the financial ceiling the Nuncio was diplomatically horrified. 'Only two million? The Holy Father has thought nothing of spending five million on the colonnades of St Peter's, and they are only ornamental.'[45] If it were objected, Roberti continued, that the new arcades would reduce the size of the courtyard, in his opinion it was too big already. He pointed out that according to a model, which he admitted might not be accurate, the arcades were only superimposed on the side walls. On the front and back walls they only covered the ground floor. He conceded that they would conceal some of the existing decorations but managed to turn even this to advantage. The ornamentation was really only suitable for a nobleman's house, not for a king's, and in any case was designed for a courtyard a quarter of the size of the present one. The comforting assurances of the Nuncio may seem to us to have something in common with the conclusion to *Candide*, 'Cunégonde was admittedly very ugly, but she became an excellent pastry-cook.'

V

DESPITE COLBERT'S OBJECTIONS the King was delighted with Bernini's second plan. And it was at this point that what had been in so many minds for so long came to a head: the necessity for Bernini to come to Paris himself. As soon as Benedetti had arrived in Rome in the spring of 1664 he had apparently hinted at this,[46] and in August of the same year Colbert's brother-in-law, the Marquis de Ménars, travelling in Italy, had done his best to persuade Bernini to embark on the journey, 'imagining that that was what Colbert wanted'.[47] A papal despatch, written, apparently, after Bernini had already left for Paris, claimed that the French ambassador, Créquy, had been pressing the Pope on this subject for four months before he himself was recalled to Paris in March 1665.[48]

Chantelou, as we have seen, quotes the Abbé Butti as saying that the suggestion had first been made by Cardinal Antonio Barberini, and then by Bellefonds.[49] Perrault also mentions this (which may refer to the invitation of 1662), though he himself puts forward the claims of Benedetti.[50] Butti had concluded by pointing out that the crucial decision had been the King's, taken after he had seen Bernini's first design for the Louvre.[51] In the impossibility of deciding the precise chain of events, the invitation is perhaps best regarded as an indication that the French were now determined to put Bernini's plan into execution.

The preliminaries of the journey are documented in detail in despatches of the Nuncio which were not known to Mirot.[52] One is dated 10 April 1665: 'Whereas an express courier is due to leave for Rome tomorrow, by order of His Majesty, in order to bring Cavaliere Bernini to Paris, Monsieur Colbert has suggested that I send my letters by him.' In a second despatch, evidently addressed to Cardinal Chigi, Roberti says that Colbert, who, he asserted, had 'a desire and an extreme passion' to get Bernini to Paris, had been sent to him on the previous day by order of the King. He had read out to him his observations on Bernini's second plan, and told him that the King had resolved to send the present courier express, with letters in his own hand to the Pope and the Cardinal, begging them to persuade Bernini to gratify the King by coming to Paris. It was evidently always intended that the same courier should escort Bernini back to Paris, as in fact happened. Colbert impressed on Roberti that the criticisms in his memorandum were not the work of architects, and that if Bernini came to Paris he would see to it that French architects

were not involved in their discussions.[53] Evidently Colbert had seen the red light after reading Créquy's experiences of Bernini's tantrums.

There may, nevertheless, be more than meets the eye in Colbert's assurances. He evidently meant Bernini to assume that his memorandum was his own work. It is true that the existing draft is in his handwriting, and that he was a man of exceptional intellectual range and with a passion for detail. Nevertheless, the architectural criticisms, both in this and his earlier memorandum, are so knowledgeable and so penetrating that it is difficult to believe he had no expert advice. In his memoirs Charles Perrault says that his brother, Claude, submitted a plan of his own for the east façade of the Louvre before Bernini and the other Italians were called in, and that in essentials it was the same as what was ultimately carried out.[54] More, much more, was to be heard of this later. Furthermore, in his report of 27 March, Roberti mentioned that the memorandum on Bernini's second Louvre plan which Colbert 'held in his hand' and which Roberti characterized as 'inspired by malice' contained objections which had been 'suggested' to Colbert.[55] When it came to Bernini's third plan Perrault admits that he gave Colbert a memorandum pointing out its faults.[56] In the present instance, therefore, Colbert could still have been strictly, if casuistically, truthful in assuring Bernini that no architect, in the sense of professional architect, had been involved in his memorandum, even if one or both of the Perraults had contributed to it. It seems most probable that such was the case.

A curious point, which seems to have escaped notice hitherto, but which is worth making, is that we cannot be sure if Colbert's second memorandum ever actually reached Bernini, at least while he was still in Rome. As it was being sent to Rome by the courier who was to bring him to Paris, there would only have been a few days in which this could have been done, and as it was apparently addressed to Cardinal Chigi, who had had unnerving experiences on the previous occasion, it would be possible that he put discretion first and passed it no further. In any case no comment by Bernini is known.

In his despatch Roberti added that the King was sending 20,000 scudi (Vigarani, the Modenese agent, with whom Bernini was to come in contact in France, says 10,000,[57] but the official invoice, printed by Guiffrey, gives 30,000 livres).[58] This was merely to defray Bernini's travelling expenses. As to means of transport, a coach would be sent to Provence to bring him to Paris. If Bernini did not wish to come there

from Italy by sea, he could go by coach to Turin where he would find chairmen to conduct him to Lyon. He could even go on to Paris by chair if he wished. He would be treated with all appropriate honours.

Bernini's reply to the King has not yet come to light. In his letter of invitation Louis had addressed him as 'Seigneur Cavalier Bernini' and had assured him that he had formed so high an estimate of his merit that he had a great desire to see and to get to know so illustrious a personage.[59] The King's subsequent behaviour to Bernini shows that these were not empty words.

Evidently the French were prepared to gamble that the Pope's consent would be forthcoming, to the extent of sending the travelling expenses before the consent was received. In the end everything was arranged extraordinarily expeditiously. The Pope granted Bernini three months' leave of absence on 23 April 1665, and probably only two days later Bernini started for Paris.[60]

The puzzling question now arises: why did Bernini agree to go? Granted, the Italian faction at the French court had long been straining every nerve to get him to Paris. Granted, too, that once the King had actually asked permission the Pope might not have liked to refuse. Yet even so, the final decision must have rested with Bernini himself, and if he had had the smallest disinclination to go, his age alone would have been a valid excuse. His willingness is particularly surprising in view of what he said to the French ambassador about the hostility of the French architects to him. Colbert's assurance to Roberti of his protection of Bernini against the French architects had evidently been widely disseminated, at least among the Italians at the French court, as Vigarani also mentions the matter in a letter of 24 April 1665 to his master.[61] Nevertheless, anyone in the circumstances would wonder how efficacious such ostensible immunity might be.

Bernini's own explanation of his motive – that he was curious to see the King – is no doubt partly true, but as it was to Louis himself that he said it, it may not be the whole truth. No doubt he was flattered at being preferred by the French to their own architects, but the most cogent and, on the whole, the most likely explanation is somewhat different. Bernini was intensely devout. He was a regular and fervent church-goer and was a close friend of Padre Oliva who at this time had recently been appointed General of the Jesuits. According to Baldinucci it was at this stage that Cardinal Antonio Barberini exerted further pressure in favour of the

Paris visit by writing from Paris to Oliva, who then told Bernini it was his duty to make the journey even if it were certain it would kill him. Bernini corroborated this story to Chantelou as they were driving to Paris, and Oliva himself confirmed it in a letter, printed by Baldinucci, to the former French Ambassador to Rome, Hugues de Lionne.[62] In fact Bernini survived both the outward and the return journey and lived for another fifteen years.

VI

NINE MEN – AND no women – accompanied Bernini from Rome to Paris: his second son, Paolo, then an apprentice sculptor of eighteen, his assistants, Mattia de' Rossi and Giulio Cartari, his majordomo, Cosimo Scarlatti, three servants, the French King's courier, Mancini, and a quartermaster, also provided by the King. All the most conspicuous monuments which would have met Bernini's gaze as he left the city on this occasion would have been his own. The direct route north from his palazzo near the Piazza di Spagna leads into the piazza. Though the famous steps were not built until the eighteenth century, Bernini seems to have designed something similar for an abortive project in the 1650s (see note 166), and the fountain in the middle, known as the Barcaccia, was, in all probability, the young Bernini's first public monument in Rome (though it was commissioned of his father). In addition, the piazza is dominated by his façade of the Palazzo di Propaganda Fide at its southern extremity. At the end of the Via Babuino, in the Piazza del Popolo, the twin churches flanking the Corso, which Bernini was ultimately to complete, had at this time barely been started according to the plans of Carlo Rainaldi. Facing them across the square was the early Renaissance church of S. Maria del Popolo. Its interior was to be transformed by Bernini, and it already contained two important sculptures by him. It lay in the shadow of the Porta del Popolo, whose inner face he had remodelled ten years previously in honour of the solemn entry of Queen Christina of Sweden into Rome. It was, and remains, the principal entrance to Rome from the north.

Throughout the journey, and indeed throughout the trip, the newsletters from Mattia de' Rossi to Pietro Filippo Bernini supplement,

sometimes in fascinatingly intimate detail, the relatively meagre accounts given by Baldinucci and Domenico Bernini. Nevertheless many details are not known. We are not told, for instance, what means of transport Bernini used, stage by stage, though as a general rule it seems to have been a coach on the level and a litter over mountains. The younger members of the party rode horses. Rossi describes an incident which occurred a day or two out from Rome. This was at Radicofani, the medieval robber barons' castle which, looking like something out of Salvator Rosa, still dominates the road between Bolsena and Siena.[63] Cosimo Scarlatti, Rossi tells us, was riding a piebald horse. This so much frightened the horse of the King's courier, Mancini, which was being led, that it shied, whereupon Scarlatti's horse threw him in the river.

A letter from the Modenese ambassador in Rome to his master warns him that when travelling from Bologna to Milan Bernini would not be calling at Modena, fearing the delay it would cause.[64] It would be easier on the return journey, he thought. It was something of an act of renunciation on Bernini's part, as one of his best portrait busts (of Francesco 1 d'Este) was at Modena and he had also modelled a huge bronze eagle for the façade of the ducal palace.[65] In the event the journey seems to have been accomplished reasonably quickly. Mancini, King Louis's courier, had left Paris on 11 April and had reached Rome some time before the 23rd, when the Pope gave Bernini his consent. This was referred to as an express courier, whereas Bernini, on his journey, had to be given the comfort due to his age and celebrity. Moreover, the numerous deputations and receptions on the route would have delayed him. It is therefore surprising that he reached Paris on 2 June, only about six weeks after leaving Rome.

The curtailment of sightseeing caused by the decision to hurry affected more than just Modena. Even in Siena there was to be no dawdling, despite a commission from the Pope (so the Modenese envoy told his master in a letter of 25 April 1665).[66] Siena was the home city of the Pope's family, the Chigi. Alexander VII evidently wanted Bernini to inspect the family chapel in the cathedral. This contains sculptures by Bernini himself sent from Rome only two years previously but never seen by him *in situ*. Even so, it seems clear from Rossi's letter of 1 May that Bernini can only have had the inside of a day at Siena. He was entertained there by the Pope's brother, Don Mario Chigi. Then the party left for Florence. This was Bernini's own home soil, though he

may never have been there before. Even here he seems to have allowed himself no more than two nights. Baldinucci tells us that he was entertained, by order of the Grand Duke of Tuscany, by Gabriello Riccardi, Marchese di Chianni, and lodged in the Palazzo Medici-Riccardi. He adds that both the Grand Duke and the Duke of Savoy gave Bernini escorts within their domains and that in every town that they passed the whole population turned out to look at them. The maestro's own comment on this, preserved by Domenico Bernini, illustrates better than any other of his recorded sayings the bluff, extrovert side of his character. Bernini said people were treating him as though he were a travelling elephant.[67]

Occasionally, at least on the Italian side, though no mention is made of danger from robbers, the party were yet liable to their share of the normal discomforts of pre-rail travel. On the road from Florence to Bologna (where they spent less than a day) Rossi describes their arrival at a remote Apennine inn called Scarico l'Asino where no bedroom was available, even for Bernini himself.[68] But enquiry revealed that there was a Gregorian abbey nearby. Bernini's status as papal architect would have opened as many ecclesiastical doors as his royal commission would in the case of princely ones. The abbot was delighted to lay on sumptuous entertainment at short notice, Bernini's visit even coinciding with one by another Roman notability, the Abate Rospigliosi, who was on his way to Germany. He was related to the current papal Secretary of State, Cardinal Giulio Rospigliosi, who, in two years' time, was to be Pope Clement IX.

After Bologna Baldinucci specifies Bernini's route as Milan and then Turin, but gives no details. Nor are there any concerning the passage of the Alps, either in his account or in Rossi's letters. However, a despatch dated 20 May 1665 addressed to Colbert from one Esbaupin, a *maître d'hôtel* from the King's household who had been sent to make various administrative arrangements, said Bernini had spent, or would spend, single nights at Saint-Jean-de-Maurienne, Aiguebelle, Chambéry and La Verpillière.[69] At the frontier town of Le Pont-de-Beauvoisin the district representatives were awaiting Bernini by order of the King, and once inside France every stage was cushioned. With rising enthusiasm and astonishment Rossi describes the successive honours that were heaped on the travellers. Writing from Lyon on 23 May 1665 he says,

Two days before we arrived in French territory the Signor Cavaliere received a letter from Lyon to say that royal officials had arrived there, sent by Monsieur

Colbert by order of the King. They were there to attend the Signor Cavaliere in the way that is customary in the case of Princes and Ambassadors. Then yesterday, the 22nd of this month, as we were approaching the city of Lyon, a coach-and-six appeared, sent for the Signor Cavaliere and his son, Paolo, and another coach for the Signor Cavaliere's household. We got into it and were driven to the city. The Signor Cavaliere was then escorted to a house in which there were three rooms hung with tapestry, one for the Signor Cavaliere, one for Signor Paolo and the third for the household, and there we remained throughout yesterday, and this morning until two o'clock. During this time the Signor Cavaliere was waited on by the senators of the city, who accorded him royal honours, as for major princes and ambassadors. All this was said to have been commanded by His Majesty.[70]

Rossi continues by specifying the various servants sent by the King to attend the Signor Cavaliere. Nor were his claims exaggerated. An invoice from the city of Lyon survives in respect of expenses incurred in the official reception of Bernini and his party.[71] It even includes hire of the tapestries mentioned by Rossi, as well as chairs, tables, beds, mattresses, linen, carpets, green damask and miscellaneous accessories. Domenico Bernini adds a picturesque anecdote to the effect that Bernini dressed his majordomo, Cosimo Scarlatti, as a gentleman in order that he might share the honours offered to the party by the city of Lyon.

Domenico Bernini quotes a letter from Bernini himself written from Lyon on 22 May in which he said, 'Such honours have been done me in this kingdom as to make me wonder whether I shall be able to live up to the magnitude of the idea which I realize that the King has of me.'[72] He was to repeat this sentiment, and the associated idea that his fame would decrease after his death, more than once, later in the visit. On 24 May the party embarked at Roanne on the Loire. In case Bernini should be affected by the heat, someone, probably Colbert, had had the fore-thought to send a supply of ice there. They disembarked at Briare, where a carriage sent by the King's brother, Monsieur, awaited them. Though he was to marry twice and become a father Monsieur was notorious for his homosexual tastes which, as so often, were accompanied by what seems to have been a genuine interest in the arts as an adjunct to the elegant life. Throughout Bernini's visit, as indeed in the preliminary negotiations, Monsieur's name is mentioned in the documents and he was to see a good deal of Bernini. From Briare the route led via Châtillon-sur-Loing (now Châtillon-Coligny), Montargis, Fontainebleau and Essonnes.

Outside Juvisy, which they reached on 2 June, some six miles south of Paris, another coach came out to meet them, containing someone who was to be a key figure in their lives throughout the stay in France. This was Paul Fréart, Seigneur de Chantelou, the writer of the diary which documents the stay. He had been sent by the King to act, in effect, as equerry and also as interpreter to Bernini, and to help him in his dealings with the Parisians. He had already performed a comparable function, twenty-five years previously, in the reign of Louis XIII, when Nicolas Poussin had been summoned from Rome. He had the advantage of speaking Italian, while Bernini had no French.

Aged now fifty-six Chantelou was thus ten years younger than Bernini. He was a courtier who cultivated the arts, a notable collector and the greatest patron of Nicolas Poussin. In the ensuing six months he hardly left Bernini's side, bearing with him in his ebullient egotism, shielding him to the best of his ability from the consequences of his tactlessness and soothing him when the prima donna in him took over. Though Rossi's letters include a number of fascinating particulars which Chantelou, for one reason or another, elected to omit, there were inevitably many occasions when Chantelou was with Bernini at functions in Paris and Rossi was not. And it is the sheer quantity of information concerning Bernini's day-to-day life in France which gives Chantelou's journal its incomparable value.

VII

CHANTELOU DESCRIBES THE events that led up to the visit from his point of view. The court was then at Saint Germain-en-Laye. Having learnt at the end of May that Bernini had already arrived in France, he took advantage of finding himself next the Archbishop of Lyon at the King's Mass to enquire about the latest news. This sign of interest may mean that he already guessed that the King would depute him to act as Bernini's mentor, but it was not until the day before Bernini finally arrived in Paris that the command reached him from Colbert. Chantelou then found himself in some embarrassment. He had duties to perform at Saint-Germain on the following day. The ambassador extraordinary of the Knights of Malta was expected there, and he, Chantelou, was the only

maître d'hôtel du roi then available. Colbert told him he must find a replacement. As always excellently informed, Colbert instructed Chantelou to start from Paris on the following day on the road to Essonnes, where he would find Bernini who was scheduled to lunch there. As Chantelous did not dispose of six carriage-horses Colbert authorized him to take his (Colbert's) brother's coach.

All worked according to plan. Chantelou found a substitute for his court duties at Saint-Germain (the Marquis de Bellefonds), he borrowed the coach, left Saint-Germain early the following morning (2 June), drove through Paris and out at the other side on the Essonnes road and encountered Bernini's party on the Paris side of Juvisy. The pantomime which followed would have seemed less strange to the seventeenth century than it does to us. Both Bernini and Chantelou got down from their vehicles and faced each other. Chantelou then proceeded to make his speech of welcome in French, even though he knew that Bernini would not understand a word of it. When he had finished he said, in Italian, that his Italian was not up to speech-making, but he invited Bernini and Paolo into Colbert's brother's coach, where he did his best to repeat the substance of his speech in Italian.

Bernini replied,

It has been a great honour for me to be called to the service of a King of France. As well as this, the Pope, my lord and master, ordered me to come here. But had there been no more than these considerations I should still have been in Rome. The chief and main cause of my leaving home was that I had heard that the King was not only a great prince, but also the greatest gentleman in his kingdom. This report made me curious to get to know him, and stimulated my wish to serve him. I lament that my talents are not proportionate to this honour, nor do they correspond with the estimate which people have of me.

Discussing the reason for his coming he added,

The beauty of all things, including architecture, lies in proportion. One might say it is a divine attribute, since it takes as its origin the body of Adam, which was not only made by God's own hand, but was also formed in his semblance and image. The variety of the orders of architecture stems from the differences between the bodies of man and of woman and their different proportions.

It was at this stage of the journey, though he repeated it later, that Bernini confessed to Chantelou that the General of the Jesuits had told him it was his duty to go to France even if it killed him.

Chantelou would have it that the remaining short journey to Paris was passed in conversation of this kind. But this was not the case. He omits an incident which is described in detail in one of Rossi's letters, and alluded to briefly by the Nuncio and by Baldinucci and Domenico Bernini. It is of no significance in itself, but it serves to emphasize that however accurate Chantelou seems to be, and doubtless is, in the information which he includes, he is nevertheless apt to give no hint when he is omitting something. Rossi's letter, dated 5 June 1665, and therefore only three days after the event in question, tells us that in fact a further shuffling of personnel and coaches took place after Chantelou had met Bernini. 'Another three miles farther on', he writes, 'we encountered the coach of the Nuncio containing also the Abbé Butti and other gentlemen. They too were on their way to meet the Signor Cavaliere.'[73] In his despatch of 5 June the Nuncio says that he had prepared accommodation for Bernini at his house in Paris.[74] Rossi went on, 'The Abbé, the Cavaliere, Signor Paolo and the *maître d'hôtel* got into the Nuncio's coach, and the other gentlemen went into the coach of the King's *maître d'hôtel*.'

This was the first appearance of the Abbé Butti, who was to be a major figure in Bernini's life in Paris. Throughout the entire period of Bernini's mission the Abbé, evidently a genial busybody, took it on himself to be in attendance at almost all times, apparently unasked. The little-known diary of one Sebastiano Baldini says of him,[75] 'The Abbé Francesco Buti [*sic*] from Rome, has lived in Paris since the time of Cardinal Mazarin, whose secretary he was. Nowadays he composes various verses for His Majesty, and also comedies to be set to music, and for this he receives a good salary and office accommodation. He is very friendly with Monsieur de Lionne and perhaps acts as his secretary'.[76]

The rearrangement of the coaches was tactful. The switch, from Bernini's point of view, from the constraint imposed on an honoured guest in a foreign country and with a language difficulty, to uninhibited conversation in his own language among his own countrymen would doubtless have produced the usual noisy symptoms of relaxation among the elderly men in the Nuncio's coach. And it was in this way, and not as Chantelou says, that after six weeks on the road Bernini finally entered Paris at about six o'clock on the evening of Tuesday, 2 June 1665.

The Court at Saint-Germain

VIII

CHANTELOU AND PERRAULT have both given descriptions of Bernini's appearance at the time of the Paris visit. Combining the two, and making allowance for Chantelou's bias in favour of Bernini and Perrault's prejudice against him, it emerges that he was of small to medium height, thin rather than fat, with a dark skin, good complexion and very assured manner. The top of his head was bald (the fashion for wearing wigs, which was already in force, had evidently not yet reached distinguished elderly men), but his remaining hair was white and wavy. His eyelashes were very long, his forehead high, his temperament fiery and his eyes those of an eagle. This striking metaphor evidently conveys an idea of his most extraordinary feature. He was very vigorous for his age, a great raconteur, and as fond of walking as though he were no more than thirty or forty. With his quick repartee, his excellent memory and his lively imagination he gave the impression of a man far more thoroughly educated than he was. The drawing of himself at Windsor, which evidently dates from this period, supplements the descriptions. A natural vanity has minimized the baldness at the top of the head. For the rest, the glance of the large, dark eyes is intimidating, the ebullient waves of the side hair still luxuriant and the expression both critical and assured.

The Rome which Bernini had left was, as we have seen, at least superficially what he himself had made, and what he made remains. But the Paris which he saw would be almost unrecognizable now. There was no Rue de Rivoli, no Place de la Concorde, no Opéra and no Etoile. The most conspicuous monument to survive only superficially changed from mid-seventeenth-century Paris is probably Notre-Dame. It is difficult

enough, even with the help of Charles Méryon's amazing etchings, to visualize Paris even as recently as the mid-nineteenth century, so emphatically did Baron Haussmann leave his mark on it. But if we bear in mind that one of the most conspicuous monuments of the *ancien régime*, the Bastille, perished with it, that more than half of what is probably still the biggest building in Paris, namely the Louvre, dates from the nineteenth century and that the most conspicuous portion of it in Bernini's time, the Tuileries, was destroyed at the end of the nineteenth century, the point should be made.

Since the King, at the time of Bernini's arrival in Paris, was still at Saint-Germain-en-Laye there was no shortage of official accommodation in Paris. Until the court returned, Bernini and his party were lodged in the Hôtel de Frontenac, where they were met on arrival by Monsieur du Metz, the superintendent of the royal furniture. The Hôtel de Frontenac has long since ceased to exist, and there has been speculation regarding its precise location. In a letter of 7 August 1665 Rossi describes it as 'in the middle of the courtyard of the Louvre'[77] - that is, probably actually inside the present Cour Carrée. The Nuncio, in a communication of 5 June, said it was 'one of the houses which are scheduled to be demolished'.[78]

In a letter written three days after the party arrived in Paris Rossi noted with approval that their quarters were lavish.[79] As at Lyon the rooms were hung with tapestry, and the beds were '*superbissimi*'. What he meant by this was not the softness or otherwise of the mattresses, but rather carved and perhaps gilded bedposts and above all elaborate bed-curtains. There were also four servants in attendance in addition to those Bernini brought with him. In a later letter (19 June) Rossi allayed his correspondent's fears regarding Bernini's safety. Cosimo Scarlatti remained in charge of the cooking arrangements, and all the doors were securely guarded.[80]

Rossi's account of the arrival of the party again conflicts with Chantelou's in one intriguing detail. Again it is Chantelou who is wrong. He would have it that it was after lunch on the succeeding day – Wednesday, 3 June – that Colbert arrived to meet Bernini for the first time and to welcome him on behalf of the King. Chantelou tells us that Bernini was taking his siesta at the time, but nevertheless received Colbert in his bedroom.

The truth, related by Rossi in his letter of 5 June, and confirmed in a

despatch of the Nuncio's which was not known to Mirot, is more to Colbert's credit.[81] He presented himself at the Hôtel de Frontenac on the very evening of Bernini's arrival and had come from Saint-Germain specially to do so. Bernini had already gone to bed but received him there. On the following morning (Chantelou says it was two days later) Colbert himself took Bernini round Paris, and gave him a thorough tour of the Louvre in the afternoon. The caricature, ascribed to Bernini and headed '*un cavaliere francese*', may well represent Colbert. Like his other caricatures it resembles a child's drawing. With a mop of hair, the

Caricature of (?) Colbert by Bernini.

eyes so small as to be omitted, the subject advances with hands outstretched, his mouth twisted in an insincere smile. Aged, at this time, forty-six, it was yet early in Colbert's career as the indispensable right-hand man of the still wayward and already autocratic young King.

Chantelou tells us that Colbert included both Notre-Dame and the Sainte-Chapelle in the morning tour. We should dearly love to know what Bernini thought of these marvels of medieval engineering, which must have been novel to him, owing to the virtual non-existence of Gothic in Rome. The nearest we can get to knowing comes from an incident later in the tour. On 15 September Chantelou tells us that he went to Saint-Denis with Bernini and Colbert. 'The refectory vault', he says, 'is supported by Gothic columns which look extremely weak to bear such a load. When we all admired it we noticed that there are two vaults, one of which leans against the other.'

Rossi and Chantelou agree on at least the earlier details of an expedition which took place two days after Bernini's arrival. Colbert appeared at the Hôtel de Frontenac at seven in the morning of 4 June, with two coaches-and-six, to escort Bernini and his party to their first audience of the King at Saint-Germain. Bernini, Colbert, Chantelou, Paolo Bernini, Rossi and the Abbé Butti went in the first coach; the others in the second. Two hours later they drew up outside the old château at Saint-Germain. This somewhat bizarre sixteenth-century building still survives though much restored, and now completely remodelled internally. Otherwise the present state of the castle area is crucially changed in two different respects. The so-called new château, where Louis XIV had been born in 1638 and where he now received Bernini, was demolished in the eighteenth century. And the colossal terrace, over a mile long, which crowns the escarpment and commands sweeping views of the Seine valley towards Paris, was not given its final form by Le Nôtre until several years after Bernini's visit.

At the time of Bernini's arrival at Saint-Germain it was reported that the King was not yet dressed. While they were waiting in the ante-room Rossi records an extraordinary, almost surrealist incident on which Chantelou is discreetly silent. Without warning the King's head suddenly appeared 'above a door', looked at Bernini, smiled and then withdrew.[82] Mirot, translating this passage into French, would have us believe that the King opened a door slightly and peered round it. But it is questionable if the Italian words – *sopra una porta* – would admit of this. And though

the room in question no longer exists it would not be impossible that it had an opening over the door. But another possibility remains. Both Baldinucci[83] and Domenico Bernini,[84] who include versions of this anecdote, use the word *portiera*. It is therefore possible, and indeed seems the most likely answer, that the door was already open, and that the King's head appeared round the door curtain. In any case, the incident shows that the young King was not yet so entirely constrained by etiquette as to stifle a boyish curiosity.

Domenico Bernini's account of the incident is far more dramatic. He embroiders Rossi's story, perhaps on the strength of family hearsay. According to his version the situation would have resembled Joan of Arc's recognition of the Dauphin, whom she had never previously seen, when he was merely one of a crowd.

The King being unable to suffer the delay before seeing him, revealed merely his head round a curtain and started searching with his eyes among the crowd of gentlemen who were there to decide which of them might be Bernini. But the latter, who had noticed the slight movement of the curtain, suddenly said, 'That is the King.' To the Maréchal de Turenne, who was at a loss to know how Bernini had been able to recognize the King, never having seen him before, he replied, 'I recognized in my first glance at that face a grandeur and a majesty such as could only be that of a great king.'

The audience which followed almost immediately bore out the first impression of informality thus created. When Bernini and his party were shown in, the King was discovered leaning against a window. Bernini repeated, necessarily again in Italian, the substance of what he had already said to Chantelou, and presumably also to Colbert, concerning his reasons for wanting to come to France. He finished by saying, 'I have seen, Sire, palaces of emperors and popes which are to be found in Rome and on the route from Rome to Paris. But for a King of France, a monarch of our own time, there is need for something greater and more magnificent than any of these.' Then, with a sweeping gesture he declaimed his carefully thought out finale: 'Let no one speak to me of anything small.'

The King said to his neighbour, 'Very good. Now I see that this is indeed the man as I imagined him.' Then, addressing Bernini, he went on, 'I have a certain fancy to preserve the work of my predecessors, but should it be impossible to build on a grand scale without demolishing

what they have left, let it be done. As far as money is concerned, there need be no restriction.' The King's reference to preserving the old buildings suggests that at some point in his speech Bernini had hinted that he was proposing to demolish them.

Whether or not he said so there is reason to suppose that he had at least been thinking along these lines. The Nuncio, for example, reported that on the day after his arrival Bernini had confided to him that the existing work at the Louvre was of little consequence.[85] A report of 19 June 1665 from one of the Modenese envoys mentions that gossip in Paris then had it that Bernini was proposing to demolish all of the old palace,[86] though a letter from Vigarani of the same date says that Bernini's latest plan preserved the existing building.[87]

Chantelou's and Rossi's accounts of the audience show that Bernini's insistence on the grand and magnificent was to the King's taste. But in one respect he had already given offence, and this was to remain the only bone of contention between him and the King. Louis had already seen, from the first audience, that Bernini had no opinion of French architecture, or indeed of anything else in France except the King himself. This is perfectly clear from Vigarani's letter of 19 June 1665. Carlo Vigarani, whose name has already been mentioned more than once, was a member of a Modenese family who were working in France in the 1660s and who specialized in fêtes and in the mechanism of fountains. They also acted as informants to the Duke of Modena. Carlo Vigarani met Bernini on several occasions during his mission. Perrault notes that Bernini spoke disparagingly of him.[88]

On this occasion Vigarani reported, 'I know what was said by His Majesty at Versailles in the presence of fifty courtiers, after he had honoured me by saying to me that he did not wish Bernini to see the fête at Versailles' (which, presumably, Vigarani was helping to organize), 'because in the space of only half an hour's discourse that he had had with him he had recognized him as prejudiced against everything that has been done in France.'

Chantelou tells us that as they walked back to the old château after the audience they noticed that in honour of the Feast of Corpus Domini the royal tapestries designed by Raphael and Giulio Romano had been hung in the courtyards. They consisted of the *Acts of the Apostles* series, for which Raphael's cartoons survive in the Victoria and Albert Museum, as well as the *Procession of the Blessed Sacrament* and *Triumph*

of Scipio sets. Soon after this we must deduce that Chantelou left Bernini's party for the time being, as Rossi records a number of encounters at this stage on which Chantelou is silent. The first of these was with the Queen Mother, who was ailing and in bed (she was to die, of cancer, in the following year). Colbert then conducted Bernini to the chapel – a Gothic masterpiece of the age of St Louis, and the only major portion of the medieval building which survives. While he was there, in prayer, the King arrived with the Queen. They were accompanying the Sacrament, and when they were already on their knees Rossi saw the King indicating Bernini to the Queen. Bernini then visited the infant Dauphin, and, while waiting for an audience of the Queen, the King's doctor offered his services. The Queen, who was Spanish, tried Bernini both in that language and in French, and appeared to be disconcerted by his inability to speak either, to the point of saying almost nothing herself. After lunch Bernini retired for his usual siesta. Finally Rossi tells us that Bernini was received by the King's brother, Monsieur, and by Madame, who was the daughter of Charles I of England.

Unlike the audiences which immediately preceded this one a subject cropped up, to which there was to be a significant sequel. Monsieur asked Bernini if he would have time to do a portrait bust of the King. Bernini replied soberly that he would if he could. The party then started back for Paris.

During the next few days and weeks Chantelou passed many hours alone in Bernini's company, and reports his conversation on a number of topics. Discussing the difficulty of portrait sculpture, Bernini said by way of illustration (and Chantelou noted that he was to repeat it frequently) that if someone whom one knew were to cover his face with white – his hair, his beard, his eyebrows and, if it were possible, his eyes – he would be unrecognizable.[89] He added, 'When someone faints, the pallor which spreads over his face is enough to make him almost unrecognizable, so that one says, "He is not himself".' Bernini astonished Chantelou by saying that in a marble portrait bust, in order to imitate nature it may be necessary to carve what does not exist in nature. Effects of colour were an instance. The livid colour around some people's eyes could be suggested by incisions in the right places. Bernini emphasized that to produce an effect of naturalness in art is not the same thing as servile imitation of nature, and added an observation which did not convince Chantelou as completely as his others. 'If', said Bernini, 'a

sculptor represents a figure with one hand upraised and the other against his body, the upraised hand should be made larger than the other, as the air round it produces an effect of diminution.' Chantelou remained doubtful about this at first, but later recalled that Vitruvius recommended something similar, namely that corner columns of temples should be larger than the others by one-sixteenth to compensate for being seen against the sky.

On the great sixteenth- and seventeenth-century controversy regarding the respective merits of painting and sculpture Bernini had nothing more constructive to say than that while the painter could correct what he was doing the carver in marble could not. During his work on the bust of the King he was to reiterate this idea, and then himself refute it in practice. He went on to explain his methods of artistic creation. He was in the habit of walking up and down the gallery of his house and sketching in charcoal on the wall as ideas came to him. Second and third thoughts were noted in the same way without attempting to correct or elaborate them. As one always had affection for one's latest idea the remedy was to forget about these sketches for a month or two, after which one could look at them more dispassionately. If time pressed he recommended looking at one's sketches through coloured or distorting spectacles. All this with the aim of counteracting a natural bias in favour of one's latest work.[90]

The seventeenth-century Venetian writer Boschini described how Titian was in the habit of doing, in principle, much the same thing – how he would turn towards the wall the canvases he had just sketched in and re-examine them several months later 'as though they were his mortal enemy'.[91] Boschini's book was not published until nine years after Bernini's visit to France.

When the Papal Nuncio sounded Bernini on his opinion of celebrated Antique sculptures the verdict was somewhat surprising. He praised most of the standard repertory – the *Laocoön*, the *Antinoüs*, the *Gladiator*, the *Apollo Belvedere*, the so-called *Cleopatra*, the Farnese *Hercules* (which he thought should only be seen from a distance), the Farnese *Bull* and the *Venus de' Medici*. He gave higher praise to the *Belvedere Torso*, despite its being no more than a fragment, and highest of all to the so-called *Pasquino*, which is both ruined and fragmentary, but enormously animated.

On the subject of architecture in Rome, when it cropped up later in

his stay (19 September), Bernini was rather less forthcoming. When the Nuncio opined that Antiquity could show nothing, not even the Pantheon, to compare with St Peter's, Chantelou demurred. The Nuncio then appealed to Bernini, who declined to support him. He was in favour of centralized buildings. 'The most perfect forms', he said, 'are the circle, square, hexagon, octagon, etc. The dome of St Peter's is indeed fine, and there is nothing comparable with it in Antiquity. But there are a hundred faults in St Peter's, and none in the Pantheon.' Nevertheless there was agreement on the superlative merit of the Colosseum, and the Nuncio added that if he were Pope he would restore it.

IX

FROM 7 JUNE Bernini was working on his Louvre designs, and this raises a problem. We have seen that Colbert's criticisms of his second plan may not have reached him before he left Rome, and there is no report of their being delivered to him in Paris, yet the substance of the objections must have reached Bernini somehow, with or without the stormy scene which attended his reading of Colbert's first memorandum. We are told of no further tantrums. We merely find him peacefully engaged on a totally different design, his third.

Like his earlier two, this was for the elevation of the main (east) front. His drawing for it was engraved, as were his later designs for the three other façades (south and west fronts and the courtyard) together with the ground plan, by Jean Marot in the same year (1665). It is these engravings which constitute our main source of knowledge. The third design for the main façade is strikingly novel. The intersecting concave and convex curves of the first have gone, likewise the broken concave ones of the second. Undoubtedly the change was due to the fact that in the meantime Bernini had seen the site and the existing buildings. What he had done, in planning a façade with walls which were all straight in plan, was to reduce the element of fantasy in the hope of increasing the effect of majesty. At the same time he did not revert to an unbroken straight line in the plan. The corner pavilions project in front of the adjoining sections of wall, and the centre then projects again, and more strongly. The lowest storey is treated as the base for the two floors

above, which are articulated with a colossal order – of Corinthian half-columns in the centre and of pilasters in the corner pavilions. As in both the earlier designs there is a line of statues against the sky-line.

On 9 June, when Bernini had only been working on his new Louvre design for two days, the Nuncio brought the Venetian ambassador to see him. Bernini thereupon read out to them a memorandum which he had prepared, and which constitutes his only surviving formal written statement on the subject. It is surprisingly realistic as coming from him, and shows that he had taken to heart what the King had said about sparing the old building.

Reflections on the Building which His Majesty proposes to undertake

The present King of France is a most potent sovereign, great alike in intellect and spirit, and mighty in power. There is time ahead of him in which to achieve great things in that he is young and the Kingdom is at present at peace. It is desirable that his palace should be commensurate with these considerations. It would therefore be unpardonable to contemplate other than a huge and majestic edifice; and in order to realize his ideas in this respect he has summoned an architect from Italy.

Though a great and majestic palace is necessary it must be admitted that our life is of limited span. When a prince has resolved to undertake a great work, and particularly one which accords with his own taste, he wishes to see and enjoy it as soon as he can. The Frenchman is not very phlegmatic by nature, and peace in France may not long endure. There is no suitable site in Paris for such a building unless one were to demolish much of the city at the expense of many millions and of much time, and in the case of the Louvre the greater portion is already in existence.

For these reasons it is not practicable to contemplate an undertaking on so vast a scale, and we must therefore weigh these various considerations in the balance of judgement and choose the least bad.

Chantelou tells us that Bernini's visitors discussed his statement for a long time. He does not vouchsafe to tell us what they said, but merely concludes, predictably, that they approved.

The same could not be said of Colbert when he arrived at the Hôtel de Frontenac on 19 June to see the new designs before Bernini presented them to the King. Chantelou was not present at the interview but was informed of it by Paolo Bernini. It is clear that Colbert was up to his old tricks again, and Bernini (in Colbert's eyes) up to his. There were

objections to Bernini's siting the King's bedroom once again in the noisiest part of the building, and to the provision of a covered way for the King's coach which Colbert said would also provide cover for an assassin. Bernini left the room, Chantelou tells us, with his face *sombre*.

At Saint-Germain on the following day, Saturday, 20 June, the new elevation of the east façade had quite a different reception. The King, according to Chantelou, said nothing about the *convenance* but was enthusiastic concerning the *majesté* of Bernini's drawings. He insisted on retaining them for further study after Bernini went back to Paris that evening. In the meantime he had found time to show them to both the Queen and the Queen Mother, explaining to the latter that he was not going to lecture her on them as he had already been doing so to the others to such an extent that his jaw was weary.

Rossi tells us in his letter of 26 June that Hugues de Lionne, the Foreign Minister, and inevitably also Butti, were present at the audience, as well as Colbert, and that the King said, almost to himself, 'This is not only the most beautiful drawing ever made, but also the most beautiful that ever *could* be made. I am delighted that I asked the Holy Father to grant me the Signor Cavaliere. No one other than he would have been capable of this.' Then, turning to Bernini, he said, 'I had had high hopes of you, but your work has surpassed my expectation.'

Chantelou says that Bernini had made alternative designs for the basement storey, one being rusticated, the other imitation rock. He had used the latter idea, rather tentatively, at the Palazzo di Montecitorio in Rome. He asked the King which he preferred, and when he was told it was the latter, he congratulated His Majesty on his taste. Chantelou evidently did not dare to report Bernini's further remark in this connection, and for this we are indebted to the less inhibited Rossi. According to him – though he makes no comment on it – Bernini said, 'Sire, inasmuch as you have not seen the buildings of Italy you have remarkably good taste in architecture.' The King made no gesture of reproof. His reply, in the circumstances, was a model of restraint. He said it was true that he had not seen them, but having had to examine the indifferent designs for the Louvre which had been submitted by the other architects he was the better able to appreciate the merits of Bernini's. Bernini himself could hardly have taken a different view.

Enlarging on Bernini's ideas for the elevation of the east façade Rossi explains that it was allegorical. This was undoubtedly true. Like all

artists who worked in the grand manner Bernini's mind moved naturally in terms of allegory. In this case Rossi's attempt to explain it is more naïve than Bernini's would have been. The palace was to rest on a rock, and the main doors were to be flanked not by columns but by large statues of Hercules. He symbolized strength and labour. Therefore, whoever wished to enter could only do so by virtue of labour and merit. Rossi adds that this conceit pleased the King, as well it might. Both he and Chantelou add that it was on this occasion that the King asked Bernini for a design for the west façade of the Louvre, facing the so-called Cour des Cuisines in the direction of the Tuileries.

After this audience, as after the first, Chantelou noted that Bernini repaired to the castle chapel, that he remained there a long time and that every now and then he kissed the ground.

Six days previously Bernini had had an architectural experience of a different kind. On 14 June he had been taken to see the unfinished new church of the Theatines, which was being built to the designs of Guarino Guarini. It no longer exists but is known from an engraving. Though perhaps rather less extreme than the churches which Guarini was later to build at Turin, and though still without a roof, it must already have looked very odd. Certainly the Theatines themselves thought so, and asked Bernini nervously how he thought it would come out. He replied non-committally that he thought all would be well. Unfortunately there is no indication that Guarini himself, who, as we have seen, seems to have been inspired by the first of Bernini's Louvre designs when building the Palazzo Carignano at Turin some years later, was present on this occasion, though there is evidence that he was in Paris at this period. Despite this, or perhaps because of it, Bernini criticized the building in some detail, and with his usual frankness. The monks were evidently worried about the proportions of the interior. Bernini expressed himself against disproportionately lofty church interiors. He went on to tell the Theatines a story of an architect (unnamed) who threw his coat on the ground and then lay on it, as being the only way to get a good view of such an interior. Perhaps this was, after all, Bernini's delayed comment on Notre-Dame and the Sainte-Chapelle. Bernini told the fathers that churches of circular plan like theirs should always have some kind of vestibule and not consist merely of a circle, as the average visitor automatically advanced a few paces inside before looking around. He finally reassured the monks that when the church was vaulted the interior

would seem bigger, and illustrated it with his experiences in countering a complaint from the Pope in a similar situation at Castel Gandolfo.

The audience of 20 June produced another important and far-reaching result. The King at last asked Bernini to undertake a portrait bust of him. Bernini, naturally, agreed, but said he would need twenty sittings of two hours each (in the event he was to require less).

This was the culmination of much uncertainty and rumour. We have seen that Monsieur had enquired about this during Bernini's first visit to Saint-Germain on 4 June. Later, on the 11th, Bernini had begun to get restive at hearing nothing from the King. He told Chantelou that various people had already spoken to him about it – the Duc de Créquy (presumably while they were both in Rome), de Lionne and Cardinal Antonio Barberini. The latter, who, as we have seen, had probably been more instrumental than anyone else in getting Bernini to Paris, had not been mentioned by Chantelou until now. Evidently Chantelou had been doing one of his brief disappearing acts at the moment when the Cardinal spoke to Bernini – probably at Saint-Germain on 4 June. Bernini went on that if a bust were wanted (he also mentioned one of the Queen, of which nothing more was to be heard), there was no time to lose. His current leave of absence from the Pope expired at the end of August, but in that case he would willingly stay an extra two months, till the end of October. Bernini gave no indication that there would be any difficulty in getting his leave prolonged, evidently assuming that it was no more than a formality (this did not prevent him from stressing, when it suited him later on, that his leave had expired). He said he could not spend the whole winter in Paris on account of the cold. Because of his age he did not want to start back later than November.

Chantelou had replied that he knew Colbert had it in mind to suggest the bust; he had in fact spoken about it, but perhaps he did not want to interrupt the Cavaliere's work on the Louvre drawings. Bernini replied sharply, 'There need be no interruption. In any case I am handing over the Louvre work to Mattia who will make the finished drawings.' He, Bernini, had already taken it on himself to procure clay for the models.

In his memoirs Perrault gives a characteristically malicious explanation of the origin of the bust.[92] He says the idea for it came from Bernini himself who saw it as a good way of currying favour. In fact Bernini's reference to the Duc de Créquy leaves very little doubt that the matter

had been raised in Rome long before. If any further proof were required it may be found in the fact that Bernini had brought Giulio Cartari with him from Rome. He was one of his assistants in sculpture, not in architecture.

X

FROM NOW UNTIL the end of Bernini's visit, some four months later, the emphasis shifts, both on the pattern of his life in France and also as regards his image at the French court. He had been summoned in the capacity of architect, the second of his many talents. But since building, even with the resources of a king, is a lengthy undertaking, and since the result is inevitably the work of many hands, the job was not ideally suited to display the talents of an artist whose stay in France was not to be long and who was essentially an individual virtuoso craftsman.

But as soon as the King commissioned the marble bust everything changed. For one thing, sculpture was Bernini's first and main art. For another, he would be able to finish the bust before returning to Rome. Finally, the court would be able to see him at work, could actually witness the greatest living sculptor, the one whose virtuosity was universally and justifiably considered to have surpassed that of Antiquity, in the act of deploying his extraordinary talents. It is therefore not surprising that a stream of smart ladies of the court and affected, simpering young men (Chantelou records as many as forty in attendance at a sitting) fell over themselves to accompany the King when he came to sit, and stood around goggling with imperfectly concealed amazement at Bernini's antics – stalking the King as though he were a deer, suddenly peering at him from an unexpected angle, and even, on occasion, rearranging the King's garments and combing the royal hair. Naturally, too, such courtiers outdid each other in declaring variously that the result was a speaking likeness or else that one or other feature failed to do justice to the beauty of the royal physiognomy.

Nevertheless the sittings were as yet still some time ahead. They were not to start until August. In the meantime Bernini was hard at work, forming his visual impression of the King's appearance and personality by means of concentrated observation, together with action sketches

which had the function of the candid camera shot. Bernini watched the King playing tennis and sketched him at council meetings and giving audience. He said he was even prepared to sketch him at Mass.

In his biography of his father Domenico Bernini quotes him as saying that if a man stood still he was never so much like himself as when he moved about; it was in his movements that his most personal and specific characteristics were revealed.[93] Concurrently, but at this stage independently, Bernini was developing his ideas for the design of the bust as a work of art, irrespective of the likeness. These were realized in the clay models from which the marble was then blocked out. When this was done Bernini worked for a time on the marble without seeing the King again and only occasionally referring to the sketches he had already made. We know that by this time the bust was already a recognizable likeness. The sittings from the life which followed were by way of giving the work the finishing touches, principally as regards the expression.

Even if work on the bust was from now on uppermost in Bernini's mind and in his affections, and even if, for that reason, he might have been prepared, as he had hinted to Chantelou, to hand over most of the practical work on the Louvre to Rossi and others, he was not allowed to do so. The King, and above all Colbert, saw to that. There were, in any case, to be fresh calls on his architectural creativity. On the very day that he commissioned the bust (20 June) the King also commissioned the west façade. The courtyard and south façade designs followed. Naturally Bernini had also to provide ground plans of all his projected work and later on to supervise the engraving of them. Then there were to be plans for a *place* facing the east front and for dealing with the space between the Louvre and the Tuileries; and there was to be endless bickering over whether or not he had left enough room between the proposed east front and the church of Saint-Germain-l'Auxerrois. Also on how many houses in that area would need to be pulled down, and whether or not the royal exchequer could run to the expense of compensation. Also on the method of paying the workmen and on the respective merits of the French and Italian systems of construction. While Colbert found fault with Bernini's projects on grounds of amenity, Bernini himself was dismayed to discover, rather late in the day, that the existing Louvre buildings were inaccurately aligned. The river front was at an obtuse angle, and not a right angle, to the adjoining range of buildings. This, if not corrected, would upset the *enfilade* of the new

rooms (in point of fact the ground plan of the Louvre is still full of not-quite right angles).

At the end of July an entirely new and unexpected Louvre worry came Bernini's way. Le Vau, the rejection of whose plan by Colbert had originally caused all the intrigue of which Bernini's visit was the culmination, suddenly surfaced again. He was reported to be working, unasked, on a new plan for the Louvre. At the same time he set in motion a whispering campaign to the effect that the King was cooling off as regarded Bernini's plan.

As though this were not enough, there were fresh architectural commitments. At the end of September Bernini was to spend a week or more designing a royal mausoleum for Saint-Denis. This was a project which had been adumbrated at an early stage of the visit (it is mentioned in a memorandum which Colbert handed to Bernini on 19 August). Here, even more than at the Louvre, Colbert was to infuriate Bernini by blowing hot and cold – saying that the building had to be suitably magnificent, and then, when Bernini designed one that was just that, complaining of the likely expense. At one stage François Mansart was also put to work on the same job. Nothing came of his project either, but the essence of it was later used by his great-nephew, Jules-Hardouin Mansart, for the Dôme des Invalides.

Two other members of the royal family made minor architectural demands on Bernini. The Queen Mother asked him for a design for the baldacchino over the high altar of the church of the Val-de-Grâce. And at intervals there were shrill pipings from Monsieur, who wanted Bernini to improve his cascade at Saint-Cloud.

The miscellaneous demands made on Bernini by the King and the royal family were not confined to the practical sphere. Colbert, speaking on behalf of the King, was out to take full advantage of his presence in France to solicit his advice on the training of young artists, and finally persuaded him to take an active part in inaugurating the new French academy at Rome. As well as all this there were architectural demands from private individuals. The Maréchal d'Aumont and Monsieur de Lionne wanted Bernini to design them new staircases, and the Commandeur de Souvré asked him to provide plans for new buildings at the Temple. In the intervals from all this the sixty-six-year-old Bernini was surreptitiously helping his young son, Paolo, to sculpt a marble relief of the young Christ.

One of Bernini's main difficulties at the start of his work on the bust of the King was where to find a block of marble which he considered suitable. In the event he never did. Because his time was so limited he had to put up with what had already been quarried and happened then to be in Paris. He consistently described the block which he finally chose, and which he used, as 'stale' (*cotto*). He said at one point to Chantelou (19 September) that he thought it must have been lying about in Paris for over half a century. Later, when he had succeeded in carving it, he said, never being one to minimize his own achievement, that he was amazed that he had been able to do so. In the event he had to use the drill more, and the chisel less, than he liked or than he normally did. The block was the least bad of several: Bernini himself, in a letter of 22 July,[94] says three, as does Rossi (17 July); Chantelou and the Nuncio say two. On the day after the King commissioned the bust, Bernini and Chantelou had gone to see what marble was available. They went to the Tuileries and along the river, and ended, in the evening, at the Val-de-Grâce. The blocks they chose were to be sent immediately to Bernini's studio in the Louvre. He was annoyed when they failed to arrive on the next day (22 June) and complained to Charles Perrault, in his capacity as Colbert's assistant. This may have been Bernini's first encounter with the man who was to prove the most insidious of his enemies. Perrault's excuse was that it was proposed that Bernini should do a full-length statue of the King instead of a bust, and that Colbert had already written in that sense to the Abbé Butti. This very unexpected idea predictably nettled Bernini. He might well have asked Perrault what business it was of the Abbé Butti's. What he did say left no room for further argument. 'No. It has to be a bust, and for more reasons than one. First, because that was what was agreed. Secondly, because a bust permits of refinements which are not feasible in a full-length statue. One is intended to be shown in a room, the other in a long gallery. A bust is to be seen from close quarters, a statue from a distance. It therefore needs to be seven or eight feet high, and there is not even enough good marble in Paris for a bust, let alone a statue.' Chantelou adds that these arguments were then sent in a letter addressed to Colbert. At the same time Bernini asked permission to return on the next day to Saint-Germain for the purpose of sketching the King.

In the event this request resulted in Bernini's punishing Perrault, at least to the extent of discomforting him physically. When the court was

at Saint-Germain there was evidently an efficient service of despatch riders between there and Paris. The appropriate officer on this occasion at the Paris end happened to be Perrault himself, as Chantelou noted that it was Perrault who, in order to confirm Bernini's audience, was obliged to call on him (Chantelou) at four o'clock the next morning.

The audience which duly took place later that day (23 June) is described only briefly by Chantelou. In a few lines he says that on arrival at Saint-Germain they found the King playing tennis, that Bernini observed him carefully, and that after lunch and a siesta he was received by the King who was about to give audience to the English ambassador and the Resident of Denmark. Chantelou adds that Bernini drew a profile of the King and also a full face. As on both Bernini's previous audiences, however, it is possible that Chantelou's reticence may be due to embarrassment at the informality of the relations which prevailed between Bernini and the King, and above all to the liberties which Bernini took. These are reported in some detail by Rossi, who had no such inhibitions, in his letter of 26 June.

We found the King playing tennis. As soon as he noticed the Cavaliere he saluted him with an agreeable and laughing gesture. After the game was over the Cavaliere was shown into the King's apartments where he met the English ambassador, who was being granted an audience, during which the Cavaliere was present. After the audience Monsieur Colbert, Monsieur de Lionne, Monsieur Triglie and Monsieur le Maréchal de Turenne were shown in. [Inasmuch as Rossi spells Chantelou 'Sciant Lup' it seems possible that by 'Triglie' he may mean Michel Le Tellier, the Minister of State for military matters.] The Cavaliere sent for me to bring his sketching block, and he then started to draw, having got the King to pose standing, or rather leaning, against a small table, bareheaded. As the King's hair was not disposed in the way that the Cavaliere wished, he asked for a comb and himself adjusted it. The King suggested to the Cavaliere that for his own comfort he should sit down, but the Cavaliere said that this portrait had to be done standing up. During this time courtiers who were present were reading letters to the King, and at the first signs which His Majesty made they were all amazed how the Cavaliere had caught the likeness. And the King himself was so anxious to see it that he kept moving and looking towards the drawing, so that the Cavaliere had to catch him actually on the run. After the Cavaliere had reached a certain point with the drawing he rested a little. Everyone admired the drawing, and the King, in particular, said, 'Very good. This is the best and most faithful likeness that has ever been done of me.' When he had finished the drawing in full face the Cavaliere drew the King in

profile. Again, on seeing it, the King said, 'It is I. I recognize myself.' In doing these drawings the Cavaliere took only an hour and a half and no more.

Unfortunately none of Bernini's sketches of the King have come to light, but his skill at catching a fleeting likeness can be illustrated by his sketch of Cardinal Scipione Borghese.

Bernini spent all or most of the day on 24, 25, 27 and 30 June working on the clay model for the bust, which was shown to Colbert on 1 July. On this occasion Colbert told Bernini that the King had allocated Cardinal Mazarin's old apartments at Saint-Germain for him to work in. This was evidently looking ahead to the possibility of Bernini's working the marble there. In the event this was unnecessary as the King returned to Paris just as the bust reached the critical stage.

Two pieces of marble were finally delivered at the Louvre on 30 June. They were deposited in the Salle du Conseil, which had been allotted to Bernini to work in. One of the blocks had been intended for the sculptor Bistel and the other for Guérin. Blocking out of the one which Bernini chose had been started by 6 July, presumably by Cartari, and had progressed far enough by the 14th for Bernini himself to start work on it. In the meantime, on Sunday, 28 June, Bernini had been back to Saint-Germain for his second sketching session with the King. Rossi, in an unpublished letter of 3 July, says he himself was not present this time (this was understandable, as he was Bernini's assistant in architecture, and on this visit there was no architectural business to discuss). Chantelou, for his part, is even more laconic than on the earlier occasion. Nevertheless one of the few fragments of information which he vouchsafes reveals that, though Louis XIV seems normally to have used an interpreter (Chantelou himself) when speaking to Bernini, he in fact knew quite a lot of Italian. Bernini, who had said, when applying for this audience, that he would be prepared to sketch the King at Mass, was in fact doing so at a privy council, slightly surreptitiously, when he caught the King's eye. Bernini thereupon said '*Sto rubando*'. This idiomatic Italian, and the curious conceit behind it, might well have puzzled anyone other than an Italian (it means literally 'I am in the act of robbing'), yet the King grasped the point and replied in Italian, '*Sì. Ma è per restituere*' ('Yes. But only in order to pay back'). He was to give one more proof (3 September) of this degree of linguistic ability before Bernini left.

Bernini's next visit to Saint-Germain, on 5 July, was primarily to

show the King his drawings for the Val-de-Grâce altar and for the west façade of the Louvre. Chantelou says nothing about further sketching of the King, but Rossi says cryptically, 'Later the Cavaliere drew different parts of the portrait of His Majesty, so as to be able to use them in the model in Paris.' On 12 July Bernini again sketched the King at a privy council. Neither Chantelou nor Rossi records anything unusual as occurring on this occasion. But before the fifth and last of the sketching sessions, which took place at Saint-Germain on 19 July, Bernini said that he wanted to draw the King in a different way from what he had done hitherto. In the event he asked the King to sit down, and then himself got down on his knees on the floor and drew him from there. Anyone who looks at the finished bust will understand the reason for this manoeuvre. The proud angle of the head, thrown back as though giving an order, presupposes knowledge of what the King's face looked like from a physically lower level. After that audience Rossi tells us that the King entered his coach to pay a call on his aunt, the widowed Queen Henrietta Maria of England.

Before this Bernini had already spent five days working the marble himself (14-18 July), and after the final sketching session he put in a further five days (20, 21, 23, 24 and 27 July). When he had only worked on it for a single day Colbert saw it (15 July) and already noted its 'majesty' and degree of resemblance. Another visitor (on 28 July), Monsieur de La Garde, found the bust already a good likeness, while Madame de Lionne, who saw it on 30 July – her charm, which was later to prove her (and her husband's) undoing,[95] much affected Bernini – actually said that he might spoil the bust if he did any more work on it. At this stage the lace collar was not yet begun, and probably not much of the hair. It is also certain that the drapery was still attached to the core of the marble and that the pupils of the King's eyes were only indicated in chalk. Nevertheless Madame de Lionne's remark is a good indication of what Bernini could achieve as regards likeness without actual sittings. When Colbert also said (29 July) that the bust was already so good a likeness that he did not think live sittings would be necessary, Bernini's reply constituted one of the best of his statements on his aims and methods.

There is always more to be done if one wishes to do it well. Up to this point I have drawn on my imagination, and have only rarely had recourse to the sketches which I made. I have relied principally on what is here [he patted his forehead] where I have the idea of His Majesty. Otherwise I should be making,

in effect, a copy and not an original. But all this is very painful to me. In commanding his portrait the King could not have asked of me anything more laborious. Nevertheless, I hope that the result will be the least bad of all the busts that I have done. In this kind of portraiture mere resemblance is not sufficient. One must express what goes on in the heads of heroes.

On the previous day Bernini had commended Chantelou for characterizing the bust as 'giving a likeness as regards nobility and grandeur'.

One of the visitors at this early stage (22 July) was the Marquis de Bellefonds, who said he would have liked to see some hair on the King's forehead. Chantelou tried to defend Bernini (who was himself present) by saying that the King's forehead was very fine. It would be a pity to conceal it, and in addition he might change his way of wearing his hair. Bellefonds' reply to this – that when the King had less hair he would wear a wig – is a good indication (in addition to Bernini's combing the King's hair on 23 June) that what we see in the bust was natural hair (certain commentators, including Wittkower, refer to it as a wig).[96] Bernini's comment on this occasion was that painters had the advantage over sculptors in being able to depict some objects showing through others. Unlike a sculptor, they could also depict hair on a forehead without obscuring it. This thought fired Bernini to attempt the impossible. A week after Bellefonds' visit Chantelou noticed that Bernini had in fact added a lock of hair on the forehead of the bust. With less than his usual tact he suggested that the master had taken the hint, to which Bernini replied that the King's forehead was never entirely bare.

The addition of this lock, of which Bernini was very proud, could only be achieved by cutting back all the upper part of the forehead except for the curl itself. This was later to be criticized adversely, and it did in fact falsify the shape of the King's forehead, as can be seen by comparison with the painted portraits. Nevertheless Bernini knew what he was doing. If it were possible to see the forehead of the bust in profile it would be clear that he had achieved his effect at the cost of physical deformation. But as the hair which frames the forehead projects far in front of it on both sides it never *is* possible to see the forehead in profile (though the occasions when the light causes shadows to fall on the recessed part of it, or when dust settles on it, could not be prevented, even by Bernini). The episode of the curl illustrates Bernini's later practice in sculpture. The two-dimensional effect of the bust in the eye of the spectator was achieved at the cost of violating the three-dimensional

actuality. Bernini made a comparable assumption in the last bust which he executed, that of the doctor, Gabriele Fonseca (Rome, S. Lorenzo in Lucina), where the play of light on the drapery is suggested by incisions which bear little relation to the actual folds of the garments. The episode of the curl also belies both what Bernini had said when the matter was first suggested, and what he told Chantelou after his initial presentation to the King at Saint-Germain on 4 June – that unlike a painter a sculptor cannot correct his work.

One further development before the return of the King to Paris occurred on 27 July, when Bernini asked for a piece of taffeta on which to model the drapery. The 'staleness' of the marble was immediately apparent when he and Cartari embarked on the audacious undercutting which seems to make the drapery float in the air, and which necessitated extensive use of the drill.

Not realizing that the King was returning to Paris so soon, Bernini told Bellefonds on 28 July that he would need to go to Saint-Germain within eight days, evidently for the first live sitting. However, on the very day in question, 5 August, Bellefonds announced that the court was returning to Paris in another week. It would therefore not be necessary to go to the trouble of having the unfinished marble bust transported to Saint-Germain. On the next day Colbert told Bernini that he must vacate his rooms in the Hôtel de Frontenac in favour of unspecified court officials. New sleeping accommodation was to be found for him and his party at the Palais Mazarin (now the site of the Bibliothèque Nationale), about a quarter of a mile to the north of the Louvre.

The question then arose of what to do with the bust. Was it also to be moved to the Palais Mazarin? Bernini said at once that he would prefer not to change the light, but later that day he visited the Palais Mazarin and found a suitable place to work on it. He would therefore prefer to have the bust moved there. If he left it in the Louvre it would be impossible to stop court officials drifting in and out at all hours of the day to look at it, thereby distracting him. Moving the bust to the Palais Mazarin would naturally presuppose the King's willingness to go there for sittings, and for this his approval was necessary. Bernini himself moved into the Palais Mazarin – actually into the Cardinal's own old rooms – two days later (8 August). Rossi, in a letter of 14 August,[97] found the rooms even more magnificent than those they had vacated at the Hôtel de Frontenac. Bernini noted a picture labelled as by Veronese

and immediately announced that it was only a copy. He knew, of course, who had the original – another Cardinal. On 10 August Perrault reported that the King had approved of the bust's being moved to the Palais Mazarin, and on the afternoon of the next day Louis himself arrived there for the first sitting. According to the Nuncio[98] he had come straight from Saint-Germain that morning, and finding that the Queen had already lunched he had apparently gone without it himself. He said that he and Monsieur had been meaning to descend on the Maréchal de Gramont, who was present, and who replied that it would have been no more than pot luck, but that they would have been welcome to it. It is impossible to imagine this degree of informality on the part of the Louis XIV of Saint-Simon – the elderly Roi Soleil – in the most familiar phase of his long life. And indeed the picture of the young King as it emerges from Chantelou's journal and Rossi's letters would be almost, if not quite, unrecognizable to any reader who derived his image of Louis XIV mainly, as most do, from Saint-Simon.

This incident, like one which occurred at the ceremony of laying the foundation stone of Bernini's Louvre on 17 October, also shows that the Maréchal de Gramont was on very intimate terms with the King. At the foundation ceremony Gramont arrived slightly late, and Louis actually took out the foundation medal for him to see after he had already inserted it ceremonially. Inasmuch as Gramont showed himself one of Bernini's most outspoken enemies there can be little doubt that the cause was his jealousy of the favour shown to Bernini by the King.

The King's return to Paris, and the start of the regular sessions on the marble, opened a new phase in the history of the bust and indeed of Bernini's mission. In the meantime Bernini had been kept busy in many other directions.

XI

THE CHURCH AND convent of the Val-de-Grâce, with which Bernini was briefly involved early in his visit, were crucial in the life of the Queen Mother of France, Anne of Austria. They stand on the left bank of the Seine, about a mile and a half due south of Notre-Dame. Soon after her wedding, as a child bride, Anne selected the foundation for her special care, and often for her residence, when it became clear that her husband, the young Louis XIII, had no interest in her. And it was here, one night early in 1638, when stranded by bad weather and having nowhere else to go, that he was said to have been forced to share his wife's bed. Nine months later, on 5 September 1638, the future Louis XIV was born at Saint-Germain.

To commemorate this important event the Queen vowed to rebuild the convent on a sumptuous scale, but in the event its architectural history proved chequered. After the King died, in 1643, Anne became Regent and assumed she would have ample funds for her purpose. But she had reckoned without the great architect, François Mansart, who, with his usual extravagance, caused a financial panic in 1646, after only a year's work and when the walls of the new church were only cornice high.

After Mansart's dismissal the work dragged. The dome had only just been finished, and was still being decorated by Mignard, when Bernini arrived in Paris in 1665. His first visit to the church, on 13 June, appears to have been ostensibly by way of sightseeing. Bernini and Chantelou were received by Jacques Tubeuf, who, as supervisor of the Queen Mother's household, had been responsible for getting rid of Mansart, nineteen years previously. Mansart had been succeeded by Lemercier, on whose death, in 1654, the office had fallen to Pierre Le Muet. One of his assistants, the young Gabriel Le Duc, was among the many who now went round the building with Bernini.

The party ascended to the cupola to see what Mignard had been painting on it and then walked to the convent buildings. Bernini was shown the model of the baldacchino for the high altar – presumably Le Duc's, though this was not specified at the time. Tubeuf asked him what he thought of it, but he replied non-committally. Later, Chantelou asked Bernini why he had been so reticent. 'I had noticed', Bernini said, 'that the young architect [Le Duc] did not take kindly to what I told him.

When we were speaking of the dome of the Val-de-Grâce he said it was of the same proportions as that of St Peter's in Rome. But it is not. He [Le Duc] then said "Each man to his taste". In order not to give offence I said nothing about the decoration of the church, which spoils it, nor of the other ways in which it is defective.' Later still, when speaking of the cupola, Bernini said it was like a very small skull-cap on a big head.

Bernini's next visit to the Val-de-Grâce, on 21 June, was only to look for marble, though this caused a misunderstanding later on. Then, on 25 June, Tubeuf and de Bartillat (the latter the treasurer-general to the Queen Mother) called on him to commission a design for the high altar and baldacchino. Bernini had evidently seen enough on his first visit to the church to realize, or suspect, that it was a nest of intrigue, as events proved before long. He replied that the superior of the nuns had already discussed the matter with him, that he did not know what authority that might carry, and that he would be glad to have it in writing. When Chantelou said that what the two visitors were saying truly represented the wish of the Queen Mother, he said he would think about it.

On 30 June a message was received that the Queen Mother could not explain exactly what she wanted at the Val-de-Grâce, and asked Bernini to come and see her. Before doing so he seems to have spent most of the day on 3 and 4 July working on his drawing for the altar. In his letter of 10 July[99] Rossi described Bernini's project as oval in plan, with eight Corinthian columns and entablature, and a frontispiece with a glory of angels and God the Father; the whole to be regarded as the altar of the Nativity, and to include figures of the Madonna and Child and St Joseph.

On the way to Saint-Germain, on 5 July, Bernini asked Chantelou to recommend his Val-de-Grâce drawing. He said it showed him in the triple capacity of painter, sculptor and architect, and added that beautiful things (though of course he did not really know how to produce them) needed verbal assistance. In addition to illustrating his curious false modesty and his political instinct, this episode probably shows, as did his treatment of the Queen Mother's emissaries, that he realized he was treading mined ground.

At Saint-Germain Bernini showed his drawing first to Colbert, whose predictable first reaction was to complain of the likely cost, but who then seems to have used it as a pretext to broach the subject of a French academy in Rome. Chantelou says nothing about Bernini's showing the drawing to the Queen Mother, and Rossi only mentions very briefly that

he did so. But something must have happened, and that not to Bernini's liking, as on 8 July Colbert came into Paris from Saint-Germain and asked Chantelou if Bernini had been annoyed at the way in which the Queen Mother had received his drawing for the Val-de-Grâce altar. As a practised diplomatist Chantelou replied that if so he had not said so. Nevertheless Chantelou himself added details which go a long way towards explaining what he had not told us about the Queen Mother's displeasure. The root cause was probably that Bernini, as we know, seems to have made his drawing before hearing from the Queen Mother's own lips what exactly it was she wanted. Chantelou now explained to Colbert that Bernini had not known that it was planned to erect another grille in the left transept of the church like the one on the right. It was to correct the asymmetry of the contrast between one long and one short arm that he had sited the altar where he had, and also so that the Queen Mother could see it from her oratory, which she could not do if it were elsewhere. In reply Colbert expressed what was probably the first unqualified adverse criticism of Bernini which he had yet permitted himself, 'He never takes the trouble to inform himself properly.' Chantelou replied with dignity that Bernini had been by himself when inspecting the site of the altar. Tubeuf had indeed asked Chantelou to let him know when Bernini would be coming again, but Chantelou had not been able to do so. Bernini had gone there two days before he said he would, as he returned to the church when he was looking for marble for the bust.

The true explanation is likely to have been of a kind which would not have occurred to Colbert and might well have been beyond his range of comprehension. Even now, in his sixties, Bernini was still so explosively creative that the mere mention of another job immediately drove him to his drawing-board. Throughout his mission to France, including the eve of his departure, he showed himself willing to produce new designs of almost every kind at minimum notice.

Bernini was not present at Chantelou's conversation with Colbert on the subject of the Val-de-Grâce and this was virtually the end of the affair, though on 9 August the voice of François Mansart was heard expressing approval of Bernini's altar design. Evidently the Queen Mother decided, or was persuaded, after the audience of 5 July, not to have further dealings with him. There are a few further allusions to the matter in Chantelou. On 22 July, when Bernini called on the painter Mignard, he was shown the latter's design for the Val-de-Grâce altar.

He looked at it long and attentively in silence. Then he said, 'The difference between this and the one which is being executed [presumably Le Duc's] is like that which exists between the sun and a torch. I should not be surprised if a four-pound torch were preferred to one of five pounds, but to prefer it to the light of the sun itself would be worse than blind, and that is incomprehensible.'

Anyone who knew Bernini might assume from this that the four-pound torch was Le Duc's, the five-pound one Mignard's, and the sun, naturally, Bernini's own. Oddly enough that may not have been his meaning. On 7 September he expressed himself very strongly to Chantelou, saying that it was the rejection of Mignard's design for the Val-de-Grâce altar which had very nearly turned him right against the idea of continuing to serve France. He had alluded to the subject on 28 June, when the Commandeur de Souvré asked his help over the new buildings at the Temple. Bernini then commented, 'They only ask my opinion in order to give themselves the pleasure of not following it, as they did with the altar of the Val-de-Grâce or the staircase of the Hôtel d'Aumont.' The subject of the latter had first cropped up on 18 July, when the wife of the Maréchal d'Aumont had consulted Bernini on the staircase she was proposing to build at the Hôtel d'Aumont. We know from other sources that two successive staircases had already been made or projected by different architects, and the one that was now under construction, and which, despite Bernini, was eventually built, was a masterly and highly original work by François Mansart. On 28 July Bernini said he had made a drawing for a new staircase, as Madame d'Aumont had asked him for it. Predictably he had found Mansart's project faulty. The proportion of the stairs was wrong, and the flight did not end in the middle of the landing. He would have a model made of his own project, though he would have preferred not to intervene in a job which was already under way.

As to the Temple – originally the seat of the Templars, and at various times a bank and a prison – Bernini finally submitted a plan for the Hôtel du Grand Prieur towards the end of his visit (26 September). Of this, likewise, nothing came. It is of some interest that François Mansart had been involved at the Hôtel d'Aumont, and that a pupil of his, Pierre Delisle, was ultimately to do the work at the Temple. Throughout Chantelou's journal Mansart assumes the guise of an ogre – one who is often ominously heard, but never actually seen. Similarly, Mansart's

greatest work, the Château de Maisons, was always being held up to Bernini (rightly) as a place he must visit, but though Chantelou, on 30 September, says he had done so, no details are given.

In addition, Bernini's advice was sought at the Hôtel de Lionne, a recent building by Le Vau. On 17 August he made sketches for various small improvements, and on 20 August he suggested wide-ranging changes. But on 2 September Bernini, in evident pique, said it would be better to keep to the existing plan. A sketch by Bernini at Stockholm has been identified with this project.[100]

On 28 July Bernini had ended his diatribe about the Val-de-Grâce affair by saying that he did not know what would happen at the Hôtel d'Aumont, but that he thought that a cabal of architects would prevent his work being carried out. As we have seen, he had been well aware of such a thing even before he arrived in France and the existence of it was admitted on 10 August by Chantelou's wife (evidently a retiring woman; nothing had been heard of her until this point). We shall come on further evidence of a cabal at the Louvre at a later stage.

In the case of the Val-de-Grâce project the existing baldacchino is so obviously Berninesque in appearance, so reminiscent, in its spiral columns, of his first great masterpiece at St Peter's, as to lend weight to the theory, which is still sometimes expressed, that it is from his design. Against this is Bernini's conviction that his plans would not be carried out, and, as regards detail, the fact that the plan of the existing baldacchino is circular, not oval as Rossi said in his letter of 10 July, that there are six and not eight columns, and that six capitals and six bases were ordered in January 1664, long before Bernini arrived in Paris.[101]

It therefore seems likely that Bernini's rivals did succeed in suppressing his plan and that the then-existing design by Le Duc, of which Bernini had been shown the model on 13 June, was followed in the main. But the idea of the spiral columns may well have derived either from his baldacchino at St Peter's or from his design for the Val-de-Grâce.

The episodes of the Val-de-Grâce, the Hôtel d'Aumont, the Hôtel de Lionne and the Temple illustrate how feeling against Bernini, inspired by the jealousy and resentment of the local architects, was followed by the abandonment of his plans, as, on a much larger scale, was to be the case at the Louvre.

Throughout his stay Bernini's behaviour caused embarrassment from time to time. As early as 19 June, when he had been less than three weeks

in Paris, Vigarani reported that malicious rumours were circulating about Bernini's brashness, that he should have been advised how to behave in France, but had not been.[102] It was in this despatch that Vigarani also reported that at his very first audience the King had realized that Bernini was prejudiced against French art. On 15 July Colbert went so far as to say to Chantelou that he wished Bernini would spare other people's feelings more. Though Bernini, as we have seen, *had* exercised some discretion when being taken round the Val-de-Grâce, his frankness in the presence of the King may, as we have also seen, have embarrassed Chantelou.

There is plenty of evidence that Bernini's various *faux pas* were widely discussed, though some of those that Chantelou records may not have gone further. Sometimes they consisted merely of the expression of an honest opinion – such as that the infant Dauphin was too fat – when it would have been tactful to say nothing. An example of this occurred at the very beginning of his stay (7 June). On this occasion Bernini spoke his mind on the subject of the Tuileries. This building, which ran inland at right angles from the western extremity of the Grande Galerie of the Louvre, and which was finally pulled down several years after being gutted in the Commune of 1871, consisted of a long string of distinct pavilions, with independent roofs of assorted shapes and sizes. It must always have looked bizarre, and was described by Napoleon as 'uninhabitable'. Bernini said he assumed the roofs had not all been built at the same time. 'It reminds me', he said, 'of someone who, liking his drink cold, has instructed his valet to that effect. To begin with, the valet does what he is told and makes the drink very cold. Then, seeing it well received, he makes it colder still, the next day still more so, and finally serves it almost solid ice, without the master realizing it, unless it makes him positively ill.' On a later occasion (23 July) he remarked, apropos the cascade in the park of Saint-Cloud, of which Monsieur was so proud, that the art which had gone into such things ought to be concealed in an effort to make them appear natural, but that the French did the opposite.

On at least one occasion Bernini's adverse criticism was justified since it concerned what he considered the unsuitable conditions of display of one of his own works. This was at the church of the Carmes Déchaussés which he visited on 28 July and again on 11 August. Chantelou describes the work as 'a marble figure of his design'. It is in fact a *Madonna and Child* which had been commissioned and presented by Cardinal

Antonio Barberini, and executed according to Bernini's design probably by his pupil, Antonio Raggi.

On another occasion (22 July) Bernini waxed eloquent when telling Chantelou how fickle the French were. This was, admittedly, at a time when he was understandably mortified over the outcome of the Val-de-Grâce fiasco. He recalled how Pope Urban VIII, when he was still Cardinal Barberini (and therefore before the year 1623), had dissuaded him from coming to France, how he said that things were started there with enthusiasm, but that this enthusiasm only lasted as long as straw took to burn, that after appreciating and encouraging someone for a year or two they would then drop him, that if he (Bernini) left Rome he would be leaving his school and going somewhere where he would know no one and no one would know his work, and that the one who was best at intrigue was always the most successful, even if devoid of ability and talent. Bernini now told Chantelou that he realized what Cardinal Barberini meant. Since the conversation, on Bernini's own showing, had occurred more than forty years previously, Bernini's powers of memory may be considered as remarkable as his lack of tact. The luckless Chantelou, always the courtier as well as the host, replied at first defensively. 'Things are very different now,' he said. Then, rallying, he gained a good, and for him surprising, debating point by reminding Bernini how shabbily his idol, Annibale Carracci, had been treated after finishing his great work on the Farnese gallery – by the Italians.

At other times Bernini gave offence simply by behaving as he did in Rome, which did not correspond with the code of good manners current in France. When, for instance, the officers of the Academy called on him he received them courteously, but after the interview escorted them no farther than the door of the room. He habitually did the same with Colbert. On another occasion (21 August) Bernini had just lain down, exhausted, after a sitting for the bust, when Monsieur de La Vrillière came in. Chantelou whispered, 'He is a Secretary of State,' but Bernini did not get up. Afterwards he apologized.

Much of the time it seems clear that the French court was being unnecessarily touchy, and needlessly quick to take offence. This is undoubtedly the case in one incident which became specially notorious. On being shown the King's bedroom in the Louvre (23 August) Bernini said at once that the decoration was that of a woman's room. This was immediately held against him, and it even got back to the King, who

asked about it on 3 September. Chantelou replied that the remark was a malicious misunderstanding. It was not, and certainly was tactless. But inasmuch as the room in question had been the Queen Mother's, Bernini's observation could have been considered fair comment. No such allowance can be made for another notorious gaffe when (2 August) Bernini said that the King, in wishing to preserve the Louvre, had destroyed it. Despite the awed silence which greeted this witticism Bernini persisted. He enquired if it had been properly understood and positively requested that it be repeated to the King. His conceit in his own idea of his wit even ignored the fact that if any destruction were being done it was, in the literal sense, he, Bernini, rather than the King who was doing it. Towards the end of his stay so many of his *faux pas* had come back to him that he made an enormous effort to give no further offence. But by then the harm was done.

On the other hand, despite his many instances of indifference to other people's feelings, Bernini was acutely aware of social distinctions. On 25 August, when Chantelou told him that the Comte d'Harcourt ranked as Highness Bernini said, 'Jesus! I only addressed him as "Eccellenza".'

From an early stage in Bernini's visit Chantelou took it on himself to take him sightseeing to churches and private hôtels in Paris. The collections which he was shown were, in point of fact, far from being of the quality of the Roman ones to which he was accustomed. The French royal collection, which as a result of Colbert's exertions was soon to achieve a splendid combination of size and quality, was still small at the time, and not to be compared with that of Charles I of England. Two of the main inheritors of the latter by purchase – Cardinal Mazarin and Eberhard Jabach – had been resident in Paris. Mazarin was already four years dead and his collection split up, though some of the best things had passed to the King.

The Jabach collection, like the Château de Maisons, is frequently mentioned by Chantelou, but Bernini's efforts to see it were likewise continually being thwarted. Though always referred to by Chantelou as 'Jabach's drawings' it also contained important paintings. Eberhard Jabach was still under fifty at this time, but had long been one of the richest men in Europe. Like the Rothschilds in the nineteenth century he was a German (from Cologne) who had made a vast fortune as a banker in a foreign country (France), and at the time of Bernini's visit had recently been appointed by Colbert director of the newly formed French

East India Company. Like the Rothschilds again, and like most other new-rich, he was an energetic collector of works of art. When he was still in his twenties he had been painted by Van Dyck. The portrait is now at Leningrad. If, at the hands of the great flatterer, the resulting image seems ugly, as it does, we may yet be sure that it was flattering. The bloated young man dispenses, it is true, with jewellery and other ostentatious adjuncts, but the inappropriately aristocratic pose in which Van Dyck has cast him, with one hand on his hip and the other draped nonchalantly over the base of a pillar, does not hide the swagger or the ruthlessness, and the image in general remains unsympathetic.

Bernini and Chantelou were actually on the point of setting out to visit Jabach's collection early on the morning of 25 July. Mignard had undertaken to warn Jabach of their arrival, and one of the King's coaches, in which Bernini normally travelled, was already at the door. Then a message arrived to the effect that Jabach had gone to the country. Bernini was furious. He said, 'It is not just he. It is the fault of the nation. There is no punctuality in France.' Considering that it was to a Frenchman (Chantelou) that he said it, this remark is an extreme case of Bernini's rudeness. Chantelou merely replied, meekly, 'We are not all the same.' He might have added, but did not, that Jabach was hardly a typical Frenchman, or indeed a Frenchman at all.

The incident was referred to ten days later (4 August). The indefatigable gossip, the Abbé Butti, said it was Charles Le Brun, the court painter – who seemed to have resented Bernini's presence even before he saw him – who had deliberately prevented Jabach from showing his collection of drawings to Bernini. He was afraid, Butti said, that the Cavaliere would notice the ideas that he (Le Brun) had filched from them and incorporated in his own paintings. By the same token, Le Brun did not want Bernini to visit the Gobelins. Butti had been assured by the Italian painters that whatever was any good in Le Brun's work had been taken from Jabach's collection of drawings, and that the only way for Bernini to see them would be by saying as little as possible about it. Another attempt was nevertheless made to fix an appointment for the following Sunday. But on 10 August Bernini was suffering from an inflammation of the mouth and cancelled the visit. It was not until just before he returned to Rome – on 11 October – that he finally succeeded in seeing the Jabach collection. On that occasion he had the unusual experience of seeing two notorious rivals, Le Brun and Mignard, together.

In the course of his sightseeing of Parisian collections Bernini dropped two perceptive comments on Raphael. When looking at drawings belonging to the painter Mignard (6 July) Bernini revealed himself, slightly surprisingly, as spokesman of the cult of the unfinished in art, a theme which has been continually discussed since his day. On this occasion he said that Raphael's talent was so great that his first thoughts, expressed in his drawings, were among the most beautiful things in the world, and that in general drawings by the greatest masters were, in a way, more satisfying than the finished works. The other concerned Raphael's portrait of Pope Leo x (25 July). Bernini was looking at a copy of the picture *chez* Chantelou: the original was, and is, at Florence. Bernini remarked that Raphael was here working in the manner of Titian (he repeated this observation on 6 October). He admired the picture's truth to nature, the grandeur and beauty of its style and the treatment of the velvet and the damask, and said, 'This is Raphael's greatest and final style.' Modern scholarship would not entirely agree with Bernini. Though the portrait of Leo x is indeed a late Raphael, and though its technique is indeed astonishingly Titianesque, Raphael's last work of all, the *Transfiguration*, is not in his Venetian manner.

On two separate occasions – at the Carmelite church (16 July) and at Lefèbre's (9 August) – Bernini gave somewhat extravagant praise to pictures by Guido Reni, having just castigated Veronese and the 'Lombards' (in which term he included the Venetian school) for bad draughtsmanship. At Lefèbre's, in addition, he had offered to get Queen Christina of Sweden, a close friend of his in Rome, to buy the collection.

But the painter whom, during his French mission, Bernini praised most highly was Nicolas Poussin (he seems, oddly enough, not to have mentioned Poussin's great contemporary and friend, Claude Lorraine). Early in the visit (13 June) Bernini had spotted Poussin's altar-piece in the church of the Jesuit Novitiate in the Rue Pot-de-Fer-Saint-Sulpice, though the picture is far from typical. On his visit to the dealer Cérisier (10 August) he had praised the Poussins highly, and at Chantelou's own house, which, *faute de mieux*, he had visited on 25 July after being denied access to the Jabach collection, he had pored for a solid hour over Poussin's second set of the *Seven Sacraments* – painted for Chantelou himself some twenty years previously, and marking a peak in Poussin's work. Bernini on this occasion got down on his knees, changed

his spectacles and finally said, 'You have shown me the merit of an artist who makes me realize that I am nothing.'

This was going very far indeed for Bernini, and surprised Colbert when Chantelou told him of the visit (29 July). When Colbert commented, 'I had heard it said that he did not praise Poussin, nor Poussin him,' Chantelou told him how Bernini had said he had defended Poussin's early altar-piece of *St Erasmus* to both Guido Reni and Pope Urban VIII (later, on 8 September, Bernini claimed to have been responsible for getting Poussin the commission).

Despite the many tactless remarks which Bernini made in France there is plenty of evidence in Chantelou alone that he was not totally devoid of a sense of diplomacy. As he was indebted to and temporarily dependent on Chantelou, and as he must have known that Chantelou was Poussin's principal patron, the question arises to what extent his praise of Poussin was due to politeness. No definitive answer seems possible, though the praise which Bernini accorded to Poussin was so extreme as to leave little doubt that it was not *all* politeness. Whatever Bernini may have thought of Poussin when they were both in Rome – Bernini the spoilt and opulent darling of successive Popes, Poussin the ascetic and ailing recluse – his reaction in Paris suggests that the paintings which he saw there, and particularly Chantelou's set of the *Seven Sacraments*, had been a revelation to him.

This is surprising in several respects. Though there is no reason to assume that Bernini would have seen these pictures in Rome, since Poussin sent each one of the set separately to Chantelou as soon as he had finished it (which naturally had the strange result that he can never have seen them all together himself), Poussin's earlier set of *Sacraments* had been painted for Cassiano dal Pozzo, who, like Bernini, had been a member of the Barberini circle. It would have been surprising if Bernini had not seen them, but equally surprising if, having done so, he should then have been as much swept off his feet by the sight of the second set as he seems to have been. Finally his reaction to Chantelou's Poussins is surprising in another respect. The difference between their styles, Poussin's austere and intellectual, Bernini's exuberant, could hardly, as it seems to us, be more extreme; and this calls for some review of the difference between seventeenth- and twentieth-century attitudes.

To the twentieth century Bernini is the quintessence of the Baroque, and therefore the antithesis of classicism. This view may have approxi-

mated to that of Bernini's contemporary, G. P. Bellori, the influential writer on art, though he was too prudent to formulate it. But it was certainly not Bernini's view of himself. Concerning Antiquity there was no divergence of view between him and the more 'classical' artists, of whom Bellori approved. Both saw it as the fountain-head of excellence. Bernini regarded a thorough grounding in Antique art as the essential element in the training of young artists. During his time in Paris he repeatedly stressed that if they were led away by working direct from Nature at too early a stage they would never acquire the grand manner.

If Antiquity was the deity, then Raphael was its prophet and Bernini consistently emphasized his pre-eminence. According to Baldinucci, Bernini ranked Correggio second in his hierarchy,[103] and to judge by the results, Correggio actually affected him the more. But both Raphael and Correggio had died many years before Bernini was born, and it was considered that in the interval Italian artists had fallen from grace. In their efforts to achieve ideal beauty they had departed too far from Nature and had become self-conscious, mannered, cannibalistic. The one who had rescued them, turning their attention back to Raphael and the Antique, and achieving a just balance between them and Nature which led to true nobility of style, was Annibale Carracci. Thus far Bellori and Bernini were at one. Where they differed was in what happened next. Bellori evidently held the view that Bernini himself had gone astray and had led others with him. But Bernini considered himself both the heir to Antiquity and Annibale Carracci's successor. The mere fact that he was the leading artist in Rome would have encouraged him in the former view, while in any awkward pause in the conversation, if not expounding the plot of one of his comedies, Bernini would usually relate an anecdote about Annibale. He even boasted a tenuous personal connection. He was a boy of eleven when Annibale died in 1609 after a long illness, probably of neurotic origin. Nevertheless Bernini is said to have attached himself to Annibale's party during a visit to St Peter's, Rome. Annibale had said on this occasion that to complete the interior there should be conspicuous features both at the far end and under the dome. The adolescent Bernini thereupon vowed to supply these deficiencies. Within twenty years he had already achieved one of them – the baldacchino. The other – the Cathedra Petri – likewise eventually materialized, though not until the period of the Paris mission.

It therefore seems likely that if Bernini ever had doubts that two such

different forms of art as Poussin's and his own could both be the heirs of Antiquity he kept them to himself. If the subject had arisen, Bernini's reaction would probably have been that approximation to the Antique was a matter of degree, and that in this case there was also an element of nationalism. Poussin's art was not so much the antithesis of his own: it was rather the French way of doing it. If we compare the work of either with most contemporary Dutch pictures, which ignored the heritage of Antiquity far more completely, such a view may seem rather less far-fetched.

XII

DURING THE FIRST three weeks of July, when preliminary work on the bust occupied the foreground of Bernini's thought and activity, when the court was still at Saint-Germain and before a date had been set for its return to Paris, he continued working concurrently, with Rossi's help, on the subsidiary façades of the Louvre. The necessity for these, which had not been faced until this point, arose from the realization that the style of Bernini's new east front would clash with that of the existing buildings. The problem is succinctly explained in a long memorandum from Colbert, mainly devoted to the desirable internal arrangements of the palace.

It would only remain [this document states] to render the other façades of the Louvre rather more in accord with the design for the huge and magnificent façade which the Cavaliere Bernini has made, and this can be done by raising the walls somewhat, and giving them a balustrade ornamented with figures, which will also have the desirable effect of concealing the roof. [It will be noted that Colbert characteristically supports the idea of the terraced roof, not on account of its greater effect of majesty but for practical reasons.] It will therefore be necessary, since it has pleased the King to commission it, to make another façade on to the Cour des Cuisines, and to double the *corps de logis* in order to create apartments for the King and the guard.[104]

The Cour des Cuisines was the space to the west of the west wing of the Cour Carrée, facing towards the Tuileries. Bernini's new east wing was to be located farther east than Le Vau's, and separated from what there was of the latter by a narrow courtyard. On the west Bernini was

proposing similar treatment. Both his new outer wings were to be connected with the old inner ones by short, thick arms which would have provided enormous rooms on the *piano nobile*. Until the middle of the eighteenth century small buildings extended right up to the line of the present east façade. It was in fact their presence, and the expense of demolishing and compensating for them, which was always alleged as one objection to Bernini's project for extending the Louvre in this direction.

P. Clément's great edition of Colbert's writings, which prints this memorandum, was published before Chantelou's journal appeared in print. In consequence the conjectural dating of the document by the editor – to the year 1664, when Bernini was still in Rome – can be seen to be wrong, but it has nevertheless misled some later critics, and the memorandum has never yet been correctly dated. Mirot spotted that Clément's dating was wrong, but associated the memorandum with a reference in Chantelou dated 13 August 1665. Wittkower pointed out that it must date from after 20 June, when both Chantelou and Rossi noted that the King commissioned the Cour des Cuisines façade, but assumed that it was written before 1 July of the same year, when Bernini finished his drawing for that façade. Neither of them seems to have noticed that the recurrence of certain phrases in the memorandum – *une grande et superbe bibliothèque* or the climate of France giving *que quatre ou cinq mois d'été* – in Chantelou's précis of a memorandum which he says Colbert handed to Bernini on 19 August leaves no doubt that the two were the same. More will be said about this memorandum later.

The other two designs followed in astonishingly quick succession: the courtyard elevations on 11 July, and the design for the south, or river façade (which was to be repeated on the north side, facing the Oratory), on 19 July. On 15 July, in response to Colbert's plea for a *place* opposite the east façade, Bernini drew with a compass on the floor a distance with a radius one and a half times the height of the façade. He explained that as the sacrosanct church of Saint-Germain was to the side it would be possible to include a broad approach road opposite the centre of the façade. He showed Rossi's finished drawing for this *place* to the King after the first live sitting for the bust on 11 August. By this time it had become oblong rather than semicircular, as Chantelou had noted on 8 August. The memorandum which Colbert handed to Bernini on 19 August adumbrated a new stone bridge to replace the Pont-Rouge, as

well as a large square *place* on the south side of the river, with a monument to the King in the middle. But no more was to be heard of this, at least in that form.

This was almost the end of Bernini's creative work for the Louvre, though there were still to be plans for various adjuncts such as an amphitheatre and a chapel. In addition, work started in August on a scheme for lowering the *piano nobile* and therefore the overall height of the building. This led to what has commonly been referred to as Bernini's fourth Louvre project, but it was in fact only a variation on the third.

As long as Bernini's plans were confined to the original project, primarily the east façade, where there was little pre-existing building, the question of the King's expressed preference for preserving the work of his predecessors did not seriously arise. It did arise when Bernini was commissioned to redesign the west and south façades, where the buildings existed already. Bernini's own memorandum of 9 June (above, p. 38) shows, even if in curiously veiled and unspecific language, that he had already taken the King's hint, and in a letter of 24 July Rossi expatiates on the court's delight in all Bernini's Louvre designs, and particularly that 'nothing of the old building would be touched or spoilt'. This is indeed borne out by the designs themselves, and is of particular interest in the light of later developments. For what Bernini was proposing for the Louvre – to encase the old buildings with his new ones – is in principle what Le Vau was to do at Versailles, where he wrapped the *enveloppe* round the château of Louis XIII, as the King did not wish to destroy it. Once again it looks as though Le Vau had taken a hint from the rival whom he hated.

But even if Bernini planned to hide the older buildings in the Cour Carrée there remained the Petite Galerie, and the Grande Galerie to the west, which would still be visible. Here clashes both of style and scale were inevitable, and here Bernini ran into trouble with Colbert as soon as he presented his plan for the west façade. This time there can be no doubt that Colbert's objections were not spontaneous. Indeed, Perrault boasts of his intrigues to this end. Bernini, Perrault writes,

was given an excellent room in which to prepare his drawings, where no one was allowed to enter, apart from himself, M. de Chantelou and M. Colbert. After a fortnight or thereabouts, the Sieur Fossier, who had been instructed to supply the Cavaliere with whatever he might need for his drawings, told me that if I wished he would show me the Cavaliere's drawings. I accepted his offer

and was shown the drawings on the following day. M. Colbert asked if I had seen them and I said No. I swear this is the only time when I failed to tell the truth to this minister. 'It is on a very grand scale,' he told me. 'There are doubtless some isolated columns,' I suggested. 'No,' he said, 'they are attached to the walls.' 'The entrance is presumably very big,' I insinuated. 'No,' he answered, 'it is no bigger than the existing door into the Cour des Cuisines.' I added something else in the same vein which made him volunteer the information that Bernini had made the same mistake as M. Le Vau and most of the other architects. It was in this way that I pretended not to know the Cavaliere's drawings, my criticisms being likely to have more force if I had not seen them than if I had. In addition, I should probably not have dared to speak my mind so freely.[105]

Slightly later Perrault admits that while the court was still at Saint-Germain he wrote a memorandum for Colbert on the faults of Bernini's design.[106] Some of this may have found its way to Colbert's memorandum of 19 August, which included the remark that Bernini's proposals for the King's accommodation would leave him no better housed than at present, despite enormous expense.

Though Perrault is not precise about when these unedifying episodes occurred, and though he evidently said more to Colbert than even he would admit, he obviously thought that he had succeeded in turning Colbert against Bernini; while Chantelou's account of the interview on 1 July leaves no doubt that by then Colbert was indeed prejudiced:

My brother and I [Chantelou writes] went to the Tuileries to wait on M. Colbert, who was due there. When he arrived we accompanied him round the building. In the gallery at the end of the Grande Galerie he asked me what the Cavaliere Bernini had been doing. I told him he had been working on the back façade of the Louvre. He then asked if he had made it as lofty as the east front. I said he had. He replied, 'In that case it will not be good.'

Only then did Colbert go to Bernini's office. As soon as he saw the new drawing he said it was the same as the front one. Bernini replied that in fact there were many differences, and to prove his point he had the design for the east front brought out. Colbert then spoke of the height of the new façade. 'It should be so planned', he said, 'as to accord with the existing buildings to which it will be adjacent, and which would seem low in comparison. On the other side there are no such problems.'

Bernini replied acidly, 'There are no problems on either side. The galleries are like the arms in relation to the head. They ought not to be as high as it is. In any case, the summit of the roofs of the old buildings will be as high as the new one.' Here he took a pencil and demonstrated on paper what he was saying. He went on to explain that he had had similar problems at St Peter's, where, after consultation with the Pope, he had constructed two wings which made the façade seem higher, even though it was not. He assured Colbert that the same would be true at the Louvre and emphasized that architecture consists of proportions derived from those of a man. For that reason sculptors and painters made the best architects.

Bernini's defence was sound as far as the question of scale was concerned. In a complex building there is no reason why the centre block should not be higher than the wings, and some reason why it should. He was also right to stress that his design for the west façade was quite different from the east. While the latter remained a solid cliff the new design for the west façade had open arcades throughout its central section. Colbert's failure to recognize the difference was a telling indication of his limited visual sense, which was to be demonstrated again later.

On the other hand the clash of style between Bernini's grandiose Roman Baroque, with its colossal order, and the tentative French Renaissance style of the Petite Galerie or the Grande Galerie, with their high-pitched roofs, was more serious. Here the abrupt transition, which is illustrated in Marot's print of Bernini's south, or river façade, would have been similar to the one which exists on the south front of Hampton Court, where the Wren wing meets the Tudor building and towers over it. It is difficult to avoid the conclusion that both Bernini and Wren tolerated the situation on the assumption that the juxtaposition would merely underline the superiority of their own contributions.

When Chantelou told Bernini he thought the new west façade was more beautiful than the east Bernini agreed. But he took the line that he himself deserved no credit for the transcendent merit of all his Louvre designs. Quite the contrary. He was the humblest of mortals. The explanation was simple. God, not he, was responsible. When Bernini said the same thing on 11 August, the Abbé Butti said he assumed that it was also God who provided Bernini's critics with distorting spectacles which prevented them from appreciating the divine work.

The arches, which were the distinctive feature of the design for the west façade, were also prominent in the courtyard elevations. In both cases the two-storeyed arcades were separated by a colossal order of half columns. It might be difficult to find a precise prototype for this, even in Italy; but Bernini had proposed it for the east façade in both his first and his second schemes. We also know that in the first he had envisaged staircases in the eastern corners of the Cour Carrée, as he now did in respect of all four corners in his new plan. Evidently he was attached to these and reluctant to bury them.

We have, indeed, his own word to that effect. On 8 July Colbert was shown the design for the courtyard elevation. Bernini, who was still working on it, said he was very satisfied with it. He hoped that the execution would do justice to his ideas. There would be nothing like it in Europe. Two days later Chantelou found him shading the drawing. Bernini said several times that the distribution of light and shade required great care. Casting away false modesty he declared that all the other drawings which he had seen up till now only made him appreciate the more the grandeur and beauty of his own. He had told Colbert that he hoped to have the courtyard drawing ready for the following Sunday (12 July); also the one for the river front, which the King had already asked for twice. In the event only the courtyard drawing was ready then. The King told Bellefonds to show Bernini's drawing to the Queen. Bellefonds also took it on himself to show it to Louise de La Vallière, the King's current, and rather self-effacing mistress, but even the King had to wait until 19 July before seeing the design for the south, or river front.

This is the oddest of them all, and it was Perrault's adverse criticism of it, to Bernini's face, which was to spark off the great row between them on 6 October. Here on the south Bernini encountered problems which had not arisen with the east and west façades.

The difficulty sprang from the fact that Bernini's new east and west façades did not, as we have seen, coincide with the existing east and west ranges of the Cour Carrée, being situated farther out on either side. Inevitably this arrangement upset the symmetry of the outer façades on the north and south sides, which in theory Bernini was only refacing, and not rebuilding. Looking at the south front from the river, the new extension towards the west – that is, on the left – would have been largely hidden by the short end of the Petite Galerie and by the western extremity of the Grande Galerie. But on the right it would visibly extend

farther east than the eastern end of the existing wing. Its old centre, marked by a square dome, would therefore no longer be in the centre of the new façade (Colbert had made the same point when Bernini had proposed an oblong courtyard in his second scheme, and a comparable difficulty emerged at the east façade when, after Bernini's departure, the south range was 'doubled' towards the river). The centre dome, and the flanking pyramids or caps, would, in any case, have to go – if only to allow for a new top floor which Bernini planned. But some asymmetry remained. Bernini therefore opted for balance. On the right, a broad projected area replaced a small pavilion and balanced the mass of the existing Petite Galerie and the adjoining pavilion. In between were two unequal projections: a broader one on the right which had been the old centre, and a narrower one on the left, which was the old left hand pavilion.

The time was now ripe for some practical work to begin. As early as 26 June, as the Nuncio reported,[107] Bernini, distrusting the French masons, had sent to Rome for three craftsmen. Rossi was then set to work to take measurements, in the course of which he and Bernini discovered what Bernini called the 'false right angle'. And the question of which houses would have to be demolished began to assume major importance.

The background to Bernini's decision to send for the three Roman craftsmen was explained by him on 19 July.

I am experiencing great difficulty [he said to Chantelou and Butti in the coach on their way to Saint-Germain] with the choice of materials for the Louvre. I have spoken with stuccoists both in Rome and Paris who have told me it is possible to construct the vaults and the decorative work in mortar, as we do it in Rome, rather than in plaster, but no one here wishes to contemplate it. They are unwilling to go to the trouble of undertaking something new or to depart from their established practice. I have heard some of them say that to work with mortar would cost too much, and I have replied that we are dealing with those to whom expense is immaterial. They have then said it would take too long. To that I responded that there was no hurry. At last they said it was impossible. It was this that made me wish that those I have summoned from Rome would soon arrive. There are certain experiments to be done which I cannot undertake myself, things of so lowly a nature as to be outside my competence. If indeed I were to apply myself to them it would be as though the King were to grant an audience to an unhappy widow over a question of a few

farthings, and were to lose thereby the time which he should devote to affairs of state and others.

When they reached Saint-Germain Bernini repeated the substance of this discourse to Colbert, who said he had already given written instructions that the three masons should be brought to Paris as soon as possible and at any cost. Bernini went on to discuss the advantages of a lighter kind of brick and of the possibility of using pozzolana and other materials.

In admitting to Chantelou, and to Colbert's brother-in-law, Monsieur de Ménars (23 July), that Padre Oliva had told him he had a duty to go to France even if it killed him, Bernini volunteered that he had recently written to Oliva, as well as to Cardinal Chigi, Cardinal d'Este and another. And by another of the chances whereby almost all the vital documents concerning Bernini's mission are preserved, we actually have two of these four letters, as well as Cardinal Chigi's reply to the one addressed to him.

The text of the letter to the Duke of Modena, in which Bernini mentions twice that he is destroying nothing, or 'almost nothing', of the existing Louvre building, was published by Fraschetti.[108] The letter to Cardinal Chigi, though Mirot printed a short extract,[109] appears to be still unpublished in its entirety, but constitutes, in effect, a summary of Bernini's activity in France to date. It reads as follows:

I trust Your Excellency will pardon me in that I have not done my duty. Nevertheless I have always sent my regards through my son who takes my place to the best of his ability. But since my conscience is now too heavy I wish at least in part to atone for my shortcomings. The plans for the palace of the Louvre are now finished. So far as it is humanly possible to judge these things, the King is highly satisfied, and is awaiting impatiently till a start can be made. This will be done as soon as the craftsmen arrive who are coming from Rome on my orders. In the meantime we are working on the drawings for the [?] internal disposition and its architectural adornment (*li disegni delli spaccati e delle modanature*) which is necessary for the work to proceed. The great satisfaction which has come to the King in this way is due entirely to the special assistance which the Lord God has given, and continues to give me.

I have started his [the King's] portrait in marble, but of the three blocks which I have tried I am not sure if any will prove satisfactory; because as you know, to make portrait busts it is necessary to have marble of the finest quality, and here it is unobtainable. I am making myself ill by working in spite

of this restriction, both because it is my nature to do so and because I wish to return to finish the works I have in hand in Rome. But unless God gives me special assistance I fear that by attempting more I may achieve less. I beg Your Excellency to do me the favour of sending my respects to the King, or rather to that mighty spirit. For the King really had extraordinary qualities of spirit in that he is able to appreciate the best works of art, even though he has neither studied architecture nor seen good examples of it, and whereas I was afraid I had aimed too high in my plans for the Louvre, he is constantly ahead of me. And indeed, in magnitude and splendour the building will be the greatest palace which was ever made. Yet this does not frighten him, and if it is possible to diminish time by means of money it will indeed be done. And if you hear it said that good taste does not exist in Paris you will now have evidence to the contrary. I may be at fault in requesting Your Excellency to continue your protection of my family's interests and in particular of my son, but because you have done it so much I put myself at fault by requesting it.... Paris, 22 July 1665.[110]

The idea of Bernini, writing from France, begging his correspondent, in Italy, to pay his (Bernini's) respects to the King of France may perhaps be seen as an indication of the lengths to which he was prepared to go to please persons in authority.

Bernini's letter reached Rome in record time. Cardinal Chigi's reply is dated 4 August – only thirteen days later.

I am infinitely delighted that you have made so fine a design for the Louvre and that it has pleased His Majesty so well. The fact that he has perfect taste renders more estimable the approval which he has given. I appreciate that you are executing the portrait of the King, but I am distressed at the lack of suitable marble, albeit your skill at handling all kinds of marble should be equally apparent. I trust that the making of this portrait will not lead you to overstay the limit of time conceded by our Master, since, deprived of your presence it is not only the buildings which suffer here, but all of us also, being denied your conversation. The façade of my house proceeds satisfactorily under the direction of your brother, Signor Luigi. I am able to give you the best report of your son....

At this time the Cardinal was still only thirty years of age. He added a postscript in his own hand consisting of polite trivialities.

One other development at the Louvre at this time is not mentioned by Bernini in his progress report. It was the re-emergence of Le Vau. This could be compared variously with the snake in the grass or the mole undermining the house. Though Le Vau's intervention, which will be

discussed later, was still only incipient at the time when Bernini was writing his letters, it still drew no reaction from him when it was discussed shortly afterwards. His normal mixture of arrogance and self-confidence, resting on a lifetime of almost unparalleled success, could be merged, at the rare moments of crisis, with a degree of reticence of which people who only knew him superficially would probably have considered him incapable. One who did perceive this trait was none other than the young Christopher Wren, then on a visit to Paris. His own account of the one point of contact between two of the greatest Baroque architects, whose combined lives extended from the end of the sixteenth century until long after the beginning of the eighteenth, has often been printed but is worth repeating. 'Mons. Abbé Charles', Wren wrote, 'introduced me to the acquaintance of Bernini who showed me his designs of the Louvre and of the King's statue.... *Bernini's* Design of the *Louvre* I would have given my Skin for, but the old reserv'd *Italian* gave me but a few Minutes View; it was five little Designs in Paper, for which he hath receiv'd as many thousand Pistoles; I had only Time to copy it in my Fancy and Memory; I shall be able by Discourse, and a Crayon, to give you a tolerable Account of it.'

This meeting between Bernini and Wren, thirty-four years his junior, is tantalizingly briefly recorded in this letter to Wren's friend, Dr Bateman, which is only known from its printed form in the book called *Parentalia*, a compilation of family records published by Wren's grandson in 1750. The encounter is not precisely dated, though it cannot have occurred before 19 July when Bernini's design for the south façade was finished. Wren's mention of payment to Bernini specifically for his Louvre designs is not corroborated. Among other uncertainties there is no indication of what language was spoken – whether an interpreter was used, whether Wren had some Italian or whether both spoke in Latin. This would have been normal among learned men in the seventeenth century, but the possibility of Bernini's being able or willing to speak it is apparently never discussed by Chantelou, who, incidentally, makes no reference to the encounter with Wren and can therefore not have witnessed it himself. Above all, the instigator of Wren's introduction – 'Mons. Abbé Charles' – has hitherto defied identification. He was evidently a cleric who had access to Bernini, and we only know two who fulfil both those conditions. One was Butti, whose christian name was François, or Francesco,[111] the other was the Nuncio, Monsignor Carlo

Roberti de' Vittori.[112] If it were he, the inclusion of the word 'Abbé' would be surprising (even if 'Mons.' were to stand for 'Monsignor' and not 'Monsieur'), though perhaps less so on the lips of an Englishman and a Protestant.

Le Vau's continued activity on the Louvre building is first mentioned by Chantelou on 15 July. He was then working on designs for the completion of the Grande Galerie. This did not impinge on Bernini's sphere. Nevertheless Chantelou himself was evidently already ill-disposed towards Le Vau, and on 30 July he reported, in even more minute detail than usual, what must have been a remarkable morning.

Chantelou had started the day by calling on Colbert at six o'clock in the morning. He waited there for three hours before Colbert appeared. During this long wait he got into conversation with others in the ante-room, one of whom whispered to him that there was opposition to extending the Louvre as near to Saint-Germain-l'Auxerrois as Bernini was proposing to do. The existing building, it was said, was going to be left as it was, and the new building would be according to an entirely different design. Chantelou said he made no comment beyond pointing out that it was the Cavaliere Bernini who was in charge, and that what his informant had said was irresponsible tittle-tattle. Nevertheless he records that only slightly later Monsieur de La Motte, one of the Intendants des Bâtiments, took him aside and confided that Le Vau had made a new design. The new Louvre would be in the Cour des Cuisines. The existing building would then serve merely as forecourt where important officials would be accommodated.

In the middle of this conversation Colbert finally appeared. He walked quickly through the ante-room and out of the front door, motioning Chantelou, as he went, to follow him into his coach. He picked up Le Vau, Charles Perrault and one other at the same time. It was an ill-assorted party, and must have been a depressingly embarrassing occasion. Apart from other considerations Colbert was evidently in a bad or at least early-morning temper. As they headed towards the Hôtel de Frontenac there was silence in the coach for a long time. Finally Colbert said to Chantelou, 'I have no information whether or not the Cavaliere Bernini has had measurements taken for the open space before the Louvre. It should be big enough to accommodate military exercises.' Chantelou said nothing. After another pause Colbert added, 'We shall run into difficulty over the houses which must be demolished before the

foundations are laid. They can only be commandeered in accordance with the rules.'

By this time the coach had arrived at the Hôtel de Frontenac. A servant came out and said Bernini was already at work at his studio in the Louvre. Colbert and Chantelou went on there, and as Colbert entered the studio Chantelou noted that he adjusted his expression to a smile. He was evidently adept at this: on 12 September he entered Bernini's room wearing what Chantelou called his usual smile, but on hearing of the illness of Bernini's wife he hastily switched to a more appropriate expression. Bearing in mind Madame de Sévigné's inspired description of Colbert as 'the North' such first-hand evidence of his rare foibles is the more welcome. A comparable incident occurred on 28 August. Colbert arrived at Bernini's lodging unexpectedly in order to show off the insignia of the Saint-Esprit which the King had just given him. Unfortunately it was Bernini's siesta hour. Colbert was magnanimous enough not to insist on waking him.

On the present occasion Colbert looked for some time at the bust. Bernini, who had been working on the hair, then broke the silence. 'The Ancients', he said, 'always carved this feature so that the hair appeared light, but though I try to imitate them I am not succeeding.' This, in the circumstances, was probably fishing for compliments. But Colbert in his present querulous mood was not falling for it. He drew Chantelou aside and asked him to tell the Cavaliere that he, Colbert, was worried about two things. One was the space in front of the Louvre, which had to be big enough to contain all the guards regiments, the light infantry and the gendarmes, and also to serve for battle exercises. The other was to define the alignment of the foundations precisely so as to determine which houses would have to be pulled down. He realized that they could not keep the Cavaliere after October. It might take some time to evict the occupants of the houses. It was not feasible to initiate major developments at short notice. He did not know how such things were conducted in Rome, but in France they were not done like that. In addition to everything else there was the problem of the Petit-Bourbon. The King's furniture was in store there. If it was to be demolished there was nowhere else to put the furniture.

Chantelou translated some of this to Bernini, who had evidently formed his own opinion of the sense of the rest. He replied calmly that it had not been possible to do the work on the foundations sooner. Rossi

had been engaged on it ceaselessly, but when he took the measurements he had found what he called a false right angle. It would be necessary to remedy this. It was only a matter of one and a half palms, but this would be enough to throw the enfilade of the doorways out of alignment. The trouble lay in the fact that the south range of buildings on to the Cour Carrée met the west range, and the Petite Galerie, at an obtuse angle, and not at a right angle. Consequently the entrance in the middle of the proposed new east façade would not be precisely opposite the one in the centre of the existing west range. Taking his cue from Colbert's sententious disclaimer of knowledge of how affairs were conducted in Rome, Bernini declared that it was a surprising complication to discover so fundamental a shortcoming as this in a palace of the importance of the Louvre. As an afterthought he said that if not remedied it would even affect the staircases which he was proposing to build in all four corners of the courtyard. The whole thing was a dead weight on his stomach. To get rid of it he had sweated blood, but God had just removed it for him. He had put it right in such a way that it could never trouble him in future. He said nothing about which houses would need to be demolished.

Colbert now tried another ploy. He pointed out that a particular reason for haste was that the foundations should be laid before the rainy season set in. If this were missed (and this time anyone might well have concluded that Colbert was speaking of the tropics) they would have to wait until June of the following year, as the river was so near to the Louvre. This would be tiresome, Colbert opined. Bernini was hardly in a position to contest such an exaggeration, and when pressed again by Colbert concerning the houses he switched the conversation to the question of future sittings by the King for his bust. He ended, for good measure, with an encomium of His Majesty's intelligence. Colbert was naturally forced to cap this, which he did somewhat equivocally. He remarked that the members of the privy council were astonished every day by the things the King said. At that point Colbert wound up an awkward morning's work by leaving the room and re-entering his coach.

For several days after this Bernini continued muttering about false right angles (he found one, and pointed it out, on his visit to the Temple on 2 August) while further reports came in about Le Vau's machinations. On 4 August Le Nôtre himself told Chantelou that Le Vau had had his

design shown to the King, and on the following day one Bartillat announced that Le Vau was saying that his own drawing was the finest in the world. At this point Colbert's old dislike of Le Vau had the effect of making him rally to Bernini's support. He countered Le Vau's pretensions by remarking that the Cavaliere, who was, after all (he said), the leading artist of the day, spoke of his own designs, which were marvellous, with extreme modesty, which went to show the difference between him and Le Vau. Despite this, rumours were circulated (6 August) that the King, in whose make-up melancholy was said to dominate, had cooled off Bernini's designs. Chantelou countered this by denying both this estimate of the King's nature (though later – 7 October – he was to make the same point himself) and his present mood. It was evidently as well for Bernini that the court returned to Paris five days later.

PART THREE

The Court in Paris

XIII

THE RETURN OF the court to Paris on 11 August 1665 marked, in the
event, more than one milestone in Bernini's visit. It occurred, in the first
place, nearly in the middle of it in time, and it also coincided with
important developments in his two major commitments. With the bust
he was just ready for the live sittings; and at the Louvre, opposition to
him, consisting of the superseded architect, Le Vau, the painter, Charles
Le Brun, and Colbert's assistant, Charles Perrault, with support in the
background from eminences such as the Maréchal de Gramont, seemed
to be gathering force. In the two and a half months remaining to Bernini
in France it was up to him to crush opposition at the Louvre and get the
foundation stone laid. Then he could return to Rome in his accustomed
role of conqueror.

The success of the bust was a foregone conclusion. Bernini's absolute
supremacy in this line was incontestable, even in France. At the Louvre
the situation was far more perilous and uncertain. Despite support from
the King, shipwreck seemed near on several occasions, and never more
so than on the eve of Bernini's departure. Faced with an emergency
Bernini thereupon improvised brilliantly, and rose to heights which
astounded and delighted Chantelou. In the event he left Paris loaded
with honour, though this was to be diminished in the sequel with every
year that passed.

The court's transfer to Paris caused fundamental changes in Bernini's
way of life. He and his party were moved from their archaic quarters at
the Hôtel de Frontenac to the more luxurious but less convenient setting

of the Palais Mazarin. The general atmosphere of Paris changed from relative relaxation to hubbub, and this affected Bernini personally. As the King was coming to the Palais Mazarin for sittings almost every day Bernini's freedom of movement was severely restricted, not only by the fact of the sittings – which sometimes interrupted or prevented his siesta – but, even more, by uncertainty on some days whether the King was coming or not.

The live sittings got off to a lively start, as we have seen, with the first of the series on the afternoon of the very day of the King's return (11 August). Bernini was understandably flattered that the King had come straight to the sitting, and mentioned it to Michel Le Tellier and de Lionne next day. Louis' own enthusiasm for the project could not have been demonstrated more convincingly. We must bear in mind that by this time Bernini himself had already worked on the marble for ten days, and that the bust was already considered a good likeness.

Only about half a dozen courtiers, including Colbert, had accompanied the King on this occasion. Bernini made him lean against the back of a chair. After a time he took the chair to the other side of the bust and started again. The King raised no objection. He remained stationary for some time, and then told Bernini he must go, but that he would return whenever he was needed. Bernini then asked him to look at his plan for the space in front of the east façade of the Louvre.

When Le Tellier and de Lionne called next day Bernini explained the chalk marks which he had drawn on the eyeballs of the bust. At the end he would give the marble a few taps in those areas. The shadows would then represent the irises of the eyes. The visitors for their part took pleasure in explaining to Bernini the reason for Colbert's rather unexpected presence at the sitting on the previous day. It was in order to impress the King with his devotion to duty.

Bernini then spoke of the object of the live sittings, enlarging on what he had said to Colbert about his methods (29 July).

As regards the face [he said] it is for the King and myself to finish the work. He has put me in the state where I see him in my mind's eye, in the image which I have formed and printed on my imagination. I have drawn him in council, as you have seen, and speaking in his natural manner without having to keep still or submit to anything. If I had not done this, or if I had sketched him seated, he would have appeared constrained, and the image would have lacked vivacity. Since then I have not even used my drawings, not wishing to copy my own

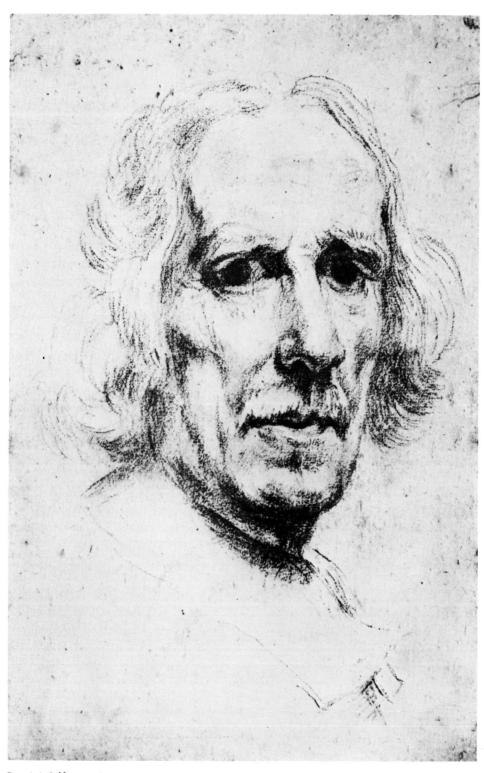

Bernini, Self-portrait, *c.* 1665

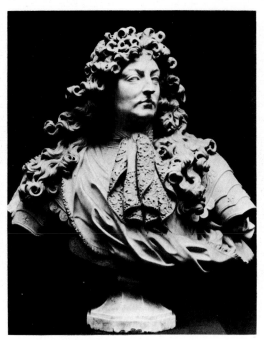

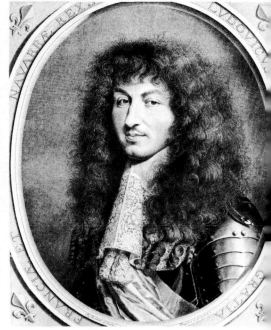

Coysevox, marble bust of Louis XIV Nanteuil, engraving of Louis XIV

Le Brun, meeting of Cardinal Chigi and Louis XIV

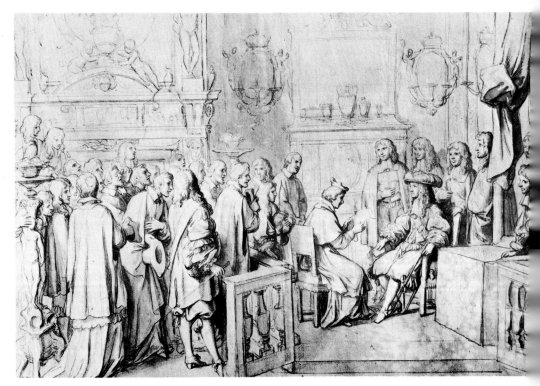

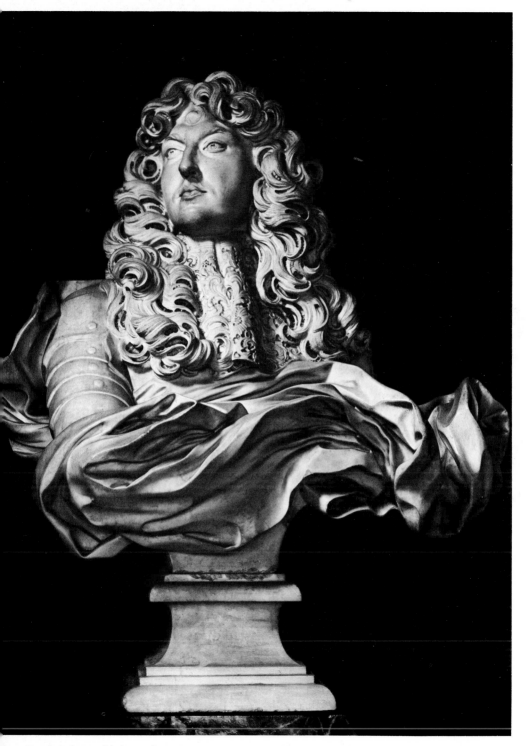

Bernini, the marble bust of Louis XIV

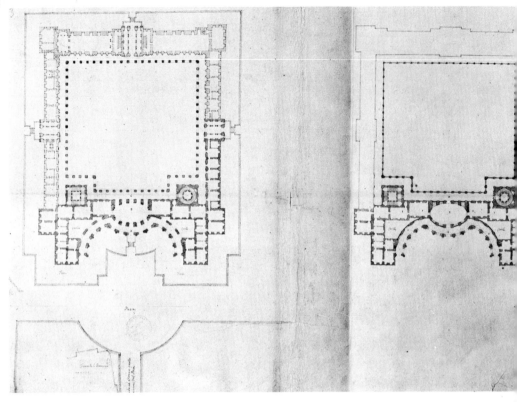

Bernini, Louvre, First project, plans for ground floor and first floor

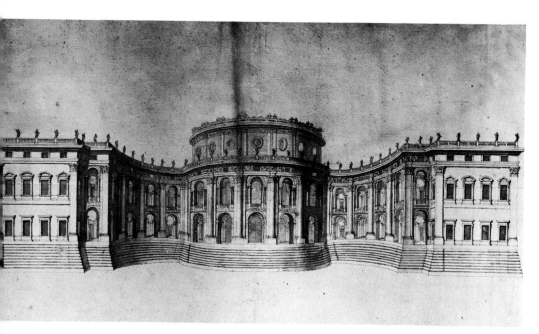

Bernini, Louvre, First project, design for east façade

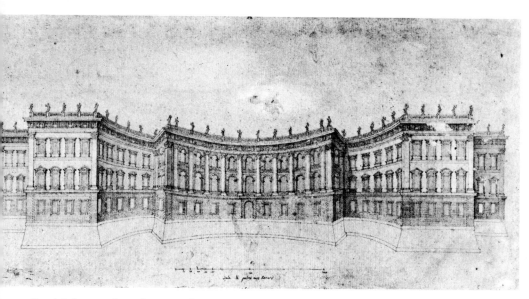

Bernini, Louvre, Second project, design for east façade

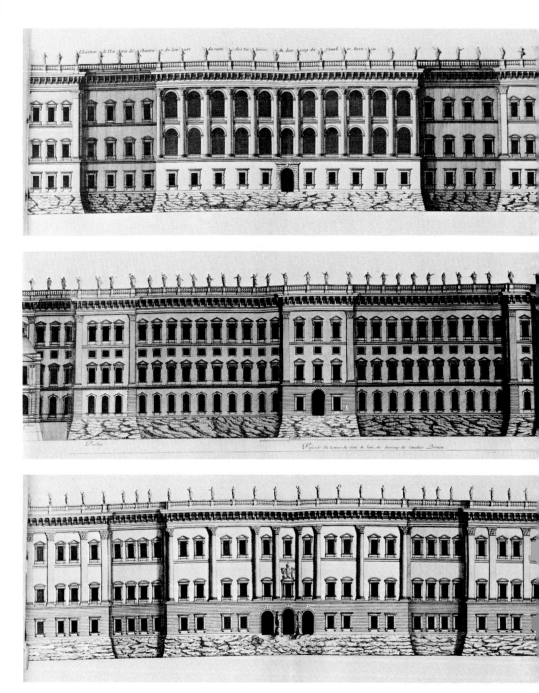

This page and above right Bernini, Louvre, Third project, engravings by Marot of designs for west, south, east and courtyard façades

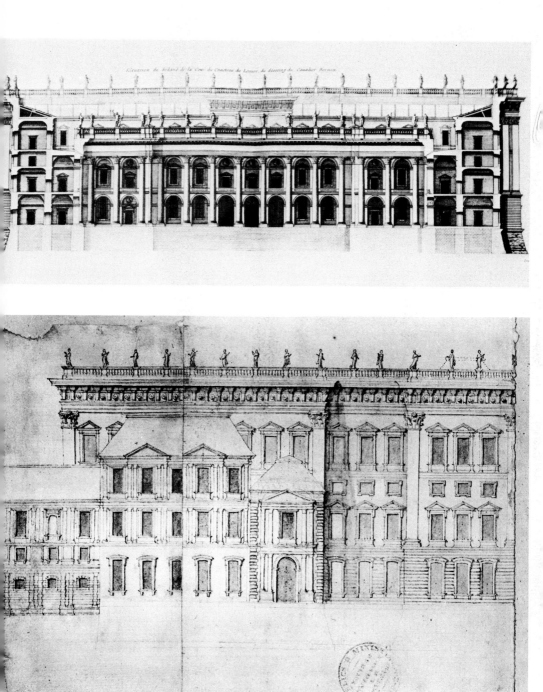

Bernini, Louvre, Third project, design for junction of south façade with a then-existing building

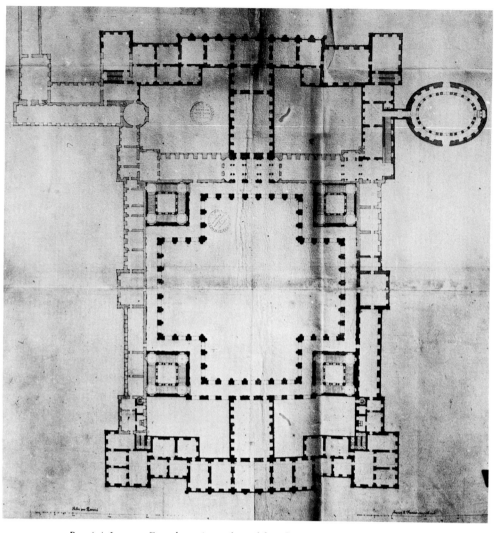

Bernini, Louvre, Fourth project, plan of first floor, including oval chapel

Bernini, Louvre, Fourth project, east façade

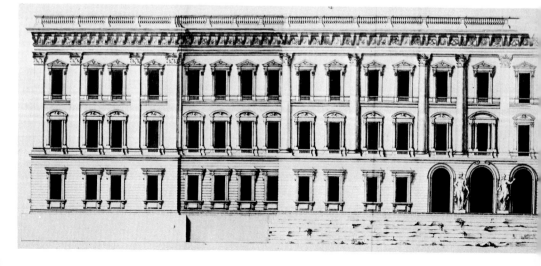

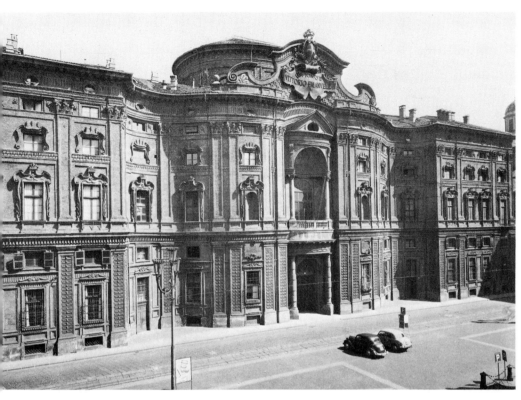

The Palazzo Carignano, Turin, designed by Guarini, *c.* 1679

The Royal Palace, Stockholm, rebuilt by Tessin

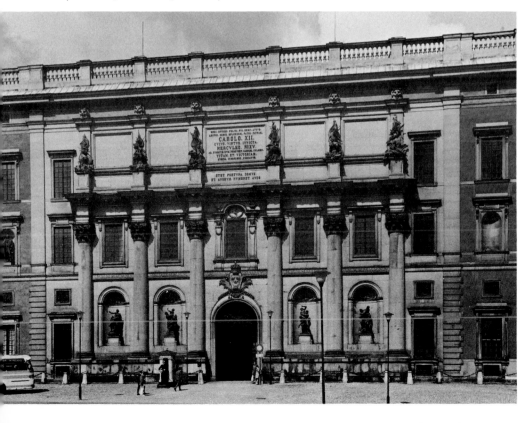

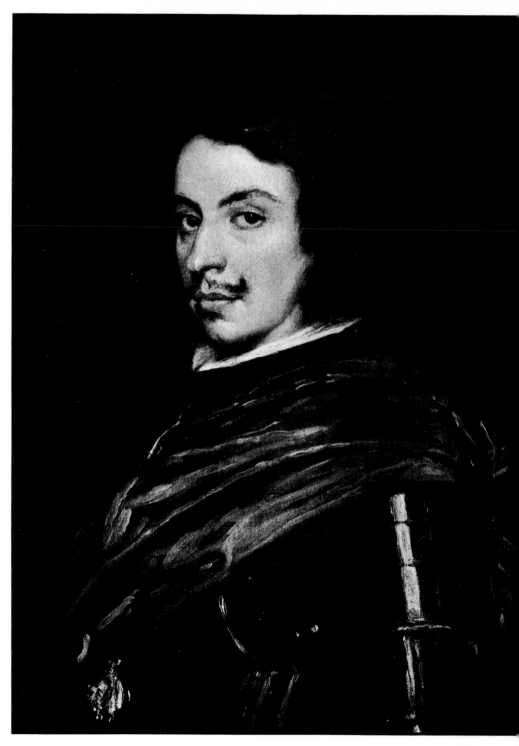

Velázquez, Francesco d'Este, c. 163

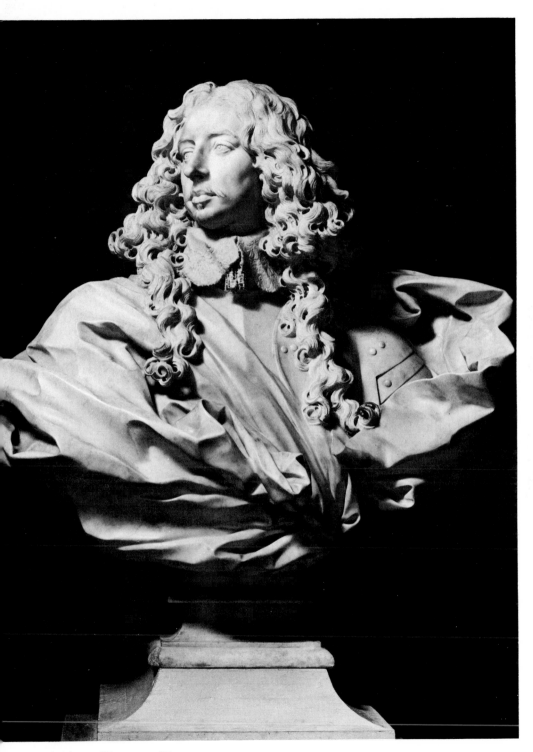

Bernini, bust of Francesco d'Este, *c*. 1650

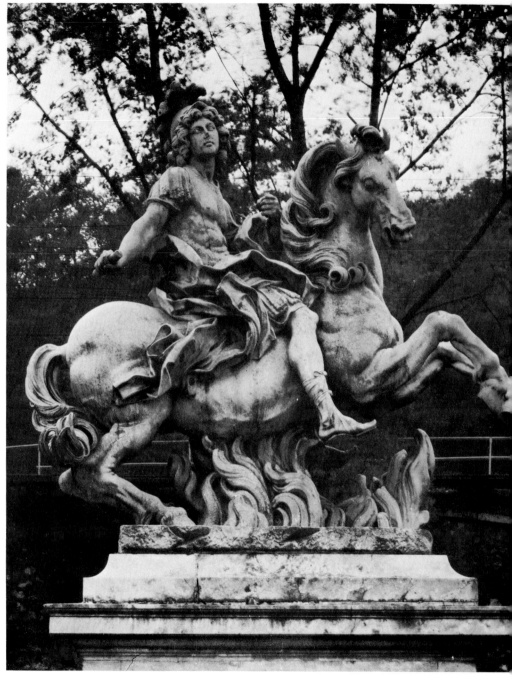

Bernini, equestrian statue of Louis XIV

Above right Bernini, terracotta for the equestrian statue of Louis XIV

Right Bernini, equestrian statue of Constantine

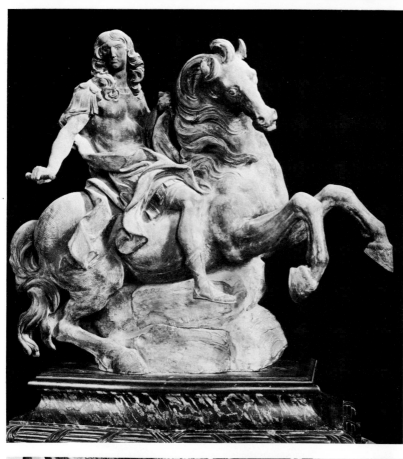

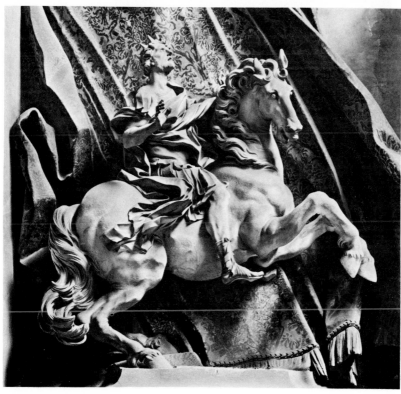

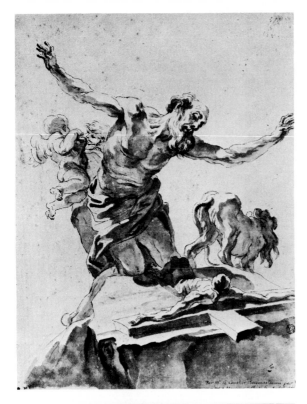

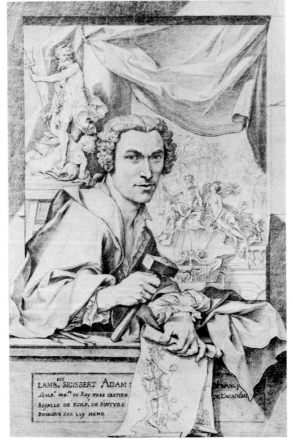

Bernini, St Jerome in Penitence

Lambert-Sigisbert Adam,
Self-portrait

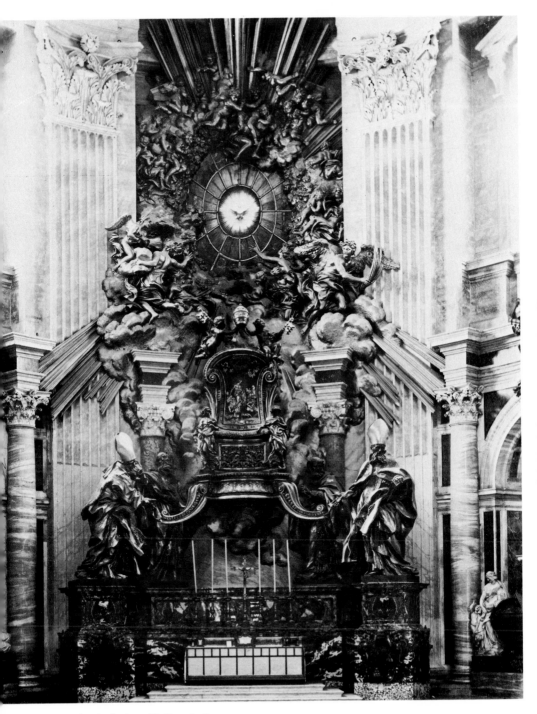

Bernini, the Cathedra of St Peter's, Rome

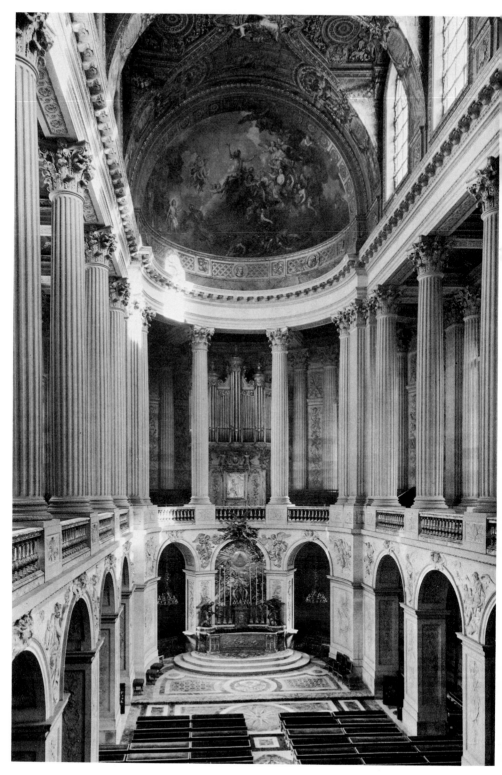

Interior of the Chapel, Versailles

work but to create an original. They were only made in order to saturate me with the image of the King.

He stressed again the difficulty of portrait sculpture and repeated that Michelangelo had never been willing to undertake it.

Bernini had said in advance that he would need twenty sittings of two hours each. In the event there were only thirteen sittings (though both Bernini and the King were occasionally confused regarding how many there had been). Chantelou specifies that on 13 and 19 August they lasted only three-quarters of an hour. Rossi says (11 September) that both the sittings in the week when he wrote had lasted an hour and a half. He also mentions the King's extreme cordiality to Bernini at the sittings. On at least two occasions (13 and 21 August) the King brought as many as thirty or forty people with him to the sittings, and on both of these occasions Bernini protested, 'They have the King all the time, but grudge me even half an hour with him.' On one occasion (10 September) when conversation turned to Bernini's famous caricatures he obliged by doing one on the spot. On this subject he also made one of his rare ribald jokes, specifically regarding caricatures of women. It turned on the fact that the Italian verb, *caricare*, from which it derives, means to 'charge' or 'load' and consisted in his observing that this was a nocturnal activity.

Sometimes the King's followers to the sittings included celebrities. Condé came on 11 August, Turenne on the 14th and again on the 22nd, and Bossuet and Corneille on 26 September. Their comments on the bust are unfortunately not recorded, though Bernini was much impressed with Condé. Bernini mentioned (21 August) that it was very difficult to suggest in sculpture the King's long eyelashes, and on another occasion (11 September) that as a man's face only remained smooth for two or three hours after shaving some stubble should be hinted at. At an early sitting (14 August) he amused the younger courtiers by stalking stealthily round the King, who himself had difficulty in not laughing.

It was always the details of the features – eyes, nose, mouth – on which Bernini worked during the live sessions. Sometimes (as Rossi reported in a letter of 11 September) he continued working the marble for an hour and a half by torchlight after the King had left a sitting. He remarked (4 September) that the best moment for a portrait sculptor was when the sitter was about to speak or had just spoken. Concerning

81

the King's face Bernini observed (6 September) that his eyes were a little dead, that he never opened them fully and that his mouth changed frequently. Naturally there were suggestions on occasion that he had falsified the features – that he had made the nose lop-sided, the jaw too prominent or the eyes squinting. Even the King himself said at one sitting (10 September), 'Is my nose really on one side?' Naturally, too, malicious court gossips seized on a remark of Bernini's (3 September) to the effect that part of the King's face was less beautiful than what he, Bernini, had made of it ('*Questo è bello; nell'originale questo vero è brutto*'). The true explanation of this unfortunate observation, and a fair summing-up of Bernini's attitude to portraiture in general was given by Chantelou (26 September): 'The secret of portraiture is to make the most of what is fine, and give the whole the effect of grandeur. You should minimize what is ugly or petty, or even suppress it if this is possible.'

In answer to a question from the King (30 September) Chantelou said that most of the drapery of the bust had been executed by Cartari. But Bernini himself carved the lace cravat. He asked for several from the King's wardrobe as possible models, chose one and then improved on it. Though emphasizing that he disliked work of this kind, he was not above playing to the gallery by remarking how surprising it was that he should have become a designer of lace. Several visitors expressed dislike of the cravat which resulted, but Chantelou replied firmly (14 October) that French heroes ought not to look like Greek or Roman ones, but contemporary. This could have led into very deep water, but Chantelou did not pursue the matter.

Partly on account of the difficulty of undercutting the stale marble, Bernini was particularly proud of the hair in its finished state. He frequently told all in earshot, including the King (23 August), that it was very difficult to give a natural lightness to it, and when he succeeded he asked Chantelou (3 September) to explain his achievement to the King. Once again it seemed that beautiful things needed verbal assistance.

As to the resemblance, two visitors said the bust was even a likeness from the back, and one (9 September) that, though neither arms or legs were shown, it nevertheless gave the impression that the King was walking. The Venetian ambassador (19 August) said the King was apparently giving an order to his generals. Monsieur de Thou (19 September) was reminded of a head of Jupiter, and several visitors compared the bust with Alexander the Great. Bernini himself said (15 August) that

the King's face had a look of Alexander. It would be interesting to know if this observation was spontaneous and independent. If so, it was a coincidence, as Louis had for some time been half-identifying himself with Alexander. Charles Le Brun's rise to fame and favour had, indeed, been marked some five years previously by the success of his huge picture of *Alexander and the Family of Darius* in which a parallel between Alexander and Louis was intentional and evident.

At the thirteenth sitting, on 5 October, Bernini carved the eyeballs, announced that the bust was finished, made a short speech and then burst into tears. For nearly a month before this he had been elaborating his ideas for the pedestal. It was to consist of a globe, done in gilt bronze and blue. This would have the practical advantage of raising the bust out of reach, and its projection would also make it difficult for people to touch the bust. On one occasion (13 September) Bernini said he wanted to put a kind of carpet under the globe, to be enamelled and adorned with virtues and trophies of war. His suggestion for an inscription was *Picciola Basa*. He preferred this to the proposal of the Abbé Butti (whose court duties had led to his composing several bad verses about the bust) which was *Sed Parva*. Both of these were characteristic of the emblematic thinking of the seventeenth century in that they were deliberately cryptic, and not readily intelligible. Butti had in fact objected to Bernini's inclusion of the word '*basa*' on the ground that it was too explicit. In either case the conceit was the same – that even the globe itself was a small base for such a monarch. When this was explained to Chantelou he prudently suggested that it should be made clear that this was Bernini's idea, and not the King's.

Bernini's pedestal was certainly not ready at the time when he left Paris, and there is no evidence that it was ever put in hand. The bust itself remained for twenty years in the setting in the Louvre which Bernini had chosen for it. There was great demand for copies of it, and many were made.[113] Colbert died in 1683, and two years later the bust was moved to Versailles, where it remains. It is as high out of reach as even Bernini wished and has bronze cupids and gilt trophies above and behind it.

It is indisputably one of his greatest and most impressive feats of portraiture, and in 1979 was still indicated by guides at Versailles as the best of the portraits of the King, despite the fact that it was not the work of a French artist. From the beginning of his career Bernini had set

himself against the traditional type of bust which aims at reproducing the sitter's head in a state of repose. He himself declared, before the live sittings for the Louis bust, that if he worked any more on it, it would speak. That indeed, was one of his aims, but it was not the only one. One of the most famous of his early busts – of Cardinal Scipione Borghese – already seems to be speaking, and the folds of the robe, though probably not violating their actual shape – as Bernini was to do in the Fonseca bust – are undoubtedly planned and carved in order to produce contrasts of light and shadow from the actual light in the room where it would be shown, and thereby heighten the effect of dynamism. But Scipione Borghese is still no more than an individual. The sitters of the late busts – Francesco d'Este and Louis XIV – are in addition personifications of their role as rulers.

It is not difficult to suggest this in portraiture by avoiding the specific in the costume and the particular in the features. But the specific and the particular are also the characteristic, and the result of such a stylized portrait is usually the sacrifice of the likeness. Bernini realized this, but set himself the almost impossible task of getting the best of both worlds. He aimed, in the two late busts, at portraying the individual and at the same time suggesting the idea of sovereignty; and he achieved his aim despite the fact that he laboured under disadvantages in both cases – in the Este bust because he did not see the sitter and had to rely on a painted portrait, and in the Louis bust because he could not obtain the right kind of marble. He took certain liberties with the King's features, such as enlarging the eyes, but he did not minimize their individual qualities.

Perhaps we may get a little nearer to understanding Bernini's achievement by comparing his busts with 'straight' portraits of the same sitters. In the case of Francesco d'Este we have, as it happens, the perfect foil to Bernini in the chance that he was portrayed from life by the supreme 'straight' portraitist, Velázquez. It is also fortunate that both his portrait and Bernini's remain in the same place – the Galleria Estense at Modena.

What Velázquez shows us is probably as near to an absolute objective likeness as it would be possible to get. We see a young man, slightly conceited and rather self-conscious. He condescends to turn towards the painter, but his attitude in general is natural. He does not posture. The dark eyes are beautiful, and their sensuality is underlined (literally) by the incipient bags beneath them. The sensual side of Francesco's

character may also be seen in his passion for good pictures. Mignard told Chantelou (7 October) that through being surrounded by admirable ones of his own (we now know that he had purloined some of them from churches) Francesco had become an excellent judge of pictures.[114] Velázquez shows a slightly ridiculous little moustache, turned up at the ends like Kaiser Wilhelm's, and so skimpy as to suggest a youth much younger than the sitter's twenty-eight years. The features are uneven: a good forehead, the nose slightly too long and too pointed, the chin almost a disaster, falling away as it does, the lower lip somewhat underhung, a slight cleft in the chin itself. A crimson sash is draped over the armour. The Golden Fleece is suspended on the left.

And Bernini? Twelve years have elapsed, which would bring the sitter's age up to forty. But as the bust was made from an existing portrait he must be assumed to be somewhat less. The slightly baggy eyes, the long nose, the sensual, underhung mouth and the cleft chin are all the same as Velázquez showed and are a tribute to the faithfulness of the painted portraits which Bernini used, and to his faithfulness to them. He will have none of the upturned moustaches, and regularizes what there is of them. Instead of the Spanish *golilla* Francesco now wears a lace collar, but the armour is more or less the same. The tremendous difference in the effect is achieved through the adjuncts and through the pose.

The prince's rather characterless hair, dark, but with, apparently, a badger's lock of grey, is transformed into a marvellous cascade of intricate curls, whose riotous curves act as a foil to the calm features. It is likely enough that Bernini was deliberately allowing himself to improve on nature in this respect, and also probable that he took a further liberty. The two long portions of hair which fall like stoles half way down the sitter's chest on either side do not appear to connect very organically with the hair above them. One suspects that they were an invention of Bernini's, and that Francesco's hair was still no more than shoulder length. (Since we know that Louis XIV's hair was natural as late as 1665 there would be no reason to assume that Francesco's was other than that in the years before 1650, when wigs for young men were still rare.)

Then, the drapery which with Velázquez was restrained in its folds, and relied for its effect on its colour, becomes violently animated in Bernini. In particular, it is permitted to defy gravity on the right, bunched well above the shoulder and assuming its own defiant pattern. This

underlines admirably and also counterbalances the imperious turn of the head, looking over the sitter's right shoulder in an attitude of cold command. It is this gesture which constitutes the most important difference between Velázquez's and Bernini's portraits of Francesco.

There is one other instance of the same sitter's being portrayed by both Bernini and Velázquez. The sitter in this case was Pope Innocent X and both portraits are still together in the Palazzo Doria in Rome. This time Bernini, like Velázquez, had the advantage of access to the sitter. Nevertheless the comparison of the two portraits is less instructive than that of the Este portraits, and the reason is not hard to find. Whereas Velázquez had shown the private image of Francesco, and Bernini the public one, in the case of Pope Innocent only one – the public – was possible. The Pope has no private image.

Unfortunately Velázquez never painted Louis XIV. But the 'straight' image of him is adequately represented by Nanteuil's engraving of only one year before Bernini's visit. The costume, a lace cravat falling over armour, is the same as in Bernini's bust. The main physiognomical difference is in the size of the sitter's eyes. In Francesco d'Este's case they were already large. Bernini had no need to take liberties. In the Louis bust he has. Otherwise the differences are the same, only more so. The curls in the bust of the King, through being bigger than Francesco's, are that much more dynamic. And the drapery is vastly more aggressive. It is the flourish under the royal signature. Corresponding with the greater dynamism of both these features, Bernini introduces greater suggestions of movement into the Louis bust by throwing the sitter's left arm back and bringing his right forward. Louis' head is tilted further back than Francesco's and less over one shoulder, and the design of the Louis bust as a whole is consequently more frontal and less diagonal. Perrault noted the way in which the sitter's right arm is evidently truncated at the elbow, so that it must be imagined that the drapery drapes a bust and not the King. Needless to say, Perrault uses this justifiable observation of a justifiable convention to draw an unfavourable conclusion unjustifiably.

The success of Bernini's bust of the King was an obvious challenge to French portrait sculptors. Bernini had hardly left Paris before the medallist Jean Warin tried his hand at a marble bust. Rossi wrote from Paris describing to Bernini its reception (1 October 1666).[115] As might be expected the courtiers overpraised it in order to belittle Bernini. Of later

French sculptors who portrayed the King, Coysevox was the most successful in attempting something like Bernini's bust but with differences.

XIV

THE TRANSFER OF the court from Saint-Germain did not prevent Chantelou from continuing to take Bernini sightseeing in the Paris area, as he had done previously. Between August and October, for instance, they visited the Château de Madrid, Vincennes and the Sorbonne, together with various houses containing pictures, such as the Duc de Richelieu's and Le Nôtre's. These were all places which could be visited in the day from Paris. Fontainebleau was too far, and that is presumably why Bernini does not seem to have visited the palace, though he had passed through the village on his journey from Italy. An excursion of a different kind occurred on 14 October, and included the then recent, and architecturally ingenious Hôtel de Beauvais and Antoine Benoît's then famous wax portraits.

Two of these outings were exceptional, both on account of the intrinsic interest of the things that Bernini was shown, and also because each posed peculiar problems of a different kind on the human level. Versailles, though Louis had done little to it as yet, was already high in his affections, and he seems to have been afraid that Bernini might crab it. And the Gobelins factory was under the direction of Le Brun, with whom Bernini had had only the minimum contact but who appeared to be firmly ranged on the side of his opponents.

The somewhat bizarre appearance at this time of the modest château which Louis XIII had built at Versailles was sympathetically described by the young Christopher Wren in another letter dating from the year of Bernini's visit. 'The Palace', Wren writes, 'or, if you please, the Cabinet of Versailles call'd me twice to view it: the mixtures of Brick, Stone, blue Tile and Gold make it look like a rich Livery: not an inch within but is crowded with little Curiosities of Ornaments. . . .'[116]

On arrival at Versailles on 13 September Bernini and Chantelou were met by Le Nôtre. Bernini was in an unusually sunny mood. 'This is fine,' he said, 'everything is good that has good proportion. This palace is well proportioned.' He added, 'In palaces of this kind solidity is not the first

consideration, and for that reason it succeeds well. What has been done here is very fine.'

They walked over the terraces and down into the Orangery. Bernini suggested it be decorated *en grisaille*. One of the others said that oil paint would damage the orange trees and that stucco would not hold. Bernini replied that the decoration could be done in fresco and without the use of size.

On their return to the courtyard of the château they encountered the King. With his usual frankness Bernini said to him that he found all he had seen to date fine and very beautiful, but he was surprised that His Majesty only visited the place once a week. It deserved, he thought, a visit at least twice weekly. The King showed pleasure in Bernini's pleasure and then left them. Bernini next presented his respects to the Queen. After his own lunch he attended that of the King, where he noticed that His Majesty watered his wine. Bernini then made the extraordinary observation that this was an unnecessary precaution. His marble bust would last longer than its sitter. After his siesta he watched the King and Queen leave for the hunt.

While the Louvre was continually being planned but only sporadically worked on, Versailles was never planned as a whole but merely built. Impatient of delay, and with the resources of the whole country at his command, Louis kept adding to his plaything, so that it grew from a miniature to a monster in a remarkably short space of time. One consequence was that its evolution is incompletely documented, and in this context Chantelou's account of Bernini's visit is valuable in more ways than one. Though the architectural additions which Louis xiv had already made were largely restricted to the two service wings in the front of the château, Le Nôtre's encounter with Bernini shows that extensive work in the gardens was already in hand. And Louis' interest in the place is convincingly shown in other ways. First in the apprehension which was expressed by Chantelou on 14 August, when the possibility of Bernini's visit to Versailles was discussed, that the King might not like it. This leaves no doubt that Chantelou was aware of what Vigarani heard the King say after his first audience with Bernini in June – that half an hour's conversation with him had been enough to convince him that Bernini was already prejudiced against French culture and that he did not wish him to attend the Versailles fête. On 14 August Chantelou had been told that the King would not object to the visit but that he did not

wish to suggest it himself. Chantelou's reaction to this was subtle, and, in the event, effective. He would take Bernini there at a time when the King was also there. This would curb Bernini's tongue. Accordingly Chantelou gave notice of the forthcoming visit to Colbert on 12 September.

In the case of the Gobelins Bernini's visit took place against a background of rather more petty intrigue. The establishment, which produced all the artefacts required for furnishing the royal palaces, was still of recent origin. Le Brun had been appointed as the first director only two years previously. He was the creature of Colbert, whose interest in the factory was almost obsessive. It emerges from Chantelou's entry for 15 September, for instance, that Colbert knew the names of the individual craftsmen there.

The possibility of Bernini's visit to the Gobelins had been mentioned as early as 4 August. That was the day when Butti had insinuated that the failure of Bernini's first attempt to visit the Jabach collection was due to a plot of Le Brun's, and had added that Le Brun would also try to stop Bernini from seeing the Gobelins. Though Bernini was in fact thwarted on his first attempt to go there also (30 August), Le Brun was perhaps not to blame, as it was a Sunday.

Soon after this the subject of Bernini's tactlessness came to a head. On 3 September the King, speaking to Chantelou of a one-eyed man, said in Italian, 'he is blind in one eye' ('È cieco d'un occhio'). When Monsieur asked what this meant, Chantelou, amazingly, said, 'The correct word is *guercio*.' The King heard this and said good-humouredly, 'Chantelou understands the nuances of that language.' What makes Chantelou's effrontery the more bizarre is that he was wrong. *Guercio* does not mean one-eyed, but squint-eyed. Chantelou hastened to apologize, saying that he was having to pay attention to his Italian on account of Bernini. Then, at the mention of the Cavaliere's name, the conversation took a more serious turn. The King said, 'He does not praise much.' Chantelou again attempted a soothing answer and the King went on to ask what Bernini had said about Vincennes. Another soothing reply, and then a direct challenge about Bernini's saying the King's rooms at the Louvre were those of a woman. This time, as we have seen, Chantelou could only suggest a malicious misunderstanding, though he had himself reported the incident at the time.

Next day Chantelou informed Butti of what the King had said in the hope that the Abbé might persuade Bernini to be more diplomatic.

Predictably Butti detected the hand of Le Brun in the matter 'because the Cavaliere does not praise his work which indeed is worthless and does not deserve praise. Le Brun paints like a Fleming.' Again he made the accusation that Le Brun filched his ideas from drawings in the Jabach collection.

When, in the event, Bernini did get to the Gobelins – on the afternoon of 6 September – it is difficult to judge the atmosphere as Chantelou is so laconic as to encourage the suspicion that he was deliberately writing it down, as he did on other awkward occasions. No mention is made that Le Brun was even present. We are merely told that Bernini said the tapestries were well made, and that he gave high praise to the drawings and paintings of Le Brun and to the fertility of his invention.

It emerged next day that Bernini too had been on his guard. After an elliptical conversation with Chantelou on the subject of his indiscretions, Bernini confessed that he had spoken very favourably of what he had seen at the Gobelins, though there were a number of worthless things there. He later (8 September) told Chantelou that a single one of his set of Poussin *Sacraments* was more satisfying than all the big pictures he had seen at the Gobelins. A little later still (15 September) Chantelou put to Colbert his project for a set of Gobelins tapestries representing the story of Moses and taken from paintings by Poussin. Colbert opposed the idea on the ground that the pictures were essentially small in scale. It so happened, though, that immediately Colbert died, some tapestries of this kind *were* made by the Gobelins on behalf of the King who had bought one of the paintings. On 15 September the mention of tapestries in connection with Poussin led to discussion of suitable borders for tapestries in general, and then to a remark of Chantelou's that Poussin preferred very simple frames for his pictures, without burnished gold.

Though Perrault (8 September) tried to make mischief out of Bernini's visit to the Gobelins it is likely that Bernini's relative restraint at this stage went some way towards restoring his reputation. When Le Brun called to pay his respects (8 September) Bernini received him effusively, and solicited his opinion of the bust 'while it was still in a state to profit from it'. No mention is made of any criticism by Le Brun, but the incident was reported to the King next day.

Bernini's second visit to the Gobelins, on 10 October, appears to have been more ceremonious. This time we are told that Le Brun received him on arrival. Bernini praised the products of the factory and criticized

the draughtsmanship of Paolo Veronese. Then he paid a curious compliment to Le Brun: 'I can talk freely to you as being an artist who has eighteen qualities out of twenty, whereas in the case of one who *lacks* eighteen out of twenty one can say nothing.'

The breach between them appeared to be noticeably diminished. Nor does a remark which was unusually outspoken even for Bernini really contradict this (14 October). Butti had said he would speak to Colbert about helping an artist who had fallen foul of Le Brun. The main target of Bernini's reply – 'That would be useless; Colbert behaves to Le Brun as to a mistress and defers to him entirely' – is clearly Colbert rather than Le Brun. On the day after the visit (11 October) Bernini expressed approval of Le Brun's project for the oval dome of the main salon of Vaux-le-Vicomte, commissioned by Fouquet when he was Surintendant des Finances. It had been cancelled on account of Fouquet's disgrace. Bernini now said that Colbert ought to set to it that it was executed somewhere. It would be a pity, he said, if it were not. Bernini's comment is the more interesting in that Le Brun's design included a building which, as Robert W. Berger has recently claimed, seems to anticipate the Louvre colonnade as executed.

During these visits Bernini gave his listeners, as on previous occasions, the benefit of his views on the old masters. He never expressed the unstinted admiration for Michelangelo that he did for Raphael. He remarked once (25 June) that Michelangelo was greater as architect than as sculptor or painter, that his figures never seemed of flesh and blood and were only remarkable anatomically. He reverted to this theme on another occasion (21 August) and said that this put Michelangelo below the level of the Ancients. When (20 August) Chantelou volunteered that it was Michelangelo who started the rot of licentious, or Vitruvius-defying architecture, Bernini defended him. Bernini continued to assert that Paolo Veronese, though a good painter, was a bad draughtsman. Both the Mary Magdalene and the Christ in the huge *Feast* (then at the Gobelins and now at Versailles) were badly drawn; so was the *Perseus and Andromeda* (now at Rennes). The perspective was wrong in the *Susannah and Elders* and in the *Rebecca and Eleazer* (both now in the Louvre). In this case Bernini made no allowance for the height at which the pictures were designed to be seen. Nor, apparently, had he realized that with this in mind Veronese had evolved a subtle way of filling the upper sections of pictures which had a low eye-level by assuming that

the receding ground in the picture space was not even, and that some of it was higher or lower than the foreground. On another occasion (10 October) Bernini mentioned that both Veronese and Titian sometimes took up their brushes and painted without prior planning, simply obeying an urgent need. On these occasions Bernini disapproved of the result.

When Camillo Pamphilj sent a collection of six or seven pictures as a present to the King (they arrived in a damaged state) Bernini said that only the Titian *Madonna* was any good. Among the others was a Caravaggio which is now famous – the *Fortune Teller* (Louvre). In connection with Mignard's work on the cupola of the Val-de-Grâce Bernini advised him to enlarge the Trinity group (which Mignard then did) and said (10 October) that in cupola painting the main groups of figures should stand out like blots (*macchie*). He also disclosed (9 October) that at the cupola of S. Andrea della Valle in Rome the painter Lanfranco had retouched his work with a brush attached to a pole which was so long that it needed two men to lift it. When, on another occasion (24 August), Bernini extolled the benefits of top lighting, Colbert's realistic comment was that there was nothing French ladies disliked more.

There were two subjects on which Bernini felt particularly strongly and on which his views are most valuable. One was optical illusion; the other was the related theme of the limits of naturalism in art, and the danger to young artists of working from the live model before their style was formed. On the first he had already dilated to Chantelou more than once. He now (23 August) spoke of his own colonnades at St Peter's, how they were designed to make the façade seem higher, and how they did so. Also, how a man dressed all in one colour seems bigger than one whose clothes are of different colours. Chantelou capped this by saying how a palace which uses the colossal order seems bigger than one of the same height which has one order per storey.

Pursuing a line of thought which he had expounded earlier to Chantelou, Bernini said (23 August) that in one of his sculptures the head seemed too small, though it was in fact correct for a work of that kind, namely one-ninth of the total height. He thereupon remeasured the Antique sculptures, the *Antinoüs* and the *Apollo Belvedere*, but found they were no different. Finally he realized that it was a piece of drapery over the shoulder of his figure which produced this effect. When he reduced it the proportions appeared correct.

The second subject – the limits of naturalism – was almost an *idée fixe* with Bernini. When Colbert praised the likeness of the bust to the King (24 August) Bernini deprecated any idea of a direct comparison by studying them side by side. No portrait sculpture, he said, could stand juxtaposition with its original which had life and movement as well as colour. On 5 September he took the opportunity of stating his views at length. This was when he addressed the Academy by invitation. The occasion seems to have been relatively informal, but Bernini's address constitutes the longest and most connected of his recorded utterances on art:

I put forward the suggestion that the Academy acquire plaster casts of all the finest Antique sculptures, bas-reliefs and busts to serve for the instruction of young artists. In this way they will form an idea at the beginning of what is beautiful, and this will remain with them afterwards for all their lives. It will only be their ruin if they are put to draw from nature as soon as they begin their instruction. Natural appearances are almost always poor and lacking in nobility, and if the imagination of the young is fed on nothing else they will never be able to produce fine and grandiose effects, since these are not to be found in nature. Those who study nature must already be in possession of sufficient discrimination to be able to recognize its shortcomings and to correct them. Young artists with no experience are not capable of doing this. To illustrate this point I tell you that there are sometimes objects in nature which seem to be in high relief but which should not be so depicted; while there are others which should be but do not seem to be. Those who know how to draw will shut their eyes to whatever they show them which should not be included, and will incorporate what should be, but which may not show. And this, I tell you once again, the young artist is not capable of doing, as the idea of the beautiful is not at his command. When I was still very young I often drew from the Antique. Then, when I made my first sculptures, I went back, whenever I was in doubt concerning anything, to the Antinous. Each time I saw this work I noticed beauties which I had missed until then, and which I never should have noticed had I not myself been a sculptor. For this reason I always advise my students and other artists not to devote all their time to study but to continue their own work concurrently. They should alternate production with copying – you might say pass between the active and the contemplative – and in this way great and marvellous progress comes about.

Chantelou, always eager to support Bernini, interpolated an observation at this point from his own experience. He told Bernini of how the sculptor Carlier, having spent much of his life taking casts from Antique

sculpture in Rome, had finally found it impossible to carry out creative work of his own.

Bernini then added a few remarks addressed specifically to painters.

In the case of painters, not only can they base their draughtsmanship on Antique bas-reliefs and statues. They should also, for their salvation, undertake copies after painters in the grand manner, such as Giorgione, Pordenone, Titian and Paolo Veronese – these in preference to Raphael, though he was the most perfect of them all.

The meaning of Bernini's somewhat cryptic remark is likely to be that Raphael neither drew as well as the Ancients, nor painted as well as the Venetians, though in the combination of the two he came out better than all other painters. Bernini added:

It was said of him that no other painter approached the mastery of his compositions, since he had been friendly with Bembo and with Baldassare Castiglione, who helped him with their knowledge and their culture.... It is an academic question whether a painter should show his work as soon as it is finished or if he is not better advised to put it on one side and then to study it again before exhibiting it to the public. Annibale Carracci had the habit of showing his work immediately in order to discover its faults – if it were too dry, or too hard, or had some other shortcoming – and therefore to correct them.

Bernini repeated the substance of his lecture as regards the training of the young to Colbert (who had asked for the written text) on 6 September, and to the King on the 9th. An incident which occurred on the latter occasion provided evidence of the King's attitude towards the connoisseurship of pictures. Two days previously (Monday, 7 September) Bernini, when dining with Cardinal Antonio Barberini, had admired a night clock, then a sensational novelty. It had a lamp inside and contained a painting by Carlo Maratta. Evidently as a result of Bernini's praise the Cardinal sent the clock next day to the Palais Mazarin so that it could be presented to the King when he next came to sit. At the presentation on the following day Bernini observed that Maratta was one of the best painters in Rome, to which the King replied that he himself should have started to look at pictures earlier, but that he had only been doing so for three or four years.

On the day after Bernini's address to the Academy Chantelou told him that he himself possessed a large collection of casts which he had had taken from Antiques in Rome some twenty years previously. The

94

Academy would be at liberty to borrow them. Nevertheless Perrault admitted, in answer to Chantelou's question on 26 September, that no steps had yet been taken to do anything about removing them, and on 4 October Chantelou gave Colbert written details.

Just before he left Paris Bernini made further recommendations on a similar theme (11 October). 'For most of the time,' he said, 'what is natural is not beautiful. But I used to get Levantines from Civitavecchia or the Marches of Ancona as models, and on such occasions I did wisely.' (On his second visit to the Gobelins, on 10 October, Bernini had suggested that the King buy some Greek slaves to serve as models; he went on to say that he had forgotten to include this recommendation in his memoir for the Academy, and that it should be added to it.)

As advice in general to those who draw from nature I say, be on your guard, and examine the model carefully. Make the legs long rather than short. A fraction more will increase their beauty, and one less will make them seem heavy and lumpish. Make the shoulders of a man broad rather than narrow, as indeed is usually the case in nature. Make the head rather too small than too large. In the case of women make the shoulders a little narrower than they really are, since God gave breadth to the shoulders of a man with a view to strength and labour, and breadth of hips to women to enable them to bear us. Make the feet small rather than large, as you see them in beautiful models and in Antique art.

He added that stance was a matter of the greatest importance.

Most men, unless they are very old, put their weight on one leg only. Naturally the shoulder on the side of the weighted leg should be lower than the other and if one arm is raised it will be the one on the side opposite the weighted leg. Otherwise the result is ungraceful and unnatural. In looking at the finest Antique statues I have always found that this prevails.

On an earlier occasion (14 July) Bernini had described to Chantelou and Butti a strange rough-and-ready process for controlling the expression of a model and claimed that it was of his own invention. It was undoubtedly ingenious. He said that he himself would assume the attitude which he had in mind and then get a good draughtsman to draw him.

XV

BERNINI'S EXPERIENCE WITH the project for the mausoleum of the Bourbons at Saint-Denis, which occupied him for a fortnight at the end of September, may be seen as a microcosm of what happened at the Louvre. It had the mark of death on it in every sense. It took off to a bad start and soon petered out. The abbey of Saint-Denis had for centuries been the burial place of the Kings of France. In the sixteenth century Primaticcio had designed a separate funerary chapel for the Valois dynasty. It was sited asymmetrically adjoining the north transept, but was never finished and was demolished in the eighteenth century.

On 15 September 1665 Chantelou conducted Bernini to Saint-Denis on the instructions of Colbert, who had mentioned the idea of the mausoleum in his memorandum concerning the internal arrangements of the Louvre which he had handed to Bernini on 19 August. Colbert included himself in the excursion on this occasion, but the visit can hardly have counted as a success. On the preceding evening Bernini had received disturbing news from Rome concerning his wife's health, and when they arrived at the abbey he proved to be at his most fractious. His scathing criticism of the tomb of François I had the effect of making Colbert frown, even though he did not fully understand what Bernini had said and had to consult Chantelou. Then, when Bernini announced that the new chapel should dominate, it was Colbert's turn to make objections; he immediately took fright, envisaging another instance of Bernini's extravagance. Bernini went on to propose a chapel behind the choir, to be entered both from it and from the outside, and big enough to take the tombs of thirty or more kings. A drawing at Stockholm has been identified as Bernini's idea at this stage.[117] Probably he was inspired by the Cappella dei Principi, the vast Medici mausoleum stuck on to the choir of S. Lorenzo in Florence which he would have seen on his way to Paris.

Colbert objected that this was too ambitious. Such a building would dwarf the abbey church – as in fact the Cappella dei Principi dwarfs S. Lorenzo, though Colbert probably did not know this. Rather surprisingly, Bernini took the hint. On 28 September he told Chantelou that he had been having second thoughts. He no longer proposed a separate building. He asked if Chantelou had seen his chapel of the Cornaro family in S. Maria della Vittoria in Rome. This has always been

considered Bernini's masterpiece. On elevated positions at the sides the Cornaro family witness, but pay little attention to, St Theresa apparently in orgasm, about to be pierced by the arrow of a smiling angel. Chantelou admitted that he had not seen the work. This was hardly surprising as Bernini had executed it several years after the second of Chantelou's two visits to Rome.

Bernini now explained that he proposed to site the tombs in the choir of the abbey church so that they looked on to the high altar and would thus be visible from the body of the church. As in the Cornaro chapel the statues of the kings would be disposed kneeling in different attitudes and leaning on simulated cushions on marble carpets draped over balustrades. Mosaic panels behind them would increase the richness of the effect. The tombs themselves and their ornaments would be of black marble with gilding. The effect of all this in a thirteenth-century Gothic church does not seem to have bothered Bernini, or even to have been taken into consideration by him. In order to make the plan of the church symmetrical he proposed building a new chapel outside the south transept to correspond with the mausoleum of the Valois.

On 29 September Bernini went back to Saint-Denis. As Colbert was not accompanying him on this occasion Bernini called on him before setting out. When he made a civil remark about a portrait of the King on horseback which caught his eye Colbert commented archly, 'Even though it is by Le Brun.'

At Saint-Denis he got Rossi to take measurements of the breadth of one of the aisles, and made some further disparaging comments about the Valois chapel. Next day Chantelou noted that he was continuing to work on the tombs, superimposing his drawing on the plan of the abbey which he had been given. We are not told whether this was shown to the King.

No more was heard of the project after this. Nor were François Mansart's schemes ever executed. No doubt Bernini's return to Italy in October 1665, and Mansart's death in the following year were factors. But it is likely that there was another reason as well. The idea of the Saint-Denis chapel seems to have been Colbert's. As the King was still young Colbert presumably felt it neither morbid nor indiscreet. He told Bernini on 15 September 1665 that the King had fifty years of life ahead of him, and this, fantastically, was to be the case – to a fortnight. Louis XIV died on 1 September 1715. But the fact, as we know, that in later life

the King so much disliked Saint-Denis that he would neither visit it nor even, if he could help it, glance in that direction, suggests that even at this stage his lack of enthusiasm for the project induced Colbert to let it drop. The sequel to Louis XIV's reluctance to contemplate his own death was to be a funeral of almost indecent modesty.

To Bernini himself the Saint-Denis episode may have been a welcome if brief return to architectural creativity at a time when work at the Louvre was becoming increasingly a matter of those practical details so tedious to him and so dear to Colbert. The job of lowering the *piano nobile* of the Louvre design, suggested by Colbert, had fallen to Rossi, as Chantelou noted on 20 August. But just before this an entirely new element did arise which tested Bernini's inventiveness for a few days. This was a project for a theatre in the empty space between the Louvre and the Tuileries. Colbert had mentioned on 13 August the desirability of some feature in this area, and had included it in his memorandum of the 19th of that month. This time Bernini really seems to have given way to that streak of megalomania which was never far beneath the surface. The building was to be a double one, with two semicircular auditoria, each capable of holding ten thousand nobles. Between the theatres was to be an apartment of nine or ten rooms for visiting notabilities. There were to be columns over sixty feet high, and a façade broader than that of the Louvre. Chantelou's brother, Fréart de Chambray, pointed out with justice (13 August) that the scale of such a building would annihilate the Tuileries. In a letter of 21 August, Rossi describes the new project rather strangely as 'a mausoleum in the form of a theatre and amphi-theatre ... which will serve for jousts, equestrian ballets, fireworks and the like'.[118]

Bernini returned to the subject on 8 October. On the previous day he had criticized the existing theatre at the Louvre. 'The real and the feigned', he said, 'do not go well together. This theatre is two or three times too deep, and only a third as wide as it should be. There should not be seats high up, as the scenic apparatus is visible from them, and this is a grave shortcoming. Also, the floor should be lowered to help the acoustics. If you tried to represent an ocean in this theatre it would only look like a fountain. You can neither see nor hear.' Bernini now said he had been thinking again about his amphitheatre, and how he was planning to allow for the representation of vast panoramas of sea and horizon. But no more was heard of it.

At intervals the name of Giovanni Paolo Tedesco crops up in the course of Chantelou's narrative. His real name was Johann Paul Schor, a native of Innsbruck. He was an artist and designer who had worked under Bernini and others in Rome, and enjoyed the reputation of being able to turn his hand to anything. On 12 October the Abbé Butti had said he was 'necessary' in France, but that it would be difficult to get him.

Bernini would have liked to return to Rome immediately after finishing the bust on 5 October, but at the Louvre the end was not yet in sight. By September Marot was working on his engravings of Bernini's designs (on 8 October Marot said he had made eighteen of them) and the famous medallist Warin, on the commemorative medal. When Bernini complained that the relief of the medal was too high Warin agreed and blamed it on Colbert. The voice of François Mansart, still unseen, was heard again. He was reported (11 August) as having praised Bernini's Louvre designs, and on 2 October he asked Marot to engrave his (Mansart's) designs for both the Val-de-Grâce and the Louvre. In the meantime, despite weekly conferences with Colbert, work on the foundations of Bernini's east front dragged and thereby impeded plans for the ceremony of laying the foundation stone. Some of this was Bernini's fault. Two of the Italian workmen arrived on 3 September; the third (Pietro Sassi) not until the 17th. The tests of their system of construction, as compared with the French, were described in scathing terms by Perrault. 'At the end of the winter', he wrote, 'the Italian vault collapsed of its own accord at the first thaw, and the French one remained firm, and in fact stronger than when it was first built. The [Italian] craftsmen were very surprised, and blamed it on the frost which had spoilt everything – as though frost was a most unusual thing in winter.'

There were renewed rumours (28 August) that, owing to political differences with the Pope, Bernini's plans would be shelved, and, conversely, repeated attempts to retain him permanently in France. In this connection Colbert offered on more than one occasion to make a Frenchman of young Paolo Bernini. There would be no difficulty in supplying him with a French wife. When it was at last acknowledged that Bernini must soon leave, regardless of whether or not he would return later, Colbert appointed Chantelou's brother, Fréart de Chambray, as supervisor of the execution of Bernini's Louvre. Chambray, as the author of an architectural work entitled *Parallèle de l'Architecture Antique et de*

la Moderne (1650), was a good and disinterested choice. He seems not
to have been a friend of Bernini's previously, but as the brother of
Chantelou he would not be accused of belonging to the anti-Bernini
faction. The mere fact that Colbert appointed him indicates that he was
still in earnest about executing Bernini's plan – or at least that he wished
to give that impression. Just before Bernini left Paris, however, the Abbé
Butti gave a reasoned account of the current state of play (12 October)
of a more disquieting kind. He said he had always doubted whether
Bernini's design would be carried out, and he still did so. Colbert had
been against doing so, he said, but to date the King's decision in favour
of it had prevailed. Colbert's attitude to Bernini's plan is likely to have
been decisive later on.

Throughout September there had been much discussion of the con-
ditions of labour at the Louvre. Colbert agreed with Bernini that work
by the day was best, but no final decision appears to have been taken;
in any case very little practical work on Bernini's scheme was ever done.
The completion of the bust, together with the repeated delays at the
Louvre, resulted in Bernini's not being fully occupied during the last few
weeks of his stay. Since this state of affairs was incompatible with his
unextinguished energy he found work for himself. At intervals through-
out his visit, whenever he had nothing more urgent to do, he had been
in the habit, as we have seen, of giving a few strokes to his son Paolo's
marble relief of the Infant Christ. It was explained that this was to be a
present to the Queen. By contemplating it during her pregnancy it was
intended to produce a favourable effect on the appearance of the child.
Now that it was finished Bernini ordered a gold frame for it. The work
is now in the Louvre. Though not particularly remarkable, it is at least
thoroughly professional in appearance.

During the waiting period, early in October, Bernini at last got round
to doing something about Monsieur's cascade at Saint-Cloud. He re-
visited the place on 4 October, and spent an hour making a drawing of
what Chantelou calls a *cascade naturelle* – evidently continuing the train
of thought he had started when, on his earlier visit to Saint-Cloud (2
August), he had said that the existing one looked too artificial. In his
own fountains Bernini had always tried to introduce the jet of water in
a natural sense. Though he had not gone so far (as certain sculptors in
the north of Europe did) as to show a male figure urinating, or even a jet
emerging from the nipples of a sea nymph, he had made his triton in

the Piazza Barberini in Rome blow it into the air through a shell in his mouth.

On the present occasion he said to Chantelou, 'I am certain that this will not please. The people here are not accustomed to anything as natural-looking as this.' Later he added, 'What I have done is only for those whose taste is for beautiful things on a grand scale. I have no doubt that they will prefer the existing cascade to the one which I have designed, but I have done it to please you. If it is well executed I think it could be that no one will pay further attention to the old one. In any case there will be two of them, in two different styles, but mine must be carried out well, and for this a model must be constructed first.'

Bernini's reference to doing the drawing to please Chantelou was a consequence of a mild deception of Monsieur's which Chantelou had reported on 18 August. (We may note that Chantelou was evidently very successful in reproducing Monsieur's highly individual way of speaking, and his habit of constantly asking questions: it is in fact not difficult to hear, mentally, the querulous, piping tones of this strange little person.)

'Is it true', Monsieur had asked, 'that the Cavaliere thinks my cascade at Saint-Cloud too artificial?' Chantelou said it was. Monsieur went on, 'Boisfranc has told me that the Cavaliere said it would be possible to make something fine out of my *bouillon d'eau*. I should be most grateful if you could ask him for a drawing for it, as though coming from yourself.'

After his second visit Bernini entrusted the preliminary work on the cascade to an Italian artist, Francesco Borzoni, then domiciled in France under the name of Boursin. Boursin's finished drawing was shown to Monsieur by Chantelou on 17 October.

'But where is this to go?' Monsieur asked. Chantelou replied, 'Where the big jet is.' 'But what about my big jet?' Chantelou reassured the little creature, saying that the jet would be preserved and that when he got back to Rome Bernini had promised to make a clay model of the new cascade which would be copied in wood so as to be sent to Paris. Like others of his kind Monsieur's taste ran to the ornamental. On this occasion he went on to deplore the fact that Bernini's plan for the Cour Carrée would involve the removal of the existing decorations. (Whatever the truth of the matter, this shows that Monsieur at least *thought* that Bernini might be proposing to demolish or cover up the Goujon reliefs in the Lescot wing.)

In the gardens of Saint-Cloud today the destruction of the château has left the Grande Cascade as the principal attraction. Though it was altered after Bernini's visit, most notably in the eighteenth century, when Lambert-Sigisbert Adam's huge sculptures of river gods were installed, it remains in essentials much as it appears in Perelle's print. It therefore seems clear that nothing was done to realize Bernini's suggestions.

Chantelou's account of the Saint-Cloud excursion is nevertheless enough to make any reader who knows the place regret that we have no pictorial record of the occasion. Bernini's mission had, indeed, been full of episodes which call for illustration but never got it. Though Le Brun was certainly no genre painter, what would we not give for more drawings like his reconstruction of the meeting between Louis XIV and the young Cardinal Chigi? And if Chantelou's journal had been known to any of those painters of the early nineteenth century who specialized in imaginative reconstructions of picturesque moments of history, we might have been that much richer. Even today a talented film director could make much of scenes such as Bernini's first audience of Louis XIV, with the young King only just dressed in the early morning, and discovered lounging against a window; or of Bernini sketching him playing tennis or in council; or Chantelou and Bernini being escorted round the gardens of Versailles by Le Nôtre and then casually meeting the King – such a concatenation of celebrities positively calls for an Ingres or a Delaroche. In some ways the Saint-Cloud outing is the most suggestive of all, with the autumn leaves falling on the steep slopes around the two solemn elderly men, and the King's coach-and-six waiting for them at a distance.

Bernini's visit to the Sorbonne took place, rather belatedly, on 9 October. He said he thought the church one of the best in Paris, but pointed out the faults of the internal architecture, and volunteered that he had himself made a design for placing Cardinal Richelieu's tomb under the dome.

Nevertheless his chief occupation during the first fortnight of October was a series of presentation drawings which he did unsolicited and evidently with extraordinary facility and speed. On 30 September he explained that in Rome he did three of these every year and gave them to the Pope, Queen Christina of Sweden and Cardinal Chigi. The idea of making a drawing not as a preliminary to a painting or sculpture but as a finished work of art intended as a present to a friend of the artist's goes back at least as far as Leonardo. Vasari tells us that he did a

drawing of this kind, representing Neptune, for his friend, Antonio Segni. The drawing itself has not come to light, but there are studies for it at Windsor and a copy drawing at Bergamo. Later in the sixteenth century Michelangelo made a number of such drawings as presents for Tommaso Cavaliere, Vittoria Colonna and others. These, apparently, introduced a new element in that Michelangelo intended that other artists should make paintings from them.

Chantelou records Bernini as making seven such drawings at this time. The first of these (30 September), and the only one which is certainly identifiable, was a *St Jerome in Penitence*, now in the Louvre. Bernini said it was the work of one evening. Chantelou admired the light effects and noted that Bernini gave the drawing to Colbert a few days later. It is, indeed, a splendid combination of drama and grandeur in a few square inches. Bernini also presented Colbert, at his request, with a self-portrait drawing in red chalk. Chantelou then asked for another for himself. Bernini had already announced his intention of giving him the drawing he had made (2 October) of the Madonna and St Joseph with the Christ Child in his arms.

On 5 October Chantelou noticed a *Cain killing Abel* which Bernini had drawn on the preceding evening, and, on the next day, a *St Mary of Egypt*. She was shown naked but for her falling hair, in ecstasy at the sight of the crucifix. Chantelou permitted himself to remark that meditation of the kind that Bernini had depicted was a salutary way for those of erotic temperament to redirect their instincts to spiritual matters. He might have added, but did not, that merely to look at such works of art could have a similar effect on a spectator, as was, in fact, implicit in much of the art of the Counter-Reformation, above all of Bernini himself. Before this (23 July) Bernini had confessed to Ménars, Colbert's brother-in-law, that he himself had been very amorous as a young man – this by way of advice to Ménars not to take too much advantage of his good looks. Later (9 October) Chantelou speaks of a drawing of Christ taken down from the cross, with Mary Magdalene. Chantelou described the agony, the love and the pain – to us, a typically Counter-Reformation combination of emotions – which Bernini had depicted. Finally (17 October) there was a *Madonna* which Bernini gave to Chantelou's wife on leaving Paris.

XVI

BY THE BEGINNING of October, with the end of the visit in sight, it might be expected that some climax might ensue on the human level as well as on the artistic. Bernini, as we have seen, seems to have been determined from the start to establish what can best be called near-mystic relations with the King. The daily sittings for the bust, the informality which the King permitted him on these occasions, together with his friendliness and his willingness to overlook Bernini's anti-Gallican, Roman chauvinism, had encouraged Bernini to think he had succeeded. His remark (12 August) that the bust was the result of a collaboration between him and the King illustrates this, even irrespective of the other indications. But there was also an undercurrent, not merely in the persons of those French potential rivals and professional mischief-makers to whose activities Bernini's lifelong success had accustomed him, but of a more subtle and therefore dangerous kind. The incompatibility of the aims of Colbert and Bernini, not only in connection with the Louvre, but also in almost every other respect, had indeed become apparent before Bernini even left Rome. His residence in Paris had merely exacerbated it. Now, at the end of the mission, the growing tension might have been expected to erupt. In the event it very nearly did, but the explosion was finally averted, partly as a result of Chantelou's diplomacy. One factor, no doubt, was that Bernini was shrewd enough to see that if he quarrelled openly with Colbert the chances of getting his Louvre designs carried out would be small. And as it happened that all of Colbert's (to him) most objectionable qualities were repeated, with interest, in his obnoxious assistant, Charles Perrault, Bernini was able to clear the air to some extent by using Perrault as whipping-boy for Colbert.

The famous quarrel occurred on the evening of 6 October, and recalls the stormy scene in Rome when Créquy had discussed Colbert's first memorandum with Bernini. Chantelou's account of it is corroborated by Perrault himself in his memoirs.[121] It appears that Bernini was already tired. He had returned to the Palais Mazarin specially to see Perrault, who had said he would call at five o'clock. As Perrault was not there Bernini went to church. He then found Perrault at the Palais Mazarin on his return. This was a bad start to the interview, and Perrault's mood was evidently unaccommodating. When Bernini said he hoped the foundation stone could be laid on the following Saturday Perrault replied

that the medals would not be ready so soon. Bernini said they could be placed under other stones than the foundation stone. He wished to leave Paris on the Tuesday. Perrault then said he wanted to clear up various details, such as the distribution of the lodgings in the Louvre, before Bernini left. Bernini immediately took the line that these were things of little moment. Perrault then passed to Bernini's arches on the façade facing the Cour des Cuisines. How would it be possible to close them? Bernini sent for paper and pencil and showed how. Chantelou, feeling the rising tension, said these were trivial matters which could easily be settled several years hence. He added that there had been a similar problem in the new apartments of the Queen Mother, and that that had been solved satisfactorily. Perrault said, on the contrary, it had been very difficult. Chantelou then repeated that these were all matters of little moment and in no way urgent. Perrault said he had many other difficulties to discuss, and one in particular. Not only he but a hundred others, he said, failed to understand why one of the pavilions on Bernini's river façade was smaller than the other, this being both contrary to symmetry and bearing no relation to the dome in the middle.

This was the last straw. Bernini ominously told two of the Italians who were still in the room to leave it. Then he took up his pencil again and indicated his drawing.

If I had raised this pavilion [he said, meaning the one on the left] to the dimensions of the one in the corner, it would have been a gross error. The left-hand pavilion merely needs to harmonize with the other, despite being smaller. I should like you to understand that it is not for the likes of you, Monsieur Perrault, to make objections of this kind. You may have some understanding of the uses of a palace, but the design is the concern of someone more skilled than you are [Bernini indicated himself]. You are not worthy to brush the dust off my shoes. There will be no discussion about the matter which you have raised. The designs have been approved by His Majesty. I will complain to him, and I am going this very minute to Monsieur Colbert to inform him of the outrage which has been done to me.

At this Perrault looked extremely alarmed, as well he might, and whispered to Chantelou to try to mollify Bernini. He said he had not intended to criticize so much as to seek elucidation with which to reply to others who made the criticism. Chantelou explained this to Bernini, and urged him to reflect that he might ruin the career of a young man (Perrault was thirty-seven at the time). Paolo Bernini and Rossi, who

were present, also tried to calm him, but without success. Bernini started to walk about the room, saying at one moment that he was going straight to Colbert, at another to the Nuncio, while Perrault kept repeating that he had not meant to offend the Cavaliere. It was all to no purpose. Bernini continued expostulating.

'To a man of my standing, to me whom the Pope treats with friendship and affection, that I should be subjected to this! I shall complain to the King. I shall leave Paris tomorrow, and I don't know why I don't take a hammer to my bust after the insult that has been done me.'

Chantelou now urged Rossi to go after him and stop him, but Rossi whispered, 'Better to let him get it off his chest. I'll soothe him later on. Leave it to me.' Paolo Bernini tried to come to Perrault's rescue, saying he had not meant to offend. In the end Bernini did not go to the Nuncio or to anyone else. Paolo and Rossi took him upstairs, while Chantelou and his brother took Perrault to Colbert's to try to square matters with him.

In the event it was quickly settled, and Perrault forgiven. In Perrault's own account he says that Colbert reassured him at once that his career was not in danger. Bernini would never risk the cancellation of his Louvre plans. Nevertheless Perrault quickly chose to forget Bernini's tolerance, and after his departure continued to vilify him in word and deed.

To the surprise of Vigarani,[122] who had thought that the cabal against Bernini would prevent it, the ceremony of laying the foundation stone was performed by the King on Saturday, 17 October 1665, with the mixture of pomp and minor mishap which is normal on such occasions. Perrault and Chantelou both describe it. Butti had complained (12 October) that the commemorative inscription, though mentioning Colbert's name, had omitted Bernini's. Chantelou said this was customary. Le Vau's name had not been included in the past. At the end of the day Colbert had confided ominously to Chantelou that he feared that after Bernini left things would not go well at the Louvre.

Things were to go badly at the Louvre before that – indeed, on the following day, when Bernini was on the point of leaving. Then it was that the friction which had long been developing between him and Colbert almost led to an open breach. A brief request by Colbert, dated 18 August 1665,[123] for enlightenment in certain minor architectural details had been followed by the huge memorandum which Colbert handed to Bernini on the next day (19 August) and which went in great

detail into the internal arrangements of the Louvre. There had to be accommodation for all the court officials including the fire brigade, also banqueting halls, ballroom, armoury, library and indoor and outdoor theatres. As the King would only be in residence in the winter, the south range of the Cour Carrée was the only suitable place for his apartments. The memorandum included recommendations for the provision of sanitary appliances and accommodation for soldiery.

Bernini's comment on this, two days later (21 August), was short and predictable. It was none of his business. It could and should be settled by the Grand Maréchal des Logis. One of the few occasions when he volunteered a suggestion about the internal arrangements of his Louvre project occurred on 4 October, when he spoke briefly to Chantelou about a sculpture gallery, saying it should include good Antique works and mentioned as a possibility Michelangelo's *Slaves* which are now in fact in the Louvre and were then at Richelieu.

In his memoirs Perrault gives another malicious anecdote in connection with Colbert's complaint that Bernini had sited the King's apartments in the east wing, which was both noisy and climatically unsuitable. They should instead be retained in the pavilion at the west end of the south range, but Bernini had only allowed for three windows here, which would not be enough.

> The Cavaliere promised [Perrault writes] that he would consider this objection. Three days later he brought to the meeting ... a drawing which he held tightly to his chest, and, speaking to Monsieur Colbert, said he was convinced that the angel who presides over the welfare of France had inspired him. He acknowledged sincerely that he himself would never have been capable of conceiving anything as fine, as splendid, or as suitable as the idea which had come to him. 'I entered', he declared, 'into a profound reverie.' He pronounced these words with such emphasis that anyone might have thought he had descended into hell. Finally, after a long speech, sufficient to make even the most patient lose patience, he allowed us to see the drawing, producing it with a degree of respect which would have been appropriate to the display of a likeness of the true cross. The Cavaliere's profound reverie proved to consist of a small piece of tracing paper stuck on to one of his plans. In this he had marked, in yellow, four windows in the place of the three underneath.[124]

It is worth bearing in mind, in view of Perrault's near-genius for the malicious, and his corresponding tendency to distort the evidence, that the phrase with which he makes most play in the characteristic passage

quoted above, namely 'profound reverie' may not have been Bernini's, or, if it was, may not necessarily have been said on this occasion. The phrase *pensier profondo* is used in a poem by the Abbé Butti on the subject of Bernini's bust of the King.[125]

At the first of Bernini's two final interviews with Colbert, on Sunday, 18 October, the main bone of contention was the large chapel, which, at this late stage, Bernini had incorporated into his plan. Colbert had stressed the desirability of this in his memorandum of 19 August, in which he also recommended that the chapel should be on two floors. Bernini proposed to site it where he had formerly placed the ballroom and banqueting room – presumably in one of the short wings connecting the east and west sides of the Cour Carrée with the new façades. He had evidently tried to meet Colbert's wishes. There was provision for a gallery for the King on the same level as his apartments, and another opposite for the musicians. Colbert said this was too far away, and he also criticized the means of access. Bernini was much put out. He improvised counter-suggestions and spoke petulantly. He had done his best. He had been messed about quite enough. He could do no more, and would leave Paris. The Pope had only given him leave until the end of August. The Abbé Butti tried to defuse the situation with a suggestion, and Colbert attempted to use this to make a joke – the Abbé must not play the architect. This line was to be resumed next day by Bernini himself. In the meantime Colbert stood his ground. These things must be decided. If Bernini and he spent Monday and Tuesday on them, he, Colbert, would do his best to ensure that Bernini could get away on the Wednesday. There was a further outburst from Bernini. Then, without warning, Colbert made the constructive suggestion that the chapel could be a separate building.

After Bernini had left the meeting Colbert said to Chantelou, 'The Cavaliere is very annoyed.' He was indeed. There was a fresh outburst on the subject of Colbert as with Perrault. The difference was that Colbert was not present. This time Bernini himself shut the door before letting off steam. Then he turned on Chantelou. 'I am leaving,' he said. 'He is making a mockery of me, with all his never-ending, senseless talk about privies and conduits. He treats me like a little boy. He thinks himself so clever, but he understands nothing. A real bugger. I shall leave Paris without saying anything.'

The scene which followed is reminiscent of the second act of *Die*

Walküre, where Fricka, with firm and patient reasoning, ultimately persuades the angry and arrogant Wotan to revoke his earlier decision. Chantelou showed himself at his best and wisest, and Bernini, in the end, at his noblest and most impressive.

Chantelou said gently that Colbert was only asking for another two days of Bernini's time. He really must give him that. The King had treated him so well that for that reason alone Bernini ought not to do anything which would displease him. Since Colbert had suggested a church which should be detached from the Louvre, and which could be reached by some kind of bridge, could not Bernini work on this idea and get out a plan? He could say later that he had only done it as a favour, and could indeed frankly admit that it broke the rules of symmetry.

Chantelou's first volley predictably misfired. Bernini said he was not interested. He would do nothing more. He only wished to leave Paris next day. Chantelou persisted in trying to mollify him, and continued to meet with stubborn resistance. 'The King has always been most gracious to you,' Chantelou continued, 'and never more so than at the ceremony yesterday. Not everyone receives such friendly treatment from him. If after that you were to leave without seeing His Majesty you can judge for yourself what would be said.'

Bernini replied,

For thirteen days I have been given nothing to do. My leave of absence from the Pope expired at the end of August, and fresh delay will displease him.... The Pope could well ruin me. Many of the things they refer to me here could easily be dealt with in two or three years' time. When I go I intend, in any case, to leave a written statement for the King explaining my reasons. I know very well that Colbert is more necessary to the King than I am. I have no wish to speak merely so that someone else will reply. It is always the weakest who loses. I do not wish to get myself involved in such intrigues!

Chantelou replied that Bernini must believe him, and that what one did in anger and precipitation never succeeded.

A merciful interruption then ensued. Rossi, who must have been listening at the key-hole, so timely was his appearance, now entered the room. He begged Chantelou to help him with some of the internal arrangements of the Louvre design. But before going out Chantelou was able to see – though it was not until the next day that he understood what was happening – that Bernini had sent for the Louvre plan and was starting to draw on it.

Though the dawn was indeed in sight it had not yet arrived. When Chantelou and Rossi had finished their discussion Bernini came in and it started all over again. When Bernini said he knew the French court would want him to make a bad impression, Chantelou said he did not think they did, but that if Bernini were not careful he would do precisely that. Nevertheless, Bernini was evidently softening a little. He said he was fully conscious of the honours done him by the King. It was not of His Majesty that he was complaining, but of his treatment at the hands of Colbert. 'I have no need of France,' he said. 'They have said they wish me to stay, but their behaviour demonstrates the opposite.... Monsieur Colbert has made it clear that he has no understanding of my work. It is this which disgusts me and which has made me resolve to go.' He then passed to lighter matters. Who was the Abbé who wanted to go to Italy? (It was the Abbé de La Chambre, of whom more was to be heard later.) How did ordinary people get an opportunity to speak to the King? At this moment there was a further interruption of an unexpected kind. A message came from the Grand Condé and from his Intendant (who was yet another brother of Charles Perrault's) asking the Cavaliere's opinion of the tomb of Condé's father in the church of the Jesuits.

The next day, Monday, 19 October, Bernini was entirely transformed. Indeed, early in the morning he offended Chantelou – a very rare thing for him – by asking if he had told Colbert what he, Bernini, had said about him. When Chantelou indignantly denied it, Bernini apologized. He had been very agitated, but had hardly been able to wait for Chantelou to leave on the previous day, before following his advice. He had been so much upset that he had not shut his eyes all night. But he had also designed a new chapel and was extremely pleased with it. Finally, Monsieur du Metz had called to say that if he wished to leave on the Tuesday, everything would be put in hand to that end.

The final, and extraordinary, conference with Colbert then followed. Bernini opened the meeting. His imagination had been so much inflamed by what Colbert had said that he had found a way of designing a detached chapel of the kind he had mentioned. It was to be a large building, as big as the Pantheon, and of a very elegant shape – a perfect oval. He positively beamed at the others, and taking up an aside of Colbert's from the preceding day he made rather a heavy joke. 'I am wrong,' he said. 'It was not I but the Abbé Butti who did the design and sent it to me this morning.' Amid much giggling the Abbé agreed.

Bernini went on to explain the idea. He accepted a minor modification of Colbert's, and then dwelt on the splendour of his new chapel. It would be the most superb that anyone could imagine. As in Bernini's previous project, and as in Colbert's memorandum, it was on two floors. The King would be able to enter the royal gallery direct from his private apartments and on the same level. To descend to the ground floor there was to be a grand staircase. The shafts of the huge, free-standing columns would be of the finest French marble, white and red, with capitals of Carrara marble. Something of the effect which the Louvre chapel would have had may be seen on a smaller scale in Bernini's church of S. Andrea al Quirinale in Rome, which is likewise oval in plan, and likewise carried out in luxurious marble. The pillars on the ground floor of the Louvre chapel which were to support the galleries would be of bronze with gilded capitals.

'I have thought so much about it,' Bernini said, 'but of course I am wrong. It was the Abbé Butti. I have even found a way of giving an effect of symmetry on the side facing Saint-Honoré.' Chantelou was in ecstasy at this volte-face and concluded with an Italian quotation which he said he had heard once in Bernini's company: 'If you want to see what a great man is capable of you must confront him with an emergency' (*'Chi vuol' veder ciò che può un grand'huomo, bisogna metterlo in necessità'*). Even Colbert indicated that Bernini's proposals were entirely to his taste.

The rest of the day – Bernini's last in Paris – was fully filled. There was further discussion with Colbert about enlarging the King's apartments. Bernini then expressed a wish to see the Crown Jewels, some of which were brought in for his inspection. He made a joke to the detriment of Spain, evidently forgetting that it was the Queen's country of origin. The Queen Mother, not to be outdone, insisted on showing him her jewels. Bernini then said that when he saw such beauties of nature he felt a disinterested pleasure, whereas the sight of the beauties of Greek sculpture always inspired a defeatest spirit of emulation.

He even found time to do what Condé had asked. Chantelou led him to the Jesuit church in the Rue Saint-Antoine. The fathers explained what was proposed for the tomb, and Bernini made certain suggestions for improvement. Chantelou anticipated Bernini in passing severe judgement on the decoration of the church. When the fathers said that Cardinal Richelieu had approved of it Chantelou replied that though, no doubt, a very great statesman Richelieu had no understanding of architecture.

The church, now known as Saint-Paul-Saint-Louis, still stands, and is indeed remarkably ugly inside. The Condé tomb is now at Chantilly.

The morning of Bernini's departure, Tuesday, 20 October, was filled with visits of leave-taking of a warm and friendly character. Le Brun's rival, Pierre Mignard, to whom Bernini had shown kindness at the Val-de-Grâce, seems by this time to have become almost a friend. Bernini had kindly allowed the Abbé Pierre de La Chambre to accompany his party to Rome. After Bernini's death La Chambre contributed an 'Eloge' of him to the *Journal des Savants*. Two coaches-and-six were to take the party as far as Lyon where litters and chairs would await them for the crossing of the Alps. Mancini, the courier who had accompanied them from Rome, was to escort them to Lyon, and Esbaupin as far as Rome. Chantelou himself was coming with them to Villejuif, also the Nuncio and, of course, the Abbé Butti.

They set out, with lively discussion *en route* on the merits of Richelieu and Mazarin, about the financial irresponsibility of Pietro da Cortona, and about Borromini and Le Vau (this was when Bernini said he had never met him). On the subject of Borromini's architecture the opinion was voiced that whereas other architects took the human body as the canon of proportion Borromini based his on the chimera. Bernini remarked at the mention of Mazarin's name that Cardinal Pallavicini had considered him one of the two great men of his time. When the Nuncio said, 'I suspect the other was yourself,' Bernini pretended to deny it. At Villejuif Bernini and Chantelou took a tearful farewell of each other.

Despite Bernini's last minute retrieval of his reputation with Colbert malicious rumours were circulated as soon as he left. Their progress, meticulously recorded by Chantelou, was a kind of snowball such as would have been common at court. On 22 October, two days after Bernini left Paris, Chantelou was at the King's supper. Bernini's old enemy, the Maréchal de Gramont, started the ball rolling with heavy sarcasm. 'The Cavaliere was mighty generous,' he said. 'He gave thirty sous to an old maidservant. When she rejected them he pocketed them himself. He also took the money for himself which the King intended for his servants.' The Comte de Gramont nodded approval. He was the younger half-brother of the Maréchal and the author, or at least the subject, of the famous memoirs. The Comte de Sault had told Chantelou before the King sat down that Bernini had not been satisfied with the emolument he had received. This had amounted to 3,000 pistoles, and

a pension of 2,000 écus. Appropriately smaller sums had been paid to the others in his party. Chantelou replied that Bernini had left covered with benefits and with the esteem of His Majesty.

At this point Colbert intervened, remarking that Bernini had not seemed very impressed with what he had received. Chantelou denied it, and Colbert said he would speak to the King. The sense in which he did so was not slow to show itself.

On the same day, at the King's *lever*, several other courtiers told Chantelou that Bernini had left dissatisfied, and it was hardly surprising that the plangent tones of Monsieur were soon added to the hubbub. At his *déjeuner* he repeated the rumour in a whisper in Chantelou's ear, and on hearing the denial said twice, 'But the King thinks so.' Still other voices joined in, and Chantelou decided to write to Bernini on the subject. Monsieur repeated the accusation next day and added, 'The King says he has had it from a source which cannot be doubted.'

Two days later the King himself asked Chantelou if the story about the tip to the maidservant were true. When Chantelou said he had no knowledge of it the King added, 'Is it true that he left discontented?' When Chantelou again denied the charge and said he was writing to Bernini the King asked, 'Have you already written?' 'Yes, Sire.'

In fact Chantelou sent not one but two letters on the subject to Lyon, from which Bernini replied on 30 October. He said, 'If God gives me life I will show not with words but with deeds how greatly I am indebted to, and how affectionately I feel towards, so great a King.' This letter, as Chantelou's editor, Lalanne, pointed out, is not a full answer to Chantelou. But another, printed by Domenico Bernini, is more specific, and though the date and the name of the addressee are not given, it answers Chantelou's letter so perfectly that it must have been meant for him.[126] It is also, in all probability, Bernini's finest extant letter, fiery, proud and unaffectedly stylish.

Concerning the gossip which you tell me is being directed against me in Paris, instead of grieving I almost rejoice in it, since, whereas my ill-wishers have been powerless to discredit my deeds, they attempt, on too feeble grounds, to dishonour me by words. Hence I know not which is the greater stupidity, that of those who fabricated such things, or that of those who may believe them. It is common knowledge how great are the presents with which I have been honoured by the King, and I may say that my labours have been more liberally rewarded in six months in France than in six years in Rome. But since I have

been worthily presented with royal gifts I must receive the myrrh of malevolent misrepresentation, having already tasted the gold of riches and the incense of honour in abundance. Time will reveal truth, as I have already discovered to my benefit in days gone by.[127]

Colbert, who had already misled Chantelou once, now did so again. On 8 November, when Chantelou showed him Bernini's letter, he implied that it was to the Nuncio that Bernini had expressed his discontent and that the Abbé Butti had spread the story. To anyone who knew Butti this would indeed have sounded plausible and even likely. But though it was he who finally revealed the truth, his own part in it was not discreditable. On 30 November he told Chantelou that the story started when Bernini was saying good-bye to Colbert, and arose owing to his curious way of expressing himself. Bernini told Colbert that only the Pope and the King could have induced him to leave home. He would not have done so if anyone else had offered him 50,000 écus. He had not mentioned the King's liberality, but merely spoke of the honour done him and of the affection shown him, for which he would be eternally grateful. This was all the foundation there was, and the blame for the whispering campaign lay with Colbert. It was a contemptible storm in a teacup, and Colbert, of all people, should have known better. Butti said that Perrault, for his part, had been spreading the rumour that Bernini had let his Italian workmen starve by not paying them. He had also made play with the *faux pas* that Bernini was said to have made at Lyon on the return journey.

On 30 October Rossi reported that they were leaving Lyon on the Turin road.[128] They had reached Rome safely by 3 December, and on the 8th Bernini wrote again to Chantelou, announcing laconically, at the end of his letter, the death of Poussin.[129] In default of further letters from Rossi, who fell ill on the return journey but who in any case would have had little reason to write any more when so nearly home, we have few details of the progress.[130] Though Bernini's French journey was indeed over, his work for France was not. Three major jobs remained: the continuation of the Louvre plans, the supervision of the new French academy in Rome, and the execution of the equestrian statue of the King. In the event the second and third of these commitments were to become closely interrelated.

PART FOUR

The Aftermath

XVII

For more than a year after he returned to Rome Bernini continued to correspond with Colbert and with Chantelou concerning the Louvre. There was, of course, little that he could do from Rome, and Rossi's return to Paris was delayed by his illness. On 14 December Bernini said he had nearly finished the Cathedra and would then start the two statues of Hercules to flank the main entrance to the Louvre.[131] On 30 January 1666 he reported the Cathedra as complete. Rossi finally left for Paris early in March, and on arrival in May, set to work supervising the construction of two models, in wood and in plaster, of Bernini's final Louvre designs. He mentioned that there was, understandably, difficulty with the staircases as a result of lowering the *piano nobile*. The plan also shows that the small courtyards were deepened considerably on the west side and slightly on the east. Work on the models seems to have lasted all the summer and autumn. On 1 October 1666, in a letter which contained a detailed account of the Great Fire of London, Rossi reported that the Grand Condé had been to see the models and had much admired them, but that Colbert had not yet inspected them. After a further complaint (5 November) of Colbert's non-attendance, Bernini was finally informed, this time by the Abbé Butti, that Colbert had brought himself to make the inspection 'on the first day of Lent' 1667.[132]

Though the models themselves are lost, three of the drawings which Tessin had had made from them are now at Stockholm and constitute the basis of our knowledge of Bernini's final designs. The main Stockholm drawing shows only the southern half of the east façade. It breaks off just to the right of the centre, and this is a factor to take into account.

If the drawing had shown the whole of the façade it would have appeared too long in proportion to its height – which was no doubt why Bernini had wanted a higher *piano nobile*.[133] It would have given the effect of palace by the yard, as is in fact the case with the existing garden front of Versailles. A little, but not much, of this effect in the Stockholm drawing may be due to the omission of the balustrade sculptures. These would presumably have been added if the design had been carried out. Nevertheless we can see, and Bernini, by this time, was in a position to know, that in practice it might not be possible to retreat far enough back from the east façade to take it all in. There is, even now, only just enough space in which to do so. The choice was between a frontal view of merely a section of the huge expanse, or a view in steep perspective of the whole from the side. And in either case the less lofty dimensions of the final project might have been preferable to the towering cliff of the third.

Throughout the year 1666 it seems no structural work of any kind was done in connection with Bernini's project – officially, no doubt, because Bernini's design could not be regarded as finished until the completion of the models. In April 1667 Vigarani reported that things were still at a standstill, despite the return of the favourable season and he reiterated rumours that the plan was to be shelved.[134] Butti, in the letter in which he reported Colbert's inspection of the models, said the minister was still harping on the lack of space in the King's suite. Bernini's own correspondence with Colbert in the year 1666, however, gives no hint of impending trouble, though his complaint (8 December) that his pension had not been paid was answered by Colbert at his most governessy: 'The King,' said Colbert, 'not being in the habit of conferring graces which he does not honour, the necessary formalities for paying your pension and that of your son were put in hand as soon as you took the trouble to write to me on the subject, and I take it on myself to be so punctilious in getting it paid in future as to leave you under no necessity of reminding me of it.' As we shall see, this was to be far from the truth. Colbert added that as the Tuileries were now in a fit state to accommodate the King, serious work on Bernini's Louvre project could begin. He concluded by repeating his suggestion that Paolo Bernini settle in France with a French wife.[135] As late as 11 March 1667 Colbert repeated that work on the Louvre was about to begin.[136] But on 15 July of the same year he wrote to Bernini as follows:

The King has expressed great regret at being unable to put into execution the beautiful design which you gave him for his palace of the Louvre. But His Majesty, realizing that it would be difficult to embark on so considerable a project in the present state of war both by land and sea, whose duration, being uncertain, might necessitate suspension, and at the same time being under the necessity of being lodged, has seen fit to continue the building according to the plan started by his forebears, and this could be finished in the course of two or three years. His Majesty reserves the possibility of carrying out your design at a later date and of choosing for it a site commensurate with its grandeur and magnificence. He has therefore not abandoned hope that you may appreciate the situation and even participate in it by giving him once again the pleasure of seeing you at work with such conspicuous success.[137]

Though at first sight Colbert's letter seems to be an attempt to convey an unpalatable truth honestly, it was in fact a tissue of half-truths. The decision to abandon Bernini's project had been taken before the war started, while Colbert's own earlier letter had actually volunteered the information that the King was being accommodated in the Tuileries. In a letter to Chantelou dated 18 July – and thus before he could have had Colbert's letter – Bernini had mentioned that Rossi had arrived back in Rome.[138] Bernini must therefore have known at that time of the abandonment of his plan, but he says nothing about it to Chantelou. We have in fact no information on how he took it, and it was more probably from France than from Italy that wishful thinkers spread the rumour that Bernini was contemplating suicide – a rumour which we know from Queen Christina's sensible declaration, in a letter of 1 September 1667, that she did not think he was that sort.[139]

When, in the following year, Chantelou tried to make Colbert reverse the decision, Colbert attempted to justify it to Chantelou by repeating the arguments, and virtually also the words, which he had used in his memorandum of 19 August 1665.[140] 'The plan of the Cavaliere Bernini,' he said, 'although fine and noble, was nevertheless so ill conceived from the point of view of the King's amenity that after spending ten million he would be just as cramped as he is now.' When Chantelou said that Bernini had planned new apartments for the King in the angle nearest the Pont-Neuf, Colbert, predictably, said, 'It would be ridiculous to situate Their Majesties' suites in a spot where it would be necessary to station sentries to prevent the traffic from approaching in the morning. I informed Bernini that the King's apartments could only be where they

are now, but the Cavaliere would not listen, and only wanted to do things as the fancy took him.'

As early as April 1667, and therefore a month before France invaded Flanders, a committee consisting of Le Vau, Le Brun and Charles Perrault's brother, Claude, had met for the purpose of producing an alternative to Bernini's plan. Colbert had understandably delayed for three months breaking the news to Bernini. Rossi's imminent return to Rome was presumably the spur. Some extracts of the minutes of the meeting, taken by Charles Perrault, are quoted by the author of an eighteenth-century guide to Paris, Piganiol de La Force.[141] One of them states that the three men should work together towards the completion of the Louvre in such a way that the resulting design will be regarded as the 'work of the three equally'. Such has in fact not been the case. As a result of Charles Perrault's statement in his memoirs[142] that the existing façade, with its colonnade of free-standing double columns on the east front – the great feature of the design as executed – had been his idea, that it had been worked up by his brother, and that its essentials had been submitted before Bernini even arrived, the undivided credit was long given to Claude Perrault. More recently[143] it was pointed out that one of the crucial drawings is in a style of draughtsmanship associated with Le Vau, which invites the comment that even if a project really were the joint work of more than one person it is still only one of them who can record it in a drawing. Though the controversy continues,[144] two general points of different kinds are worth making. One is that the east colonnade of the Louvre as it exists is greatly superior to any of Le Vau's undoubted works. Secondly, all three members of the committee were available before Bernini was summoned to Paris. Once again we ask: why had Colbert gone to the trouble of getting Bernini to Paris, and how did he justify the expense?

His dislike of Le Vau remains one likely reason. This was shown again in a remark quoted by Chantelou on 5 August 1665, when Colbert compared Le Vau's behaviour unfavourably with that of Bernini. It is also probable, and perhaps decisive, that the King's imagination had been fired by what Cardinal Antonio Barberini would have told him about Bernini during the preliminary discussions – that Louis XIV positively and specifically wanted Bernini to come to France.

But Colbert's position was now acutely difficult. Influenced by constant pressure from Perrault, Le Brun and other dissidents, he was

convinced, by the time of Bernini's return to Rome, of the undesirability of his Louvre project. But the King still favoured it. This alone might have been sufficient reason for Colbert to hesitate to propose its cancellation. In addition he had a personal and pressing reason for not doing so, in that he had authorized the expense of Bernini's mission. The collapse, in the early spring of 1666, of Bernini's trial vault, built in the expectation of demonstrating the superiority of the Roman system over the French, would have played into Colbert's hands. But his best method of getting Bernini's scheme cancelled was by means of delay, and here again circumstances favoured him. First, Rossi's illness, then the ineffectiveness, as a team, of Chambray and Rossi, together with the impossibility of Bernini's ever being able to exercise effective control from Rome over building operations in Paris – these factors were heaven sent. Finally, there was the delay over the models. They took, in the first place, many months to make. It was evidently an essential part of Colbert's strategy that the final decision whether or not to proceed could not be taken until the King had seen them. The ceremony of laying the foundation stone was evidently regarded as having been a formality, and as having no meaning except, perhaps, as a means of ridding Paris of Bernini's presence. Obviously the King could do nothing until Colbert himself had inspected the models, and Colbert allowed several months to elapse before he could bring himself to spare the time. The King's own inspection probably took place after Colbert's letter to Bernini of 11 March 1667, in which he was still reassuring, and certainly before the committee of three met in April – in other words, nearly two years after Bernini had first arrived in Paris. Colbert had allowed plenty of time for Bernini's reputation to plummet.

For the King's visit we are dependent on Perrault's account, in which he again shows himself in a despicable light without, apparently, realizing it.[145] He describes the King's inspection of the models, and how he left without coming to a decision. Whereupon Perrault, combining the roles of Iago and Portia, whispered in Colbert's ear that he could set aside Bernini's plan with a clear conscience on the ground that it had infringed his undertaking not to demolish the existing building. The ingenious and tortuous argument depended on the principle that a pound of flesh had been agreed but not a drop of blood. Bernini's project would involve the removal of the four small domes, and this, together with his proposed refacing of the existing walls, amounted to demolition. 'For,'

Perrault went on, 'to remove columns, cornices and all the ornament of a building is as much to destroy it as it would be to ruin a picture by painting another design on top of it on the same canvas.' As a *coup de grâce* Perrault added that Rossi agreed with him. Whereupon the unholy pair, according to Perrault's account, browbeat the unfortunate Rossi into concurring.[146]

Though the King is unlikely to have swallowed the pseudo-legalistic casuistry inherent in this highly disreputable story, his inspection of the models, as it occurred at the critical moment, would have been decisive, though probably for a different reason. Through spending much of his life either hunting or in campaign conditions the King must have been extremely tough physically, and may therefore have placed less emphasis on his convenience than Colbert did on his behalf. But he had a correspondingly greater sense of magnificence than Colbert, and for this reason he had developed a good eye for style in architecture. Without the force of Bernini's personality and presence it would have been even more apparent, on inspection of the models, that his design was very un-French. The next stage would have been the realization that French artists – not, of course, the tiresome Le Vau by himself, but rather a consortium of the best of them – might profit by the grandeur of Bernini's ideas, particularly in the matter of the terraced skyline, but execute it in a French way, as well as in a more economical one. It almost looks as though the King had begun to realize that the mere fact of being Italian did not automatically make Bernini the heir of Antiquity, and that it might be possible for French artists to get nearer than he did to the spirit of Antiquity without ceasing to be French. The existing east colonnade of the Louvre, a tremendous masterpiece of architecture, realized this idea to an extraordinarily complete degree.

However the decision was taken, there was to be no more procrastination, war or no war. Vigarani reported activity at the Louvre by August 1667.[147] Despite this he mentioned next year (2 March 1668)[148] renewed rumours that Bernini's scheme might yet be executed, and Chantelou noted that he himself petitioned Colbert on 26 June of that year in the same sense.[149] In this document he mentioned Le Brun's and Perrault's dislike of Bernini in a belated attempt to counter their influence. But Chantelou's *démarche* had no chance of success, and the French scheme went ahead.

The desirability of extra space on the south side, the most habitable

portion of the building, and the consequent doubling of the width of this wing towards the river ultimately brought with it, as Perrault had indeed foreseen in connection with Bernini's plan, the necessity of demolishing the existing small dome of its central pavilion, and also the truncated pyramids which crowned the end pavilions. These, with the dome, would otherwise have seemed to sprout from the middle of the augmented wing, as well as spoiling the new terraced skyline. To judge from a picture by N. J.-B. Raguenet in the Musée Carnavalet they were nevertheless still there as late as the eighteenth century. It also necessitated the widening of the east façade. Despite all this the eastern colonnade appears to have been finished structurally within the time limit estimated by Colbert, namely in 1670. Then there were delays. The King's architectural interests were by then exclusively concentrated on Versailles, and after the completion of the Cour Carrée the Louvre was again neglected.

The scheme as executed in the late 1660s did without Bernini's proposed transformation of the interior of the Cour Carrée by means of arcades and staircases. This measure of economy rested, evidently, on the realization that the inside and outside of a courtyard can never be visible simultaneously. In consequence some stylistic disparity is tolerable. The new courtyard façades were therefore designed to harmonize with Lescot's sixteenth-century range, rather than with the innovations of the new eastern and southern external façades. A similar device was adopted at Versailles, where the garden façade is in a different style, and even different materials and different colour, from the town front.

The idea of a royal palace of overwhelming and calculated magnificence, situated in the centre of the capital city can be associated with the idea of Divine Right, and therefore above all with the seventeenth century. The Louvre of Colbert and Bernini would have accorded admirably with this idea. But Louis xiv's prejudice against Paris, and his final transfer to Versailles, introduced a new twist. Though a number of huge, cubic palaces, influenced by Bernini's Louvre, did get built in the heart of capital cities – not only at Stockholm, which was certainly inspired by it, but also, more indirectly, at Berlin, St Petersburg and Madrid – the suburban and country palaces which were inspired by the idea of Versailles were probably more remarkable in themselves, and also more characteristic of the final phase of royal absolutism. London got its Hampton Court, Berlin its Potsdam, Vienna its Schönbrunn, St

Petersburg its Tsarskoe Selo, Madrid its La Granja and Naples its Caserta. Since none of these might have existed without Versailles – or even Versailles itself – if Bernini's Louvre had been executed, and since in that case we should certainly have been denied the existing east colonnade of the Louvre, we can form our own verdict on which would have been the greater loss.

XVIII

IN THE LETTER in which he reported that Colbert had been to see the Louvre models 'on the first day of Lent' 1667 the Abbé Butti also took it on himself to remonstrate with Bernini on another matter. The Abbé reported that Colbert had 'received with pleasure the thanks which I transmitted to him on your behalf, but he complains vigorously that you have not yet paid a single visit to the academy of the French painters. I knew not how to excuse you. For the love of God I pray you reply immediately.'

With his acute instinct for the way the wind was blowing Butti had identified what was currently an overwhelming interest of Colbert's. Colbert had, indeed, discussed it with Bernini in Paris. The first occasion was at Saint-Germain on 5 July 1665, before Bernini's audience with the King. On this occasion both Bernini and Colbert had spoken at some length. Colbert said that the King would spare nothing to make the arts flourish in France. 'To this end', he said, 'His Majesty wishes to encourage young artists to study sculpture and painting in Rome. I am sending an artist called Errard with them to take a house where they will be kept at the King's expense.'

Bernini replied, 'That is well. But it will be necessary to adopt different methods from what have been the case in the past. It has been customary to go to Rome at the age of fifteen and then to do nothing but draw [from the Antique] for nine or ten years. As a result a man is already twenty-five before he starts his career. Things should be arranged differently. You should draw one day, then work independently the next, whether in sculpture or painting, and in this way you become much more accomplished.'

Colbert expressed approval of this excellent advice (which Bernini

repeated in his speech to the Academy on 5 September), and then enquired if Bernini would be willing for the young sculptors whom the King would be supporting to come to him, Bernini, for instruction. Characteristically Bernini seized this opportunity to suggest that the youths in question could help him by executing the sculptures which he himself proposed to design to go with his Louvre project. He added that there were even two or three good French sculptors in Rome already. When Colbert asked their names Bernini was unable to recall them.

Colbert reminded Chantelou of Bernini's undertaking ten days later, when they were watching students copying the Poussin decorations in the Grande Galerie of the Louvre. Colbert's considered views on the subject of the Rome academy are contained in the letter which Perrault had drafted for his signature and which was to have been sent to Nicolas Poussin in Rome in 1664 but which Perrault admits was never sent.[150] In it Perrault says,

> With regard to painting and sculpture, for which His Majesty has a singular esteem, and which he considers as two arts which should pre-eminently contribute to the establishment of his fame and the transmission of his name to posterity, he will omit nothing to ensure their attaining the peak of perfection. It was for this noble and admirable reason that His Majesty established in Paris, some years ago, a royal academy of painting and sculpture, that he engaged professors for the instruction of the youth, endowed prizes for the students and gave this institution all the privileges it could desire. This body has already justified itself. It is there that there have been formed students of great promise who should one day become excellent masters. But inasmuch as it still seems necessary for the young members of your profession to spend some time in Rome in order to form their style and their taste on the originals and model of the greatest masters of Antiquity and of modern times, and since it is not uncommon that those who have the most talent do not wish, or are not able, to make the journey on account of the expense, His Majesty has resolved to send there every year a certain number who will be chosen in the academy [in Paris] and whom he will support in Rome during their stay there.

Colbert lost little time in implementing his idea. He approved the statute and regulations of the academy on 11 February 1666, and Errard left for Rome some time that summer. There were to be twelve students, six painters, four sculptors and two architects. They were normally to be those who had obtained prizes at the academy in Paris – subsequently called the Prix de Rome. Accommodation was evidently limited and of

an improvized nature at first, in the so-called House of Saraca at S. Onofrio on the Janiculum. It is as difficult to imagine the great Bernini going slumming to such an establishment as it is easy to picture his distaste at the prospect. Soon afterwards the young academy moved to the Palazzo Caffarelli at the Capitol. From 1673 it was housed in the Palazzo Capranica, near the Pantheon, and then in the Palazzo Mancini. Only in the Napoleonic period, in 1803, did the academy move to its fifth home, the Villa Medici, which it still occupies.[151]

Inasmuch as Bernini had agreed to be the first tutelary god of the new institution, and since it was the brain-child of Colbert, the scene was palpably set for a return bout, for an indefinite period, of the sparring which had characterized the encounters in Paris between the most famous artist of the day and one of the greatest statesmen. Now, with hundreds of miles, as well as some bitter experiences, between them, the emphasis shifted. Colbert versus Bernini, Rome style, concerned finance. Though no conditions, apparently, had been attached to the grant of Bernini's pension, Colbert wanted value for money. And Bernini, who, throughout his career, had shown an extraordinary interest in that commodity, was equally determined not to do anything more for France until he was paid. When, in 1670, Bernini again complained that his pension was late Colbert dropped a hint, with a reference to 'people to whom the King awards pensions and who justify them by their work'.[152] The work, in Colbert's mind – since Bernini's infrequent and irregular visits to the Rome academy were not enough, now that the Louvre project was dropped, to justify the money the King was paying him – was of quite a different kind.

To the King himself Colbert explained the situation with brutal frankness. 'The Cavaliere Bernini' he wrote on 16 May 1670, 'is at present at work on the equestrian statue of Your Majesty, using a vast block of white marble which I had transported to his studio. It is for this reason that I have forwarded to Your Majesty the recommendation for paying his pension and that of his son.'[153]

This *quid pro quo* had been suggested by Colbert in a letter of 2 December 1667, only four and a half months after he cancelled Bernini's Louvre plan.[154] In it he said, with pompous embarrassment,

If you wished to add to the marks of esteem which you have for His Majesty by deploying part of your time towards the goal of his glory or his satisfaction, you could yourself experience that of seeing your own reputation established

and transmitted to posterity in each of the two greatest cities of the world. To this end it is my passionate desire that you make a statue of the King on horseback in marble, the decision to be yours whether it be of life size or over life size. I can go so far as to assure you that in such an eventuality His Majesty would be willing to have a building specially constructed to display the sculpture in all its beauty.

Predictably, Bernini fell for this. Though Colbert's vague early suggestion for a full-length statue of the King (22 June 1665) may not have included a horse, Butti had mentioned such a project on 12 October of that year. We also know that Bernini himself had at one moment been thinking along these lines, though we are not told if he had spoken of it to Colbert. Chantelou mentions it on 13 August 1665. Bernini was explaining to him and the Abbé Butti his plan for a vast amphitheatre between the Louvre and the Tuileries. 'Before that,' he said, 'I had the idea of erecting two columns like those of Trajan and Antonine, with, between them, a pedestal supporting a statue of the King on horseback, with the motto *non plus ultra* in allusion to Hercules.' This was evidently following a still earlier idea which Bernini had mentioned on 25 June: to juxtapose the columns of Trajan and Antonine in Rome and to build fountains round them. 'This would have made the most beautiful piazza in Rome,' he said.

In his letter of 1667 Colbert went on to say that the statue could be sited either on the new bridge which was planned to replace the Pont-Rouge, or at the Tuileries. Two years later there was a further exchange of letters on the subject.

Your Excellency has honoured me [Bernini wrote to Colbert on 30 December 1669] by approving my suggestions both regarding the idea and the design of the statue, as well as the proposal that the execution should be left to the young sculptors of His Majesty's academy, according to the following method. First, I will make with my own hand the clay model of the work, then I will be constantly on hand to assist the aforesaid youths in working from my model and telling them precisely how to do it. Then, I will carve the head of His Majesty entirely with my own hand, and if God gives me life and strength, I will force myself, for the great love and duty which I bear His Majesty, to do what I do not wish to promise in words but only to demonstrate by deed.

This statue will be quite different from that of Constantine, since Constantine is in the act of gazing at the cross which has appeared to him, while the King will be shown in an attitude of majesty and command. Nor should I ever have permitted that the King's statue be a copy of that of Constantine.[155]

It is clear from this that Bernini had returned to the idea he had had when Colbert, at Saint-Germain, had first broached the subject of Bernini's assisting French students in Rome – namely by getting *them* to carve statues which he, Bernini, would have designed. In the present letter to Colbert the reference to the marble Constantine, now in the Vatican, is natural, since Bernini had only recently finished it. The letter of 30 December 1669 also leaves no doubt that Bernini had even now not started work on the Louis statue, though it was two years since Colbert had first raised the matter.

Colbert himself was now in no doubt of Bernini's attitude. On 24 May 1669 he wrote in a letter to Errard, 'Continue to urge the Cavaliere Bernini to work on the equestrian statue of the King, and even though you may find him perhaps somewhat aloof and apathetic to this work, do not omit to speak to him about it from time to time.'[156] In a letter to the Duc de Chaulnes (17 April 1670) Colbert went further. 'I have not failed', he said, 'to seize opportunities to encourage the Cavaliere Bernini for his own honour's sake to expedite the work on the King's statue. But honour is not the main force which impels him. It is what is in his interest. He has unburdened himself more readily to the Abbé Benedetti than to me, and has told him he cannot believe His Majesty to be as eager for this work as he is said to be, since his pension has not been paid.'[157] Now, however, two instalments of the pension had reached Bernini before the end of the year 1669, and he evidently saw no need to delay further. The superb terracotta model now in the Borghese Gallery must date from this time, and soon afterwards Bernini set the French students to work on the marble. In his travel report to his father of 3 April 1671 Colbert's son, then on a study trip to Rome, said he had seen the statue in Bernini's studio, but that it was still only a 'mass of marble'.[158] A letter of 14 September 1672[159] said the head of the King was then finished and the rest of the work in an advanced state. If progress were maintained the whole should be finished in less than a year. A further letter, dated 23 August 1673, to Colbert from Noël Coypel, who had succeeded Errard as director of the Rome academy, said that by then the statue was nearly finished.[160]

Then there was a mysterious stoppage, both of work and news. As late as 1 February 1680 Colbert was still urging Errard to ask Bernini to come and watch the students at their work,[161] but Colbert did not write to Bernini after October 1673, and no further pension was paid after

1674. As early as 1670 there had been a strange marginal annotation by the King to one of Colbert's memoranda to the effect that he saw no reason to give Bernini any more money.[162] In addition to the pension, however, an *ex gratia* fee for the statue was paid in 1671, and another in 1673.[163] Obviously Colbert stopped the pension in 1674 because he assumed from Coypel's letter that the statue would be finished by then, even if Bernini, not unnaturally, had not admitted as much. But it is also likely that as with his Louvre designs there had been intrigues in Paris against Bernini's statue.

For it is clear that Le Brun had also been working on what was evidently designed to be a rival equestrian monument to the King.[164] As he was a painter and not a sculptor Le Brun was in this case merely the designer: the execution was to be carried out by Girardon, who got as far as making the models. We know from surviving drawings that the work was to be on a huge scale, with allegorical figures of captives and rivers, and that for the base Le Brun cribbed Bernini's idea of a rock. Eighteenth-century writers, such as Lafont de Saint-Yenne and d'Argenville, attributed the original idea to Bernini, including its setting in a monumental *place* opposite the east façade of the Louvre.[165] But Chantelou says nothing about the latter, apart from describing Bernini's improvization to Colbert on 15 July 1665, and the drawing which Bernini showed the King after the sitting for the bust on 11 August. Nor did Colbert include the Louvre site among his suggestions in his first letter to Bernini about the statue (December 1667), though, as we have seen, a vague idea for a monumental *place* south of the river had been adumbrated in the memorandum which Colbert gave Bernini on 19 August 1665.

This was not all. At about the same time the Abbé Benedetti, who, as we noted, had been partly instrumental in getting Bernini to Paris in the first place, was trying to revive a scheme of his own which he had first put forward in 1660.[166] This proposed the construction of a monumental flight of steps to link S. Trinità de' Monti in Rome with the Piazza di Spagna below. This was terrain claimed by the French, for whom Benedetti was working. His proposal, which is recorded in a drawing in the Vatican, included an equestrian statue, and was in effect an anticipation of the existing Spanish steps, which were not built until the eighteenth century. In reviving his plan Benedetti evidently now proposed that it should be Bernini's statue of the King which should occupy the place of honour in the middle of the steps: this as an alternative to

sending it to Paris. So much is clear from a report sent to Modena, dated 30 May 1671. Recording the first *ex gratia* fee of four thousand scudi to Bernini it says, 'This is on account of his having started the great statue of His Majesty which is to be placed at the Trinità de' Monti, though others say it will go to France.'[167] It is worth noting in this context that at this time French prestige was high in Rome, partly for political reasons. In 1676-7 Le Brun was actually elected president, *in absentia*, of the Academy of St Luke.

In view of what we know of Le Brun's influence with Colbert, and of his jealousy of Bernini, it would be by no means impossible that Colbert heard of Benedetti's scheme (and his letter of 17 April 1670 to the Duc de Chaulnes leaves no doubt that he was in close touch with Benedetti) and that the news reached Le Brun, who thereupon realized that this would give Colbert an excuse for leaving Bernini's statue in Rome and thus give him, Le Brun, a clear run in Paris. Perhaps Colbert was not entirely convinced, or perhaps he took the view that there was room in Paris for both monuments. At all events he made the gesture of writing, on 27 January 1679, to Errard (who in the meantime had been re-appointed to the directorship of the Rome academy) urging him to investigate means of getting Bernini's statue transported to Paris.[168] Later that year (2 August) Colbert asked Le Nôtre, then on a visit to Rome, to vet the statue, and later still (19 February 1682) he made the same request to the Duc d'Estrées, saying that he had been receiving very diverse reports on it.[169] Evidently Errard did not over-exert himself, as the statue was still in Rome at the time of Colbert's death in 1683. Bernini himself had died in November 1680.

The decision in 1684 by Colbert's successor, Louvois, to have Bernini's statue transported to Paris suggests that by then both Le Brun's scheme and Benedetti's had foundered. The conditions of the transport of the huge and unwieldy object are well documented. An anti-French news item from Rome (15 July 1684) complains that its weight had already ruined the Roman roads merely through being taken from Bernini's studio near St Peter's to the Ripa Grande of the Tiber where it was to be embarked.[170] It had reached Paris, via Le Havre, by March 1685. At the end of August of that year it was taken to Versailles. Domenico Bernini says (truthfully) that it remains there, and adds, as a piece of filial wishful thinking, that it continued to excite the admiration of the world for the artist who made it, and for the monarch whom it represents.

The truth is rather different. A published archive dated 21 March 1685 records that as soon as the statue was unpacked in Paris it was disliked, and that it was to be sent to Versailles for that reason.[171] As Versailles was by then the seat of the King the reasoning is strange, and recalls the story of Samuel Pepys receiving a gift of a haunch of venison and then, perceiving it to be tainted, sending it on to his mother. There is nevertheless no doubt about the facts. The diary of the courtier Dangeau is the source for the sequel. Under the heading 'Wednesday 14th' [November 1685] he writes, 'The King walked in the Orangery, which he pronounced to be of admirable magnificence; he inspected the equestrian statue by the Cavaliere Bernini which has been placed there and found both rider and horse so badly done that he resolved not only to remove it from where it is, but even to have it destroyed.'[172] A year later, however (1686), payment was made for transporting the work to the Pièce de Neptune,[173] and two years later still (4 January 1688) the sculptor François Girardon was paid for 're-doing the head of the figure of the Cavaliere Bernini' à refaire la teste de la figure du Cavalier Bernin).[174] The rider now has a helmet which evidently dates from this time, and instead of rocks under the horse's belly there are flames. The Sun King has been changed into Marcus Curtius leaping into the fiery abyss.

It would be of interest to know who, by ingeniously suggesting this transformation, thereby saved Bernini's statue from destruction. Was it the faithful Chantelou? Bernini can have left few other true friends in France, but Chantelou never carried much weight. Or, now that Colbert was dead, was it a nameless official, inspired neither by love of Bernini nor of the statue but merely animated by Gallic reluctance to destroy what had already cost so much? We are also not informed who it was who selected the sculpture's final resting place at the far end of the Pièce d'Eau des Suisses, though the King must have approved of this.

We have contemporary descriptions of the work which throw light on Bernini's aims. One is by his old friend, Padre Oliva, the General of the Jesuits, who wrote in November 1673, when the statue was very nearly if not quite finished, that the horse, though of marble, seemed to move and to neigh, and the King to speak and to dispense pardon.[175] The others, more important, are Bernini's own, recorded by his son Domenico.[176] When a visitor boldly criticized the King's drapery and the horse's mane as too agitated, and as departing from Antique precedent, Bernini made one of the most illuminating of all his comments on his

own sculpture. 'This which you claim as a fault', he said, 'is in fact the highest achievement of my art. It is here that I have overcome the difficulty of taming the marble as though it were wax, and have thereby in some measure united painting and sculpture. The reason why the Ancients did not achieve this may have been that they lacked the courage thus to subdue stone to their will.' Elsewhere Bernini explained the basic idea of the equestrian statue:

I have not depicted King Louis in the act of commanding his armies, that being something which is proper to all princes, but have wished instead to show him in a state to which he alone has been able to attain, and that by virtue of his glorious deeds. And whereas poets proclaim that Glory resides on the summit of a lofty and steep mountain, whose summit is very rarely arrived at lightly, I wished to show that those who in fact succeed in arriving there in safety, having survived the dangers, cheerfully breathe the air of gentle glory, which, through having cost such pain and grief, is the more welcome in proportion to the toil of the climb. And whereas King Louis, by virtue of his long series of famous victories, has already conquered the precipice of the mountain, I have shown him on its summit on horseback, palpably possessed of that glory which has accrued at the price of bloodshed. And since a jovial expression, and a mouth agreeably laughing, are proper to him who rejoices, it is precisely thus that I have represented that monarch. Moreover, though this idea can easily be recognized by anyone who looks at the sculpture, it will nevertheless be much more readily apparent when it is installed in its destined setting. For there is to be fashioned, in another piece of marble, a cliff which is appropriately steep and rocky on which the horse is to be placed in the manner which I shall have indicated.

The rock pedestal is included in a sketch now at Bassano. The idea of a monarch on horseback surmounting a rock was also realized in the eighteenth century in Falconet's famous *Peter the Great* for St Petersburg.

Bernini's curiously involved and somewhat laboured explanation of his aims has something in common with Wagner's occasional verbal 'elucidations' of his, and there is some significance in this comparison. For both Bernini and Wagner had at their disposal unparalleled technical virtuosity, and both aimed to stun the senses of the spectators or audience by methods in which, as Bernini actually claimed on this occasion, the barriers between the arts were broken down. At the same time one is left with the suspicion that despite Bernini's confidence that his meaning would be clear to a spectator of his work this may not have been the

case; and that had his verbal explanation reached the King he might have thought differently about the statue.

It is Bernini's idea of the smile on the King's face, and the reason for it, which must have puzzled and perturbed spectators. Nor could any courtier be blamed for misconstruing the mystic smile of enlightenment as a self-satisfied smirk which ran violently counter to all ideas of regal decorum. Rudolf Wittkower went so far as to suggest not only that this was the reason for the King's dislike of the work (which is probably true), but also that this was what Bernini was alluding to in his letter to Colbert of 30 December 1669 ('If God gives me life and strength I will force myself, for the great love and duty which I bear His Majesty, to do what I do not wish to promise in words but only to demonstrate by deeds').[177] This seems improbable. Bernini was surely hinting that he would make a big effort to return to France to inaugurate the statue. Wittkower admitted, however, that the smile is barely visible in the statue's present state.

The fact that it does not figure on the terracotta model shows merely that Bernini thought of the idea at a later stage than that. His verbal description is so specific that the smile must have been noticeable when the statue arrived in France. It is indeed the feature which is conspicuously lacking in two equestrian portraits of Louis which may owe something to Bernini but which did not displease the sitter, namely Mignard's painting, now at Turin, and Coysevox's relief in the Salon de la Guerre at Versailles. Nevertheless some uncertainty must remain. It is not only that the extent of Girardon's alterations to Bernini's marble are still imprecisely defined. A sitter's revulsion against the first sight of his portrait, or, in modern times, against the recorded sound of his voice, is a common phenomenon. His first reaction, in order to explain the discrepancy between what he sees or hears and his image of himself, is that the portrait, or the recording, is at fault and distorted. But as the reaction is essentially emotional it is very difficult to analyse in detail, and in the present case we must merely accept the fact of the King's displeasure.

Though Bernini himself was at pains to claim that the Louis statue was completely different from that of Constantine, such is not the case. The bodies, tails and legs of the two horses are almost identical, as are the legs and flowing draperies of the sitters. The fact that the Constantine statue came first, and that Bernini had only just finished it when he

started the Louis, led to unfortunate results. Forms which in the Constantine were a natural consequence of the incident depicted – the Emperor's vision of the cross in the sky – were taken over in the Louis, despite being meaningless in the new context, and even inappropriate to it. A horse rears when it has been frightened, or if the rider has suddenly reined it in. Both conditions were natural in the case of Constantine's vision. But Louis's horse is supposed to have arrived at the summit of a precipitous rock after an arduous climb. In such circumstances it would look tired, and its head would be down. Admittedly, the horse of a triumphant monarch should not be depicted as tired, even if it is, but it is difficult to believe that Bernini would not have found a more suitable pose for Louis's horse if he had not created the Constantine immediately before it.

And in at least one other way the evolution of the Louis from the Constantine had an incongruous effect on the former. For the Constantine was designed to be set in a shallow niche. Though actually modelled nearly in the round its effect is essentially that of a relief. The horse virtually only exists when seen from sideways on, and the conditions in which it is displayed – inset into a side wall of the Scala Regia of the Vatican, facing down the vestibule of St Peter's – more or less physically preclude any other viewing angle. But the necessity of displaying the Louis statue in a niche would have created problems in Paris. In a letter of 27 October 1673 to Coypel, Colbert asks for a sketch of Bernini's statue, and for information whether or not it was to be isolated.[178] But though, in his letter to Bernini of 2 December 1667, he had thrown out the possibility that the King might 'have a building specially constructed' for the sculpture, his remark about siting the statue on the new bridge or at the Tuileries suggests that he was thinking of an open-air location. Just how unsuitable that is to the Louis statue may be seen by looking at it in its present situation.

For both of these reasons the Constantine makes an incomparably finer impression than the Louis. It looks precisely what it is, an effective piece of theatre, whereas the Louis statue was certainly never intended to look, as it does, both pathetic and slightly ludicrous. One factor is that Bernini's share in the execution of the Constantine was evidently much greater than in the Louis; and this is probably the crux of the matter, as anyone may see by comparing the terracotta model, obviously Bernini's own work, in the Borghese with the Versailles marble. The

difference depends not merely on the preference of the twentieth century for the unfinished over the finished. The fluent curves of the model, the superb dash and confidence which are usually expressed in English by such foreign words as *brio*, *bravura*, *panache* or *aplomb*, are lacking in the marble. The process of enlargement by other hands than the master's has crossed the barrier between the irrationally tolerable and the intolerably absurd. The same may be felt, though to a lesser extent, concerning another late sculpture from Bernini's studio, the tomb of Alexander VII (in St Peter's). Nowhere are the effects of dilution of a Baroque idea through studio execution more painfully obvious than in the depiction of animals. When attempting to be heroic, animals tend to become merely heraldic; and horses, in particular, turn into rocking-horses. This principle is already the case with the horse, likewise of studio execution, which peers out of the grotto of Bernini's Rivers fountain in the Piazza Navona in Rome. And it is, in fact, the horse's head in the Louis statue, with its huge, anthropomorphous eyes reminiscent of Fuseli's *Nightmare*, and with the nose and jaw unnaturally narrow, and approximating, unnaturally, to a cylinder rather than a cone, which is responsible, more than any other single feature, for the unfortunate effect of the work as a whole.

A portrait of the ruling monarch, perched precariously but victoriously on a rearing, snorting charger, was one of the quintessential Baroque images. To achieve it had been an ambition of sculptors since the time of Leonardo in the late fifteenth century. But owing to the inherent structural problems which faced the sculptor it had been painters such as Rubens and Van Dyck who had first realized it completely satisfactorily. Bernini was primarily a carver rather than a modeller, and in marble the structural problems are even greater than in bronze. Nevertheless it is surprising as well as regrettable that he, the supervirtuoso, was not faced with this challenge until so late in his life, and then in such circumstances. For all these reasons Bernini's aims in this genre, and his achievement, are best assessed on the evidence of the Borghese terracotta.

The fate of the Louis statue, though slightly less ignominious than it might have been, or than the King at first intended, will yet have given satisfaction to those Frenchmen, such as Perrault, whom Bernini had offended, and who considered that this was a fitting epilogue to a misguided mission. Neither they nor anyone else at the time, however,

could have foreseen that over and above the limited influence exerted by his Louvre designs and by his bust of the King, and arising rather from Colbert's insistence that he supervise the training of young French artists in Rome, Bernini was to exert posthumously a spectacular effect on the visual arts in France in the succeeding generation.

XIX

BY ABOUT THE year 1690 the momentum of Louis XIV's building mania appeared to have abated. The structure of Versailles was virtually complete. The colossal wings which Jules-Hardouin Mansart had added on either side of the central core were finished. Since his marriage to Madame de Maintenon, probably in 1684, the King had behaved rather less flamboyantly. But in 1698 some degree of resurgence, or perhaps survival, of the old architectural urge combined in the King's mind with an increasing religiosity to resume work on one last extravaganza, the Versailles chapel. This had been started a decade previously, but had been abandoned almost immediately on account of the war of the League of Augsburg. Despite Madame de Maintenon's energetic advocacy of the prior claim of indigent subjects the King persisted in reviving the project and in pouring out millions on it, as in his more carefree days twenty and thirty years previously. In the meantime essential changes had come over French art. A major factor had been the death in 1690 of the dictator of the arts, Charles Le Brun, and by 1700 the group in the French academy in Paris which looked to Rubens and to Nature had decisively routed those who adhered to the more venerable gods of Poussin and the Antique. In the event it might be said that it was Rubens who opened the door to Bernini in France, and the Versailles chapel was where it happened.[179]

Here it was that the fruits of Bernini's work among the French students in Rome could show themselves on the artists' home soil. It is hardly surprising that some, at least, of the young Frenchmen who had been transported to Rome at the King's expense should be less impressed with the worn and mutilated fragments of ancient Roman sculpture, which were endlessly held up for their admiration and emulation, and of which they had to take casts to send to France, than with works such as

Bernini's *Apollo and Daphne*, which were more brilliantly accomplished, in a technical sense, than anything ever achieved by the Ancients, and which had the added virtue of being intact. In addition, Bernini himself had been in personal contact, as we have seen, with the academy in Rome in the early 1670s. Here he met and encouraged young French artists such as Antoine Coypel, Nicolas Coustou and, probably, Corneille van Clève and others. And it was this generation, rather than the younger ones, which now came into its own in the Versailles chapel. Their Berninesque leanings had been held in check during the regime of LeBrun. That restraint was now removed, and the victory of the *Rubénistes* in the Paris academy completed the process of liberation. The result, in the decoration of the Versailles chapel, was an astonishing explosion of Berninism on French soil.

The shell of the building, designed by J.-H. Mansart, the last survivor of the old team, was finished by 1703, but owing to the elaboration of the painted, and more particularly the sculptural, decoration the building was not consecrated until 1710. The prominent external parapet is decorated with a series of large skyline statues of saints and virtues, entirely in the Berninesque tradition. A team of sculptors, most of whom had done a stint in Rome, was responsible for them.[180] The arrangement of the interior itself almost certainly owes its distinguishing feature to Bernini. As in his plans for the Louvre chapel, the King was to have direct access to the royal gallery of the Versailles chapel on the *piano nobile*, and as in Bernini's final Louvre project, the chapel roof is supported by huge free-standing columns. Otherwise it is a striking, but understated fact that the two most conspicuous works of art, one in painting, the other in sculpture, were in both cases the work of French artists who had been in contact with Bernini during their student days in Rome, and that the basic inspiration of both was the same work, Bernini's Cathedra Petri. Antoine Coypel, who painted the central section of the ceiling – representing God the Father, in Glory, announcing the coming of Christ – went to Rome at the age of eleven when his father, Noël Coypel, succeeded Errard as director of the French academy in 1673. He was precocious, and, as his own son, Charles-Antoine, tells us (1745), 'the celebrated Bernini showed himself very friendly towards him, and foretold what he would be one day'. Antoine Coypel remained three years in Rome. The other artist, Corneille van Clève, who was responsible for the gilt sculptured altar-piece representing the

name of God adored by angels above the high altar of the Versailles chapel, went to Rome, we are told in the *Mémoires inédits des Académiciens*, in 1671.[181] 'He remained there six years, and concerned himself particularly with the study of Bernini.' Like Antoine Coypel he spent some time in Venice after leaving Rome.

It follows that both Antoine Coypel and Corneille van Clève were in Rome at the time – the early 1670s – when Bernini's Cathedra, which was finished in 1666, was less than ten years old and still an unescapable novelty. Corneille van Clève's altar-piece, though very much smaller, has a similar principle of design. The focal point, the monogram, is nearly at the top, like Bernini's window with the dove, and from the circular forms which surround both of them gold lines radiate, on which are superimposed angels flying on clouds. Unlike Bernini's rays and clouds, which explode across the flanking pilasters of the choir of St Peter's, Corneille van Clève's are contained within the arch behind the altar. At the sides of the Versailles altar are two kneeling angels which clearly derive from another work of Bernini which he actually executed during Corneille van Clève's student days in Rome – the altar of the Cappella del Sacramento in St Peter's, dating from 1673-4.

In the case of Antoine Coypel's ceiling, the same inspiration seems equally clear, though translation of a sculptural idea into terms of paint has brought its own modifications. But, as in Bernini's Cathedra, Antoine Coypel's angel-infested clouds are allowed to cut across the (painted) architectural forms of the ceiling. The same principle occurs in Baciccio's ceiling of the Gesù nave in Rome, which evidently also derives from Bernini's Cathedra and has been thought to have influenced Antoine Coypel. Though some indirect influence could not be excluded, it is a fact that Baciccio's ceiling was not painted until after Antoine Coypel left Rome at the age of fourteen.[182]

Bernini's Cathedra, or rather its principal decorative feature, namely clouds in relief, superimposed on irregularly radiating gold rays of jagged outline, was to become a major decorative element in French art of the eighteenth century, as, indeed, in other countries, such as Austria. Its effect was undoubtedly boosted by the success of Juste-Aurèle Meissonnier's engraved designs, some of which date from the 1720s and which include highly Berninesque sculpted altar-pieces of the Cathedra type. One of the most extreme cases of those realized in France – the altarpiece over the high altar of Amiens cathedral (of all inappropriate

places) – dates from the mid-eighteenth century, and may therefore derive from Meissonnier, rather than from Bernini direct. It is nevertheless much larger and more uncompromisingly Berninesque than Corneille van Clève's work at Versailles, with no structural arch to contain the rays. The motif was also trivialized by being adapted to innumerable small *objets d'art* such as the so-called *Creation of the World* clock at Versailles, by Passement, Roque and François-Thomas Germain.

The Versailles chapel originally contained another altar-piece of Berninesque derivation, this time a painted one, by Jean-Baptiste Santerre. It is described by d'Argenville. 'King Louis XIV,' he writes, 'who employed him to paint a St Theresa for the chapel at Versailles, granted him a pension and a lodging in the galleries of the Louvre. This picture represents St Theresa in meditation, with an angel who seems to be hurling a lance at her. The quality of the heads is so high, and the expression and action so vivid, that the picture seemed dangerous to punctilious persons, and even the priests are in the habit of avoiding saying Mass at the altar.' Though Santerre's picture has disappeared, another altar-piece, painted by Restout for Tours, clearly derives in its turn from Bernini's St Theresa.

Bernini's influence on French students at the Rome academy lasted until well into the eighteenth century, and therefore many years after his death. J.-B. Detroy, who was there at the turn of the century, shows it in at least one painting, the *Allegory* (dated 1733, now in the National Gallery, London), where the Berninesque element (from his *Verità* in the Borghese Gallery) is inextricably mixed with influence from known works by Correggio (two versions of an *Allegory of the Virtues*, in the Doria Palace in Rome and in the Louvre respectively). Correggio had also been a crucial influence on Bernini himself, and in eighteenth-century French art the two traditions coalesce. But the most fruitful field, apart from the altar-piece, for Berninism in France which is attributable to impressions formed during the artists' student days in Rome was, predictably, in garden or fountain sculpture.

In the 1720s and 1730s, when Rome itself was experiencing a revival of interest in Bernini, half a century after his death, there was a corresponding resurgence of his influence among young French sculptors who were *pensionnaires* at the Rome academy. Bouchardon and Michel-Ange Slodtz, both of whom were to become extremely distinguished, were there at the time, and underwent the influence. But most of all it

manifested itself in Lambert-Sigisbert Adam. His career started spectacularly in 1732 when, still a student in Rome, he won the competition for the *Fontana di Trevi*, a project on which Bernini himself had worked, and whose resurrection at this time could itself be seen as a symptom of the current Bernini revival. The favour shown to Adam was naturally resented by the Romans, who contrived to get the award quashed.

After Adam's return to France he executed the cascade group of *Seine et Marne* for Saint-Cloud, and the *Neptune and Amphitrite* for Versailles, both of which still breathe the spirit of Bernini, while his self-portrait drawing at Oxford reads almost like a confession of faith in the great man. In his hand he holds a drawing for his group symbolizing Air, now in the park at Potsdam, which seems a variation on Bernini's *Apollo and Daphne*. On the spectator's right is Adam's fountain group for Saint-Cloud, while the background is occupied by his *morceau de réception*, the *Neptune Calming the Waves*, of 1737, which is a vivacious recreation of Bernini's early group of the same subject for the Villa Montalto, now in the Victoria and Albert Museum.

In the field of architecture one or two of the Rome *pensionnaires*, such as Charles de Wailly and Victor Louis, are known to have been much affected by Bernini's buildings during their student days, but they left only limited traces of this influence in their executed architecture.[183] Their main significance in this context is that they were active in the second half of the eighteenth century, not the first. In consequence, their work must be considered in the framework not of the incipient Rococo but of the incipient classical revival, and it was that strand in Bernini's architecture which affected them.

XX

THE CHEQUERED CHRONICLE of Bernini's mission to France – the Baroque splendour of his reception, the cordial relations between him and the King, and the success of the portrait bust, on the one hand, and, on the other, his tactlessness to the French, the rejection of the object of his visit, his Louvre project, and the posthumous fiasco of the equestrian statue – can be seen from a bewildering variety of points of view. One can point to the incompatibility of France and Italy, of Antiquity and

the Baroque, of amenity and display, of politics and art, of Colbert and Bernini personally, as well as to various other antitheses. It evidently took some time for a seventeenth-century Frenchman to realize that Italian artists were not necessarily the heirs of Antiquity just because they were Italian. This was probably the crux of the matter, both during Bernini's mission and afterwards. Some glimmering of this truth, some degree of realization that Bernini's Louvre looked more Italian than Antique, may, as we have seen, have tipped the balance against its execution. But Colbert showed no cognizance of it when founding the Rome academy and pressing Bernini to guide it. He had just two reasons for the second action: Bernini was the biggest name in Roman art, and he had to be made to work for the pension he was being given.

In sending French students to Rome to study the god of Antiquity Colbert ignored, or underestimated, the lurking and seductive presence of the Baroque devil. The sequel, in certain cases, was as if a drama student of our own day had been sent to Greece to study the work of Sophocles and had returned soaked in Cavafy. It is true that once the students were in Rome the presence there of Bernini's work, and that of other Baroque masters, would have been liable to influence them, irrespective of whether or not Bernini had personally guided the French academy. But his connection with the institution is likely to have encouraged the tendency, by giving the seal of approval to an otherwise potentially clandestine activity during his lifetime, and by constituting a precedent after his death. It is also true that not all of the students succumbed, and that the first to do so had to wait for many years after their return to France before the climate became favourable to Berninism. But it would probably not be unfair to conclude that in founding the French academy in Rome Colbert did not foresee the consequences.

In 1710, when the Versailles chapel was finished, Colbert had been dead for twenty-seven years, and Bernini himself for thirty. But Louis XIV, the third member of the triumvirate of 1665, was still alive and active at seventy-two. And it is fitting that the last word on the most conspicuous monument of French Berninism should be his. It is preserved in Charles-Antoine Coypel's life of his father.[184] The King had first inspected the new chapel from the gallery on the upper floor. Rumours of the royal displeasure were already circulating next day when the King noticed Antoine Coypel and called him over. 'The figures in your beautiful ceiling', he said to him, 'had seemed to me too large. But my

criticism was unjust. It was necessary for you to allow for two points of view. I have now studied your work from the ground floor of my chapel, and I am convinced that you would have been in error had you made the figures smaller. The painting is beautiful, and the longer one regards it with close attention the greater is the honour it does you.'

APPENDIX

NOTE ON THE ITALIAN AND
FRENCH DOCUMENTARY SOURCES

PARTLY BY CHANCE and partly as a result of what would now be called Bernini's news value we are exceptionally well informed of every aspect of the mission. It is, as a bonus, profusely documented from both sides, the Italian as well as the French. Published in 1682, Baldinucci's life of Bernini printed *in extenso* the more important of the preliminary letters exchanged between Louis, Colbert, Bernini and the Pope. Domenico Bernini's biography of his father, though owing much to Baldinucci, added a certain amount from family hearsay. In 1759, fifty-six years after the author's death, the memoirs of Charles Perrault were published. The section relating to Bernini is a masterpiece of malice. Perrault, subsequently famous as author of books such as *Parallèle des Anciens et des Modernes* and also of tales such as *La Belle au Bois dormant*, had been Colbert's chief assistant at the time of Bernini's mission, and, in the event, Bernini's principal opponent. His brother, Claude Perrault, was an amateur architect with considerable ambitions. Charles Perrault had been constantly in contact with Bernini during his mission and had finally been attacked by him in a violent quarrel.

Perrault states in his memoirs that he had had access to the diary kept by Fréart de Chantelou, who had been appointed by the King as equerry to Bernini, and who had remained with him in that capacity throughout his stay. This diary was also used by Castellan in his article on Bernini in the *Biographie Universelle* (1811), but both Chantelou's manuscript and the notes from which he must have made it are now missing. Our knowledge of it depends on an old manuscript copy which was discovered by a French scholar, Ludovic Lalanne, in the library of the Institut de France, where it remains. Lalanne published it in instalments in the years 1877-85 and then reprinted it (1885). It is in fact by far the most detailed of the documentary sources, but it is difficult to assess its reliability. Even assuming that the existing copy is basically accurate, it is clear that the original was made, for the benefit of Chantelou's brother, at least six

years, and probably several more, after the event. That said, it is only fair to add that the degree of detail of Chantelou's diary, together with its relative lack of literary airs and graces, presupposes a conscientious regard for accuracy on the part of the diarist, despite a number of minor discrepancies which emerge in comparison with precisely contemporary documents. A particular feature of interest in Chantelou's text is the amount of detail in which he reports what Bernini said, sometimes reproducing the actual Italian words, sometimes using direct speech in French but more often indirect speech. In the present book the interpolated Italian words have not been retained, and in many cases where Chantelou had turned Bernini's direct speech in Italian into indirect speech in French it has here been returned to direct speech, in English. But nothing in the conversations has been invented.

In the 1850s G. B. Depping published a selection from the administrative correspondence of Louis XIV in several volumes. A further selection, specifically of Colbert's correspondence, edited by Pierre Clément, followed in the 1860s. Both of these collections contained copious documentation relating to the preliminaries of Bernini's journey. Further archival material, the correspondence of the directors of the French academy in Rome edited by A. de Montaiglon, started publication in 1887 and revealed in day-to-day detail the erratic relations between Bernini and the academy in its early days. This was far from all. In 1895 the Bibliothèque Nationale in Paris acquired a large quantity of Italian documents which had evidently been Bernini's own copies of his correspondence with France. They included a set of letters written by Mattia de' Rossi, Bernini's architectural assistant during his mission. These, being absolutely contemporary with the events which they described, constituted even better evidence than Chantelou. Most, but not all, of Rossi's letters were published in 1904 by a French scholar, Léon Mirot, in a long article which was a model of documentary research, but which showed little understanding of Bernini's art. Though the form of address in the letters indicated that the addressee was in holy orders his name is not specified, and his identity seems to have baffled Mirot. But a postscript by Bernini's son, Paolo, who was with him in Paris, to one of the unpublished letters of Rossi is signed 'your brother Paolo'. It follows that the addressee of the letters was Bernini's eldest son, Monsignor Pietro Filippo Bernini. A later article, by E. Esmonin (1911), specifically on Bernini's work at the Louvre, drew on some further documents from the French side. Finally some more archives were published by the Italians. In his remarkable but rather underestimated monograph on Bernini (1900), Stanislao Fraschetti published more archives relating to the mission, notably the despatches of the Modenese envoys in Rome and Paris, and in 1957 Armando Schiavo added extracts from the Vatican archives, including despatches from the Papal Nuncio in Paris which were unknown to Mirot.

These varied and detailed sources – the pro-Bernini biographies of Baldinucci and Domenico Bernini; the anti-Bernini memoirs of Charles Perrault; the journal of Chantelou; the French despatches published by Depping, Clément, Montaiglon and Esmonin; the Italian ones by Fraschetti and Schiavo; together with the letters, published and unpublished, of Mattia de' Rossi – are the principal materials of the present book.

NOTES

PART ONE

I

1. Fraschetti, p. 340, n. 2.
2. Mirot, p. 199.
3. Lalanne, p. 33. Also D. Coffin.
4. Schiavo, p. 35. Josephson, I, *passim*.
5. Laprade, p. 342.
6. Lauritzen, p. 16.

II

7. Perrault, p. 49.
8. Baldinucci/Ludovici, p. 80.
9. Baldinucci, p. 92.
10. Baldinucci, p. 89.
11. Wittkower, 1955, p. 186, no. 4; and his fig. 20.
12. Fraschetti, p. 253, n. 1.
13. Mirot, pp. 168-9, n. 3.
14. Pastor, XXXI, pp. 95 ff. Also Schiavo, p. 24.
15. Schiavo, p. 26.
16. Clément, V, p. 245, n. 18.
17. Haskell, p. 153. Followed by Hibbard, p. 243, n. 168, and Tadgell.
18. Perrault, pp. 41 ff. For Le Vau's successive plans see Whitely and Braham, *passim*.

19. Lalanne, p. 257.
20. Mirot, pp. 171-2, n. 3.
21. Mirot, pp. 174-5, n. 3, and p. 183, n. 4.
22. Mirot, pp. 171-2, n. 3.
23. Depping, p. 535.
24. Depping, p. 536. Also K. Noehles, *passim*.
25. Depping, p. 537.
26. Depping, p. 538.
27. Mirot, pp. 174-5, n. 3.
28. Mirot, p. 177, n. 1.
29. Mirot, p. 173, n. 1, and pp. 178-80, n. 2.
30. Depping, p. 538. Colbert's letter of 3 October is in Clément, V, p. 245.

III

31. Mirot, pp. 178-9, n. 2.
32. Mirot, pp. 174-5, n. 3.
33. Depping, p. 548.
34. Perrault, pp. 56 ff.
35. Mirot, pp. 178-9, n. 2.
36. Clément, V, pp. 246 ff.

IV

37. Mirot, p. 183, n. 3.
38. Mirot, p. 183, n. 4.

39. Depping, pp. 548-9.
40. Depping, p. 549.
41. Mirot, pp. 188-93, notes.
42. Josephson, I, pp. 77-92.
43. Clément, v, p. 501, n. 2.
44. Clément, v, pp. 258 ff.
45. Mirot, p. 191, note.

V

46. Mirot, pp. 171-2, n. 3.
47. Mirot, p. 177.
48. Schiavo, p. 31.
49. Lalanne, p. 231.
50. Perrault, p. 47.
51. Lalanne, p. 231.
52. Schiavo, p. 30.
53. Schiavo, p. 30.
54. Perrault, p. 40.
55. Mirot, p. 192, n. 1.
56. Perrault, p. 55.
57. Fraschetti, p. 340, n. 2.
58. Guiffrey, p. 61.
59. Baldinucci, p. 113.
60. Baldinucci/Ludovici, p. 116.

61. Fraschetti, p. 340, n. 2.
62. Baldinucci/Ludovici, pp. 116 and 120.

VI

63. Mirot, pp. 198-9, n. 1.
64. Fraschetti, p. 340, n. 2.
65. Fraschetti, p. 228.
66. Fraschetti, p. 340, n. 2.
67. Domenico Bernini, p. 125.
68. Mirot, p. 199, n. 2.
69. Clément, v, p. 506.
70. Mirot, pp. 202-3, n. 2. Wittkower (1951, p. 3) says Bernini went through Marseilles, but this is presumably a slip of the pen.
71. Mirot, p. 201, n. 1.
72. Domenico Bernini, pp. 126-7.

VII

73. Mirot, p. 205, n. 3, and p. 168, n. 1.
74. Schiavo, p. 31.
75. Schiavo, p. 41.
76. Schiavo, p. 41.

PART TWO

VIII

77. Mirot, p. 240, n. 1.
78. Schiavo, p. 32.
79. Mirot, p. 205, n. 3.
80. Mirot, p. 223, n. 3.
81. Schiavo, p. 32.
82. Mirot, p. 206, note.
83. Baldinucci, p. 119.
84. Domenico Bernini, p. 127.
85. Schiavo, p. 32.
86. Fraschetti, p. 342, n. 1.
87. Fraschetti, p. 343, n. 1.
88. Perrault, p. 71.

89. Lalanne, p. 18.
90. Lalanne, p. 19.
91. Boschini, preface.

IX

92. Perrault, p. 51.

X

93. Domenico Bernini, pp. 133-4.
94. Bernini's letter is printed on p. 71.
95. Lalanne, p. 75, n. 2.
96. Wittkower, 1951, p. 13.

97. Mirot, p. 243.
98. Schiavo, p. 40.

XI

99. Mirot, p. 227, note.
100. On an engraved plan by Marot.
101. Beaulieu.
102. Fraschetti, p. 343, n. 1.
103. Baldinucci, p. 145.

XII

104. Clément, v, p. 251.
105. Perrault, pp. 50-1.
106. Perrault, p. 55.

107. Schiavo, p. 33.
108. Fraschetti, p. 353, n. 1.
109. Mirot, p. 231. The letter is in the Bibliothèque Nationale, ms. ital. 2083, p. 163. Chigi's reply: Baldinucci, p. 124.
110. The signature looks like 'Gian Carlo Bernini', which is how Chantelou's copyist regularly reads it (e.g. Lalanne, pp. 260, 261, 263). Evidently 'Lorenzo' was abbreviated to the point of illegibility.
111. Mirot, p. 168.
112. Schiavo, p. 28.

PART THREE

XIII

113. Fraschetti, pp. 347-8, notes.
114. Gould, *Correggio*, p. 163.
115. Mirot, p. 268.

XIV

116. Wren.

XV

117. A. Braham, 1960. Also Braham and Smith, p. 253.
118. Mirot, p. 250.
119. Mirot, p. 244.
120. Perrault, p. 54

XVI

121. Perrault, p. 64.
122. Fraschetti, p. 354, n. 2.
123. Clément, v, p. 265.
124. Perrault, p. 59.

125. Lalanne, pp. 168 and 181. Also Baldinucci, p. 120, and Domenico Bernini, pp. 136 and 137.
126. Domenico Bernini, p. 145.
127. Bernini is referring to his brief period of eclipse under Pope Innocent x. His sculpture of *Time revealing Truth* was carved at this time.
128. Mirot, p. 260, n. 2.
129. Lalanne, pp. 260-1. Lalanne reproduces Chantelou's copyist's mistake of misreading Bernini's name as 'Gian Carlo'.
130. Mirot (p. 260, n. 3) quotes a payment to Mancini, apparently for the journey to Rome, but Chantelou (p. 256) implies he accompanied the party only as far as Lyon.

PART FOUR

XVII

131. Lalanne, p. 261. Also British Museum Add. M8.56232.
132. Mirot, pp. 267–71.
133. Schiavo, fig. 29, reproduces a reconstruction of the façade at full length.
134. Fraschetti, p. 358.
135. Esmonin, pp. 38–9.
136. Esmonin, p. 40.
137. Mirot, p. 273.
138. Lalanne, p. 263.
139. Mirot, p. 276.
140. Lalanne, p. 264.
141. Also quoted by Hautecœur, p. 59.
142. Perrault, p. 40.
143. Whiteley and Braham, *passim*.
144. The most recent contribution (favouring Perrault) is by C. Tadgell, *Burlington Magazine*, May 1980.
145. Perrault, pp. 73 ff.
146. Perrault, pp. 73 ff.
147. Fraschetti, p. 358, n. 3.
148. Fraschetti, p. 358, n. 4.
149. Lalanne, p. 264.

XVIII

150. Perrault, pp. 41–6.
151. Lapauze, *passim*.
152. Mirot, p. 278.
153. Clément, VI, p. 278.
154. Mirot, p. 277.
155. Mirot, p. 279.
156. Montaiglon, I, p. 22.
157. Montaiglon, I, p. 28.
158. Clément, III, p. 236.
159. Depping, p. 540.
160. Montaiglon, I, p. 48.
161. Montaiglon, I, p. 93.
162. Mirot, p. 278.

163. Fraschetti, p. 360, n. 1, and Clément, V, p. 351.
164. Wittkower, 1975, p. 99, and Josephson, II, *passim*.
165. Lafont de Saint-Yenne, p. 111; and Dézallier d'Argenville, *Vie des fameux architectes*, I (1787), p. 222.
166. Hempel, pp. 273 ff. Also Laurain-Portemer, 1968, and Marder. The latter suggests plausibly that Benedetti's scheme derived from one by Bernini.
167. Fraschetti, p. 360, n. 1.
168. Montaiglon, I, p. 76.
169. Montaiglon, I, pp. 85 and 109.
170. Fraschetti, p. 361, n. 1.
171. Fraschetti, p. 363, n. 1.
172. Fraschetti, p. 363, n. 1.
173. Fraschetti, p. 363, n. 2.
174. Fraschetti, p. 363, n. 3.
175. Fraschetti, p. 360, n. 2.
176. Domenico Bernini, pp. 150–1.
177. Wittkower, 1975, pp. 88 ff.
178. Montaiglon, I, p. 49.

XIX

179. Gould, *Colloquium*.
180. De Nolhac (1925) lists fifteen sculptors, of whom Thieme-Becker notes the following as having been at Rome: Barrois, Bourdict, van Clève, G. Coustou, Flament, Hurtrelle, Le Lorrain, P. Le Pautre, Slodtz.
181. Montaiglon, I, p. 32.
182. Enggass, *passim*.
183. A. Braham, *Colloquium*.

XX

184. Coypel, 1971 ed., p. 194.

BIBLIOGRAPHY

ARGENVILLE – Dézallier d'Argenville: *Vie des Fameux Sculpteurs* ... (1787).

BALDINUCCI – Filippo Baldinucci: *Vita del Cavaliere Gio. Lorenzo Bernino* ... (1682), ed. Sergio Samek Ludovici (1948).

BEAULIEU – M. Beaulieu: 'G. Le Duc, M. Anguier et le Maître-Autel du Val-de-Grâce', *Bulletin de la Société de l'Histoire de l'Art français* (1945-6), pp. 150 ff.

BELLORI – Gio. Pietro Bellori: *Le Vite de' Pittori, Scultori et Architetti Moderni* (1672).

BERGER – Robert W. Berger: 'Charles Le Brun and the Louvre Colonnade', *Art Bulletin* (1970), pp. 394 ff.

BERNINI, DOMENICO – Domenico Bernini: *Vita del Cavalier Gio. Lorenzo Bernino* (1713).

BLONDEL – J.-F. Blondel: *Architecture françoise* ... (1752-6).

BLUNT – Anthony Blunt: *Art and Architecture in France, 1500 to 1700* (1953). 2nd ed. (1970).

BOSCHINI – Marco Boschini: *Le Ricche Minere* ... (1674).

BRAHAM, 1960 – A. J. Braham: 'Bernini's Design for the Bourbon Chapel', *Burlington Magazine* (1960), pp. 443 ff.

BRAHAM, COLLOQUIUM – Allan Braham: 'Bernini's Influence on French Architecture' – to be published with the papers of the Bernini Colloquium held at the American Academy in Rome in May 1980.

BRAHAM AND SMITH – Allan Braham and Peter Smith: *François Mansart* (1973).

BRAUER – See Wittkower, 1931.

CASTELLAN – Article on Bernini in *Biographie Universelle* (1811).

CHANTELOU – Fréart de Chantelou: *Journal du Voyage du Cavalier Bernin en France*, ed. Ludovic Lalanne (1885).

CLÉMENT – Pierre Clément: *Lettres, Instructions et Mémoires de Colbert*, III (1865), V (1868), VI (1869), VII (1873).

COFFIN – David R: 'Padre Guarino Guarini in Paris', *Journal of the Society of Architectural Historians*, vol. XV, May 1956, no 2., pp. 3 ff.

COYPEL – Charles Coypel: '*Vie d'Antoine Coypel*', discourse delivered 6 March 1745. Printed in *Œuvres de . . . Coypel*, (reprint of 1971).

DEPPING – G. B. Depping: *Correspondance Administrative sous le Règne de Louis XIV, IV* (1855).

ENGGASS – Robert Enggass: *The Painting of Baciccia* (1964).

ESMONIN – E. Esmonin: '*Le Bernin et la Construction du Louvre*', *Bulletin de la Société de l'Histoire de l'Art français* (1911), p. 31.

FRASCHETTI – Stanislao Fraschetti: *Il Bernini* (1900).

GOULD, CORREGGIO – Cecil Gould: *The Paintings of Correggio* (1976).

GOULD, COLLOQUIUM – Cecil Gould: 'Bernini's Influence on French Sculpture and Painting – to be published with the papers of the *Bernini Colloquium* held at the American Academy in Rome in May 1980.

GUIFFREY – J. Guiffrey: *Comptes des Bâtiments du Roi . . .* (1888).

HASKELL – Francis Haskell: *Patrons and Painters* (1963).

HAUTECŒUR – Louis Hautecœur: *Histoire du Louvre, 1200–1940* (n.d.).

HEMPEL – E. Hempel: '*Die spanische Treppe*', in *Festschrift Heinrich Wölfflin* (1924), pp. 277 ff.

HIBBARD – Howard Hibbard: *Bernini* (1965).

JAL – *Dictionnaire critique de Biographie et d'Histoire* (1867).

JOSEPHSON, I – Ragnar Josephson: '*Les Maquettes du Bernin pour le Louvre*', *Gazette des Beaux-Arts* (1928), pp. 75 ff.

JOSEPHSON, II – Ragnar Josephson: '*Le Monument du Triomphe pour le Louvre*', *Revue de l'Art ancien et moderne* (1928), pp. 21 ff.

KALNEIN AND LEVEY – Wend, Graf Kalnein and Michael Levey: *Art and Architecture of the Eighteenth Century in France* (1972).

LA CHAMBRE – Pierre de La Chambre: '*Eloge du Bernine*', *Journal des Savants* (1681) (24 February).

LAFONT DE SAINT-YENNE – *L'Ombre du Grand Colbert* (1749).

LALANNE – See Chantelou.

LAPAUZE – H. Lapauze: *Histoire de l'Académie de France 'a Rome* (1924).

LAPRADE – A. Laprade: *François d'Orbay . . .* (1960).

LAURAIN-PORTEMER, 1968 – M. Laurain-Portemer: '*Mazarin, Benedetti et l'Escalier de la Trinité des Monts*', *Gazette des Beaux-Arts*, vol. 72 (1968), pp. 273 ff.

LAURAIN-PORTEMER, 1969 – M. Laurain-Portemer: '*Mazarin et le Bernin à propos du "Temps qui découvre la Vérité"*,' *Gazette des Beaux-Arts*, vol. 74 (1969), pp. 185 ff.

LAURITZEN – Peter Lauritzen and Alexander Zielcke: *Palaces of Venice* (1978).

LOTZ, 1968 – W. Lotz: '*Bernini e la Scalinata di Piazza di Spagna*', *Colloqui del Sodalizio tra Studiosi dell'Arte* (1966–8).

LOTZ, 1969 – W. Lotz: '*Die spanische Treppe. Architektur als Mittel der Diplomatie*', *Römisches Jahrbuch für Kunstgeschichte* (1969).

MARDER – Tod A. Marder: '*Bernini and Benedetti at Trinità dei Monti*', *Art Bulletin* (June 1980).

MIROT – Léon Mirot: '*Le Bernin en France*', *Mémoires de la Société de l'Histoire de Paris* (1904), pp. 161 ff.

MONTAIGLON – A. de Montaiglon: *Correspondance des Directeurs de l'Académie de France à Rome* (1887–).

NOEHLES – Karl Noehles: '*Die Louvre-Projekte von Pietro da Cortona und Carlo Rainaldi*', *Zeitschrift für Kunstgeschichte* (1961), pp. 40 ff.

NOLHAC – P. de Nolhac: *Versailles, Résidence de Louis XIV* (1925).

PANE – Roberto Pane: *Bernini Architetto* (1953).

PASTOR – Ludwig, Freiherr von Pastor: *History of the Popes*, English ed., XXXI (1940).

PERRAULT – Charles Perrault: *Mémoires* (1759), reprinted (1878).

SAUVEL – T. Sauvel: '*Les Auteurs de la Colonnade du Louvre*', *Bulletin Monumental* (1964), p. 323.

SCHIAVO – Armando Schiavo: *Il Viaggio del Bernini in Francia nei Documenti dell'Archivio Segreto Vaticano* (1957).

TADGELL – Christopher Tadgell: '*Claude Perrault, François Le Vau and the Louvre Colonnade*', *Burlington Magazine* (May 1980).

WHITELEY AND BRAHAM – Mary Whiteley and Allan Braham: 'Louis Le Vau's Projects for the Louvre and the Colonnade', *Gazette des Beaux-Arts* (1964), pp. 285 ff. and 347 ff.

WITTKOWER, 1931 – Heinrich Brauer and Rudolf Wittkower: *Die Zeichnungen des Gianlorenzo Bernini* (1931).

WITTKOWER, 1951 – Rudolf Wittkower: 'Bernini's Bust of Louis XIV' (Charlton Lecture) (1951).

WITTKOWER, 1955 – Rudolf Wittkower: *Gian Lorenzo Bernini* (1955).

WITTKOWER, 1958 – Rudolf Wittkower: *Art and Architecture in Italy, 1600–1750* (1958).

WITTKOWER, 1975 – Rudolf Wittkower: *Studies in the Italian Baroque* (1975).

WREN – Christopher Wren II: *Parentalia or Memoirs of the Family of the Wrens* (1750).

ADDENDUM While the present book was in the press it was suggested that Bernini's plan for a statue of the King between two colossal columns at the Tuileries (see p. 125) connected with the War of Devolution (Kevin O. Johnson: '*Il n'y a plus de Pyrénées*', *Gazette des Beaux-Arts*, (1981), pp. 29 ff).

INDEX